A SENSE OF MISSION

A SENSE OF MISSION

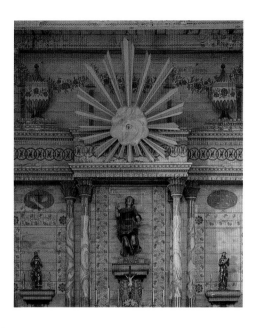

HISTORIC CHURCHES OF THE SOUTHWEST

FOREWORD BY N. SCOTT MOMADAY PHOTOGRAPHY BY TEXT BY THOMAS A. DRAIN
 DAVID WAKELY

CHRONICLE BOOKS

SAN FRANCISCO

This book was conceived, designed, and produced by Sharon Smith Wakely, with the help and support of a host of colleagues, friends, and family. Special thanks to our parents and families for their devoted interest and encouragement; to Jay Schaefer, Karen Silver, Michael Carabetta, and Brenda Eno at Chronicle Books, for their trust and guidance throughout this project; to Carolyn Miller, not simply for editing, but for her humor and grace, and for a seemingly endless supply of helpful suggestions to make this book better than it was when it first came her way; to Malcolm Margolin of Heyday Books for an enlightening exchange of ideas and information about the native Americans and their relationship to the missions; to Star Type in Berkeley for beautiful type and production; to Marlene McLoughlin for the gorgeous maps; to Katherine Gibbon for clear and patient explanations of all things related to computers; and to the following for lending their support in many ways: Jonee and Harvey Hacker, Candida Silva, Christopher Stinehour, Judy Gibson, Zahid Sardar, Larry Gonick, Jesse Bunn, Zippie Collins, Esther Mitgang, Mark and Elizabeth Wholey, Tom and Carol Christensen, Joan Olson, Beth Roy, Alison Moore, Mark Woodworth, Ward Shumaker, Brad Bunnin, David Barich, Kit Morris, Eric Johnson, Hazel White, and Sara Slavin.

We also owe many thanks to the people on the staffs of churches, museums, national parks and monuments, and historic places who have been so generous with their time and knowledge to help us make this book as informative and accurate as we can. It is their devotion that ensures the well-being of these precious buildings and their contents for generations to come. We thank Dr. Bernard Fontana of the Southwestern Mission Research Center; Orlando Romero at the Museum of New Mexico; Marina Ochoa, curator and archivist, Archdiocese of Santa Fe; Rosalind Z. Rock, park historian, San Antonio Missions National Historical Park; Jerrell C. Jackman, Ph.D., Santa Barbara Trust for Historic Preservation; Newton M. Warzecha, Presidio la Bahía; Luis Cazarea-Rueda and Don Harvey, Goliad State Historical Park; Skip Clark, El Paso Mission Trail Association; Jim Troutwine, Tumacácori State Historical Park; Juan Gonzales, Salinas Pueblo Mission National Historic Park; John Loleit and Ann Rason, Pecos National Park; Ike Lovato, Jr., Jemez National Monument; Richard Rojas, State of California Department of Parks and Recreation; Fr. Francis Guest, Mission Santa Barbara Archive Library; Bob McConnell, Mission San Miguel; Fr. Leo Sprietsma, Mission San Antonio de Padua; Gov. Harry D. Early, Fr. Matt Crehan, and Esther Antonio, Pueblo of Laguna, NM; José López and David López, Las Trampas, NM.

A special thanks to Gary Bailey of Sanford, CO, who generously repaired our tire and inflated our spirits on a Sunday evening.

— S.S.W., D.W., T.D.

Special photographic permission was granted by the office of Historic-Artistic Patrimony and Archives of the Archdiocese of Santa Fe, NM, and the San Antonio Missions National Historical Park, San Antonio, TX.

Printed in Japan.

Library of Congress Cataloging-in-Publication Data

Wakely, David.
 A sense of mission : historic churches of the Southwest / photography by David Wakely; text by Thomas A. Drain; foreword by N. Scott Momaday
 p. cm.
 Includes bibliographical references and index.
 ISBN 0-8118-0404-6(pbk.)
 ISBN 0-8118-0632-4 (hc)
 1. Spanish mission buildings — Southwest, New. 2. Spanish mission buildings — Southwest, New — Pictorial works. 3. Architecture — Southwest, New — Pictorial works. 4. Churches — Southwest, New — Pictorial works. 5. Southwest, New — History — To 1848. I. Drain, Thomas A. II. Title.
 F797.W34 1994
 726'.5'0979 — dc20 93-5122
 CIP

Editing: Carolyn Miller
Book and cover design: Sharon Smith Wakely
Composition: Star Type, Berkeley
Hand-drawn maps: Marlene McLoughlin

Cover: San José de Gracia, Las Trampas, NM
Title page: San Miguel Arcángel, San Miguel, CA
Page vi: Kiva in the *convento*, Abó, Salinas Pueblo Missions National Monument, NM
Page viii: Altar screen, San José de Gracia, Las Trampas, NM
Page x: Pueblo pottery shards, tools, and arrowheads
Page 3: Taos Pueblo, NM
Page 5: Altar in padres' quarters, Mission La Purísima Concepción, Jolon, CA
Page 6: Angel, San Xavier del Bac, Tucson, AZ
Page 11: Nuestra Señora de Loreto, Presidio la Bahía, Goliad, TX
Page 37: Angel, detail of altar screen at Santa Cruz de la Cañada, Santa Cruz, NM (see page 50)
Page 87: Mission San Xavier del Bac, Tucson, AZ
Page 99: Mission San Miguel Arcángel, San Miguel, CA
Page 126: Ceiling fresco, La Purísima Concepción, San Antonio, TX
Page 133: *Morada* near Santa Cruz, NM

Distributed in Canada by Raincoast Books,
112 East Third Avenue, Vancouver, B.C. V5T 1C8

10 9 8 7 6 5 4 3 2 1

Chronicle Books
275 Fifth Street
San Francisco, CA 94103

Table of Contents

✠

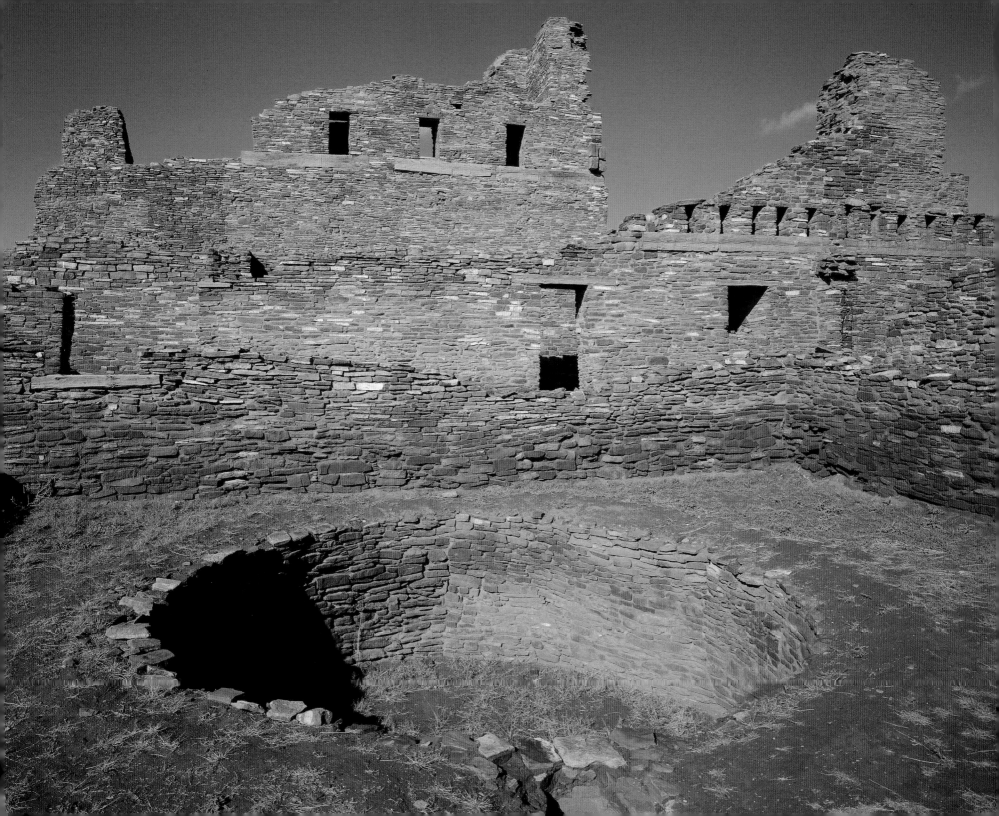

FOREWORD

N. SCOTT MOMADAY

I once heard the story of a man who was walking along a road in twelfth-century France. He saw a figure approaching, a workman pushing a wheelbarrow full of heavy stones. "What is this work you are doing?" the man asked. The workman complained that he worked from dawn till dusk, that he had a large family to feed, that life was a burden he could scarcely bear. The man walked on, and there approached another workman, pushing a wheelbarrow full of stones. "What is this work you are doing?" And the workman replied in the same way. He was wasting his life. The man went on, and after a time, a third workman approached, pushing a wheelbarrow full of heavy stones. "What is this work you are doing?" The workman looked at him, as if wondering how the questioner could possibly be serious. "I am building the Cathedral of Chartres," he replied.

From the time I first heard it, this story has been for me an inspiration. I had heard the story before I beheld and entered the Cathedral of Chartres for the first time. This year I visited Chartres again; it was my fifth visit. And the Cathedral was equal to my memory and to my imagination at once. There are few things in the world of which this can be said. The next day, in Paris, I lunched with a Parisian journalist. "How is it possible for human beings to erect such a monument as Chartres," I asked, "something that reaches nearly to Heaven's gate?" My friend thought for a moment, and then he said, "Well, you know, those people, then and there, they were full of God."

The mission builders of the American Southwest were full of God. One looks at the Mission San Xavier del Bac and sees a reflection of Nôtre Dame in Paris. There is an architectural link between the old and new worlds that binds time and place forever. Its clearest expression is in the village missions of the Southwest, those grand, crude adobe buildings at San Elizario, Jemez Springs, Pecos, Trampas, Rancho de Taos, other villages, alive and dead. Even the bones, the deep archaeology of this place, attest to a spirit that persists in the landscape and in geologic time.

The missions of the American Southwest are the beads of an ornate rosary; they are a means of reaching nearly to Heaven's gate. The people who built the missions and first worshiped in them were men and women of intense faith, and they brought to the New World the deepest spirituality of the Old. And their spirituality was informed by an aesthetic sense that was pure and simple and unique. It bore the aspects of migration. A part of it was Moorish and Spanish, another part was Mestizo and Pueblo.

A special dimension in the story of the missions of the Southwest is the native American intercession. The missions concede something to the Indian world, a simplicity, a touch of patience and calm, a world view founded upon symmetry and balance, a profound understanding of the earth, water, and sky. I lived for some years at the Pueblo of Jemez, in north central New Mexico. The equation of native religion and Christianity is a tension that results in a particular point of view and in the conception of distinguished and original art. It is an art that proceeds from rock paintings made in the time of Christ. And it incorporates Christ in the icons of his life — childhood, manhood, martyrdom. The crucifixion is an image that predominates in the missions, as it does in all the Christian world. In the missions of the Southwest, in the Indian communities, it is an image of profound mystery, as it was always meant to be, and a symbol of the mortality and immortality of man. It is a Katsina, a mask, an image of the sacred.

In the missions of the American Southwest, the sum of the parts — Moorish and Spanish, Mestizo and Pueblo, the old world and a world older still — was and is an American architecture and interior decoration that succeeds to art of very great distinction. It is an art that reflects truly the rich cultural mosaic, the extraordinary light and colors, and, above all, the sacred center of that landscape.

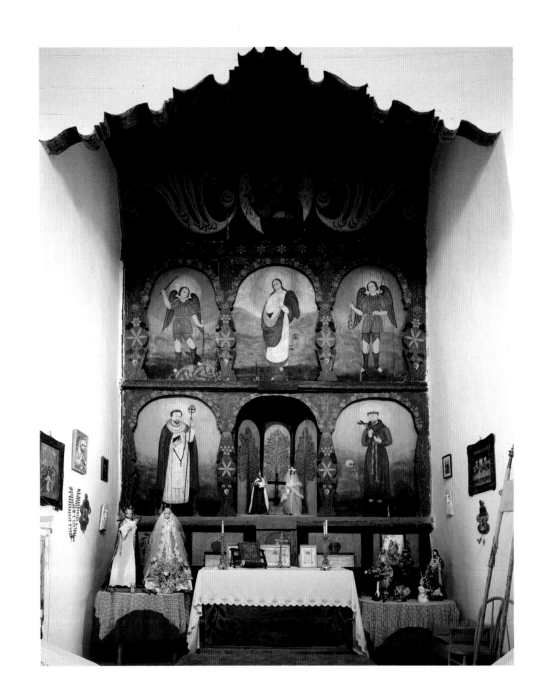

PREFACE

Coming from a family in which my father, brother, and uncle are all architects, I can honestly say that most family dinners included a discussion about various building projects. In fact, our weekend trips usually included the mandatory stop at a construction site. As a result, I would always see columns as bearers of great weight, doors as forms of accessibility, and windows as sources of illumination. I learned that within the right solution, there is harmony among all the elements.

As a photographer, I am fascinated with the structures we've created to honor the spiritual world. I am drawn to places where we've touched the earth, built and lived on it, destroyed it, abandoned it. I arrive at a site, facing it directly and truthfully, always looking for remnants from the past. Using natural light, I try to capture the spirit of these places.

Churches are safe havens for travelers, good places to get out of the heat of the day and gather your thoughts. The inspiration for this project began the first time my wife Sharon and I visited San José de Gracia in Las Trampas, New Mexico. I remember opening the heavy door, entering the dark, cool church, and being drawn in by the light falling on the altar. We sat while our eyes adjusted to the dark and began to see forms and details emerging from the shadows. We admired the simplicity of the adobe architecture, the hand-carved beams, the uneven floor, the wood-burning stoves, and the chandeliers fitted with real candles. On the altar screens, images of the Virgin Mary and the saints in their traditional iconographic forms were painted with great skill and clarity. It seemed as if we had traveled back in time, before science and technology, when almost all men and women put their faith in the mysteries of the church. I thought about the people who worshiped there, and of the Spanish and native American artisans whose religious devotion was displayed before us, and I felt very fortunate to experience the richness of this historic treasure. It was a short visit, but long enough to inspire a journey to other early churches of the Southwest.

Sharon and I limited our search to Texas, New Mexico, Southern Colorado, Arizona, and Southern California, and chose churches that were founded during the Spanish-Mexican exploration and occupation. We looked for the oldest sites, with authentic artifacts from the past such as altars, reredos, *bultos*, and other painted and carved images. Most of these churches today show signs of extensive restoration and have survived only because of the community's need for a place to worship. Many missions were completely restored in Texas and California, where Federal and state work programs in the 1930s conducted careful archaeological studies, using drawings and written descriptions from old journals to replace lost artifacts with others of the same period. Given the fragility of the building materials and often the years of neglect, it is amazing that some of these churches exist at all. Many sites have completely disappeared.

We included the abandoned churches of New Mexico in part because they illustrate the failure of some early missions, but also because they show how the pueblo people accommodated the European padres in the early seventeenth century, allowing the establishment of churches within the villages and utilizing local building materials and labor.

The churches of Southern Colorado, on the northern edge of the Spanish-Mexican expansion, were built later than those in New Mexico and for the most part have not survived the harsh weather and changes in clergy. What remains has been called "adobe Gothic." San Acacio has gone through a recent restoration and is a good example of this unique mid-nineteenth-century style.

The state of California and community organizations saw the value of rescuing the California missions decades ago and, because of that, many beautiful examples of mission architecture survive here. Each California mission in this book has unique characteristics that set it apart from the others and illustrate the wide diversity within the mission system.

We hope we will inspire you to visit the churches in this book and other Southwest churches as well, and to experience fully these historic treasures of spiritual values and tradition.

— David Wakely

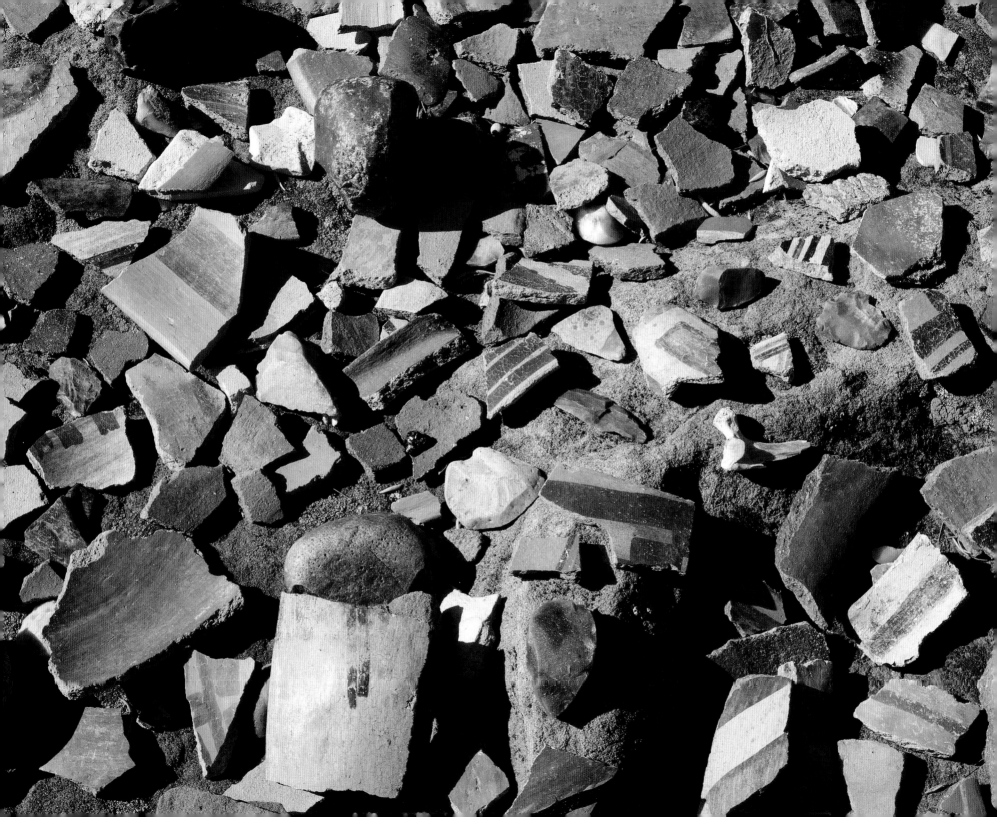

INTRODUCTION

The Spanish Catholic missions of the United States are a unique legacy from two very different cultures. Conceived as an expression of the Catholic faith of the Spanish conquerors, they were built by native American peoples who, if they accepted the religious message of the Spanish missionaries at all, did so on their own terms. Thus the missions blended two religious and symbolic systems into an expression of artistic genius.

The Spaniards arrived in North America with a set of written laws to guide their conquest and their behavior toward the American natives. These Laws of the Indies, promulgated in 1573, stated that the conversion of native peoples to Catholic Christianity was the principal aim of Spain's expansion into the New World. They further stated that this was to be undertaken without injury to the natives. The historical record shows how far from this expressed ideal the Spaniards departed, from the very beginning of their adventure in America. It is almost miraculous that the native peoples survived at all, considering the scale of the assault on every aspect of their lives, their persons, and their material and spiritual culture. Many of the Catholic missionaries did not distinguish the aim of spreading the Gospel from the drive to create a Spanish Empire, and regarded the native Americans either as destined by nature to be slaves or as children who required instruction and guidance to "raise" them to the level of European culture. In every generation, however, there were voices of moderation and restraint among the clergy, genuine defenders of the native peoples who did all they could to mitigate the worst effects of the Spanish presence.

Before the sixteenth century was half over, rumors of the great riches of the legendary Seven Cities of Cíbola lured the first Spaniards north from Mexico to what is now New Mexico. Franciscans accompanied them, but built no churches. By the close of the century, ten Franciscans had gone to the territory as permanent missionaries and began to found churches. By 1660 there were forty-five or fifty Franciscan churches in New Mexico. A few were abandoned during the drought of the 1670s; the Pueblo Revolt of 1680 destroyed others. By 1763 there were thirty priests serving probably as many churches. In 1776 an episcopal visitor inspected thirty-two churches. The actual number of buildings is difficult to determine because it varied almost from year to year and because many of the major churches had dependencies, chapels, and preaching stations attached to them from time to time. Some of these dependencies flourished and became missions in their own right, others disappeared.

In a parallel movement north, the Jesuits established a chain of missions in what is now Arizona, under Father Kino. Part priest, part scholar, part explorer, Kino intended to find an overland trail to California to determine if that land was indeed an island, as early maps showed it, and to set up a chain of missions on the way. In 1767, however, the Society of Jesus was suppressed in Spain and its territories, Jesuits in the New World were arrested and expelled, and their missions in North America were assigned to the Franciscans. This left all the missions in Texas, New Mexico, and Arizona in Franciscan hands.

The California missions were established much later than others in the Southwest. The interests of the Spanish crown and the Catholic Church were always joined; in California, however, they were specifically united to oppose the growing presence of Orthodox Russia, already established in Alaska and soon to have a foothold in Northern California at Fort Ross. In 1769, Father Junípero Serra, the Franciscan administrator of the former Jesuit missions in Baja California, was transferred to Alta California and founded the first mission there, in San Diego in 1770. The second mission was founded at Monterey, the Spanish capital of the territory. From that year until 1823, twenty-one missions, at a distance of a day's brisk march from one another, were founded by Serra and his successors.

The renewed missionary activity that brought the Spanish priests to the New World also was, in large part, a result of the Counter-Reformation.

The impulse to evangelize non-Christians had never entirely disappeared among Catholics, but several factors strengthened this impulse after the Reformation. The seas were under the control of two Catholic countries, Portugal and Spain, so it was no great problem for the clergy to reach hitherto unvisited parts of the globe. Another factor that gave some urgency to their efforts at preaching the gospel was the loss of large numbers of Catholics to the reformed churches. The missions offered a fertile field to recoup these losses.

Most of the Spanish missionaries in the Americas were Franciscans. The Franciscans were not known as learned men; indeed, they were deliberately simple, often uneducated. They shared all material resources, ate together, met throughout the day and night to chant the services of the Divine Office, and lived as simply as possible in the spirit of holy poverty that each of them had vowed to follow. The architecture of the Franciscan missions in North America reflects this simplicity, humility, and poverty. The spirit of the order seems to have been impressed on the buildings themselves.

The missions were intended eventually to be self-supporting, and were to be staffed not by members of religious orders but by the diocesan clergy as parishes of established dioceses. This process of "secularization" was undertaken just as Mexico gained its independence from Spain and the financial support for the missions ceased. The Franciscans were withdrawn, with no provision for replacements. In the distribution of mission property that accompanied this process, native Americans who had been given title to land they occupied were often cheated out of it by Anglo and Spanish adventurers, and one by one the missions were virtually abandoned.

Associations of pious laymen in Arizona and New Mexico attempted to continue some religious observances, organizing themselves in the absence of clergy to celebrate the sacraments or instruct them. These groups came to be known as Penitentes because of the severe penitential practices such as self-flagellation that marked their celebrations, especially during Holy Week. When the diocesan organization improved, the peculiar customs and great independence of the Penitentes, who still exist, were misunderstood by the non-Spanish clergy who arrived to staff the parishes of the Southwest, and for years they were estranged from the official church. But the Penitentes built chapels for their meetings, and in these little buildings, known as *moradas*, and in the continuing construction of family chapels, the traditions of adobe church building and decoration were preserved in the Southwest, but on a very reduced scale.

Most of the native Americans in California left the Church after secularization. The mission buildings fell into disrepair without resident priests, proper administration, and the government subsidies that had maintained the system previously. Many adobe churches, plundered for their wooden roofs and exposed to the elements, melted back into the earth. By the 1880s, these "romantic ruins" attracted the attention of a variety of organizations — religious, historical, and artistic — that supported efforts to preserve, stabilize, and restore the mission churches. Modern taste has come to appreciate these buildings for their organic simplicity and the fresh, even naive folk quality of their decoration. Now that both the Church and the general public know the value of these precious monuments, their future seems reasonably secure.

❧

The architectural achievement of the missions is even more impressive when viewed against the simple building techniques the Spaniards found in North America. Here, there was nothing like the great Aztec and Mayan cities and monuments. The natives of Texas, for example, were nomads, or very nearly so. Their architectural skills were limited to constructing rudimentary temporary shelters. Farther north, however, the Spaniards found the Indian pueblos, enormous clusters of small-roomed dwellings constructed according to designs that dated to prehistoric times. These were adobe buildings, built by pouring liquid adobe on the top of a wall under construction, leaving it to dry, and then repeating the process until the wall reached the desired height. When the Spaniards built their adobe churches, they used formed adobe bricks. This method was new to the native Americans, but the division of labor was as it always had been:

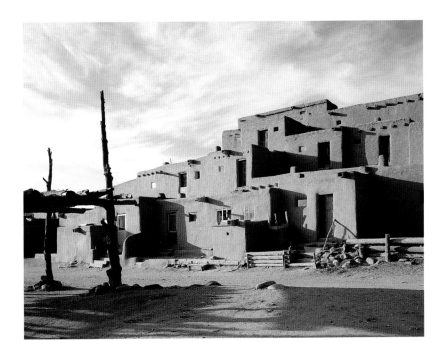

beam, to support the mud that sealed the roof. Even these smaller members (called *latias*) were not easy to find in the surrounding desert, and roofing material was almost always reused when the churches were repaired or rebuilt.

A Franciscan friar assigned to a North American mission came with a kit of basic hand tools for agriculture and construction, and a small supply of metal hardware — mostly hinges, nails, and staples. Even with the help of these tools, adobe construction on this scale required a huge effort, and the native population did not always work willingly, as such work diverted them from other necessary communal tasks.

The plan of a typical mission church is very straightforward. The worshiper came from the bright daylight into a long, narrow hall. The baptismal font stood near the entrance, sometimes in its own room, the baptistry. The body of the church, the nave, was large enough to accommodate the entire parish community, who stood, knelt, or sat on the packed earth floor. The building focused on the sanctuary, a small area at the end of the building, marked by a low railing as the most holy space where the priest said Mass.

Sometimes the plan included a transept, a transverse portion that crossed the nave at a right angle. It was often built higher than the nave, which allowed for a window in the resulting wall over the nave where these two elements met. This transverse clerestory window is a feature unique to Southwestern churches, and only a few have survived. The lateral areas of the transept were given over to side altars or chapels. Light came from a few windows placed high in the usually thick walls. A pulpit in the nave was a common feature, and sometimes a choir loft was built over the entrance. The sacristy was provided with cabinets to store vestments, sacred vessels, and all the other requirements for the liturgy.

The *convento*, the Franciscan community residence, was built next to the church, often sharing one of the long walls. The friars' cells, the refectory, and other common rooms were usually concentrated in one area to which access could be controlled, while the kitchens, storerooms, and workshops were disposed around a courtyard that derived from the traditional

Women and children built the walls and applied the smooth mud plaster surface to the finished masonry; the men built the roofs and worked with wood for the details of the building.

All the material used for the walls was readily available: It was just mud and stone. Roofing the church, however, was more challenging. A few of the stone churches were roofed with vaults and a series of domes, but wood was the most common choice and, ironically, the most difficult material to find. Large beams were required to span the distance from wall to wall, and the size of available wood determined the length of the span. This dimension, in turn, dictated the long, narrow proportions of most of the mission churches.

When these beams (called vigas) were in place, resting on decorated brackets (called corbels) at each end, smaller pieces of wood, often no more than saplings or branches, were laid at an angle over them, from beam to

monastic cloister, but was often very large in order to accommodate the entire community of native neophytes, who spent much of their day working in the *convento* and often lived in the mission complex.

Churches with no resident community often had a front courtyard (called an *atrio*) surrounded by a low wall. This plan may reflect the immediate influence of Spanish mosques, where such courts were always provided, but the Islamic builders themselves had taken this element from the customary plan of the early Christian basilica. Both the *atrio* and the nave of the church were used as burial sites.

The decoration of the churches was an issue of special concern. The initial provision of sacred vessels, statues, and pictures was modest, and additional supplies of these objects came from time to time from Mexico, but most communities soon began to manufacture their own. At first, the friars and the native Americans worked to produce the required decoration. Walls were painted with figurative and geometric ornament, and images of the saints (called *santos*) were produced in some quantity. Those painted on panels of wood were called *retablos.* Other paintings, among the earliest, were executed on buffalo or elk hide and are now extremely rare. Images in the round were also manufactured. These statues (called *bultos*) were carved of wood, covered with gesso, and painted with bright colors made from local pigments. Many were intended to be dressed in elaborate vestments.

The first *santos* were made by the clergy, but responsibility for production of these holy images soon passed to laymen who made their living from this work. These men (called *santeros*) were often itinerant craftsmen, stopping in one place after another to execute commissions for the local church, a family chapel, or homes. They found models for their subjects in Mexican prototypes, popular prints, and engraved illustrations in the missals and other books the padres had brought.

Late-nineteenth-century taste found all the work of the *santeros* clumsy. During these years, plaster statues and prints from church-goods suppliers replaced the older images. Altar screens were covered with house paint or trimmed with imitation Gothic detail. By the twentieth century the *santeros,* unable to support themselves by their traditional art, took

regular jobs and produced only a few *bultos* and *retablos* for family chapels or the brotherhoods of Penitentes, who still clung to the old ways. A few *santeros* still practice their art, and there is renewed interest in the tradition they represent and a very good chance that this tradition will survive.

No matter how well informed we may be about the history of any of the missions, as contemporary visitors we enter a world of images and symbols that are deprived of their true power, both artistic and spiritual, because we can no longer read them as they were intended. While some details may have been applied for purely aesthetic effect, the majority of the architectural and decorative elements of the missions carry a deep meaning assigned to them by an ancient, holy tradition. Almost invariably, this meaning is based on a basic symbolism that was understood by both the Spanish padres and their native American neophytes.

This system of symbols depended on the Catholic belief that Jesus, as both God and man, joined the two worlds of the created and the divine. Thus it was possible for the world of humans to share in the life of God, to be transfigured by a call to higher spiritual service, and to become a sacred sign of God's good will. The Christian significance of each element of creation was based on the natural symbolism of the element itself. For example, if water brought life to the gardens and farms around the mission, it should be no surprise that it could bring spiritual life in the sacrament of baptism. If it was used to wash everything, it was not unreasonable that water should serve to cleanse a Christian from sin. Every other element of this system of sacred signs — light, sound, color, gesture, every part of the created world — underwent a similar transformation based on its primary, natural meaning.

Architecture also took part in this symbolic system. The window high in the wall filled the church with light, the first of God's creations and the primary symbol of divinity. From the foundations set firmly on the earth, to the dome, the vault, and the painted ceiling, the building symbolized the universe transformed.

In addition to their symbolic meaning, the missions were filled with the literal images of those people and events in sacred history by which this transformation had come to pass. These included the portraits of those men and women whose lives expressed this transformation so perfectly that they served as intercessors with God for those who sought the strength and vision to follow in their footsteps. Ascetics of the desert hang side by side with young Mexicans martyred on the killing fields of shogunate Japan. Kings and queens mingle with farm laborers and nuns. And almost always, there is the Virgin of Guadalupe, the beloved image first seen in a vision by a Mexican Indian.

The interior of the mission churches reflected the style of worship that was contemporary with their construction. By the eighteenth and nineteenth centuries, when most of these churches were built, the laity had lost almost all physical contact with public worship in the church. For most of the service, the priest stood with his back to the people, facing an altar fixed like a sideboard against the farthest wall of the sanctuary. At the center of this altar was the tabernacle, a safelike box in which the Eucharist was kept, the true devotional focus of the church.

Behind the altar, against the rear wall, was the reredos, or altar screen, which acted as a backdrop for the celebration of the Mass. This elaborate display of images consisted of panels arranged in a real or painted architectural framework of niches, columns, and moldings. Such a screen was a feature of almost every Spanish church in both the Old World and the New. No laws regulated which images were placed there, although a picture or statue of the patron saint after whom the church was named usually occupied the central position. Many of the altar screens in the Southwest were commissioned by prominent parishioners who sometimes had their own patron saints depicted on the screen.

The layman seldom entered this area of the church, and the laywoman almost never. This was the preserve of the priest, who rarely left his place at the altar. Isolated from the sanctuary, the mission congregations

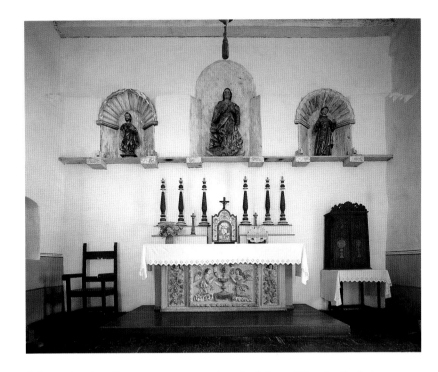

did exactly what European congregations had done: They built shrines to their favorite saints in the nave of the church where they worshiped, and directed their religious feelings to those approachable, understandable, and numerous figures. Almost always designed like little altars, these shrines are still in use today, decorated with flowers, lights, and *ex voto* offerings that testify to favors granted at the intercession of the honored saint. They are eloquent witnesses to the faith that continues to be practiced in these churches.

The veneration of the saints that the padres brought to the New World emphasized two types of saints whose popularity can be traced to the late Middle Ages. The first included the patron saints, honored not so much for what they could teach by their example, but for what they could do for a supplicant. These heavenly protectors were believed to take special interest in specific areas of human activity or to be especially powerful in

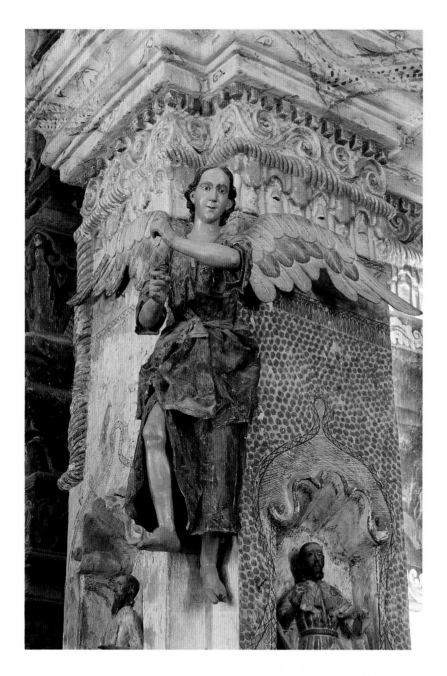

dealing with specified problems. Saint Anthony of Padua, for instance, specialized in finding lost objects. The Archangel Raphael protected travelers and healed diseases of the eye. A list of such patrons would include hundreds of saintly specialists, and many of them are well represented in the mission churches.

The second type, equally well represented in the missions, was the saint whose popularity derived from a theological movement or a change in church policy. Often this was simply a new emphasis within an existing cult. The veneration of the Virgin Mary under the title "The Immaculate Conception," for example, originated in the theological proposition that the Virgin Mary was conceived free from the original sin of Adam. Franciscan theologians strongly promoted this belief. Once an image was created to express it, the doctrine of her purity was easily spread. All the great Spanish masters painted this powerful Mary in a form that appears in a humbler version as one of the most familiar pictures of the mission churches: A young woman, her hands clasped in prayer, stands on the globe, trampling a serpent.

Sometimes a new saint would appear. Saint Joseph, for example, who was hardly known in earlier days, became the object of special devotion for some great saints such as Bernardino of Siena and Teresa of Avila. They encouraged the faithful to join in honoring Saint Joseph, and his cult increased in popularity and importance during the eighteenth and nineteenth centuries. He came to be honored as the protector of households, as the patron of workers, and as a model for married men. What is perhaps more important, he was invoked for the blessing of an easy death. It is no surprise to find San José in almost every Spanish mission church in North America.

It is impossible to know how many of the native Americans who lived at the missions were authentic converts to Christianity. We can assume, however, that many of them adapted Christian beliefs and traditions to their native religion. Such a blend was in perfect accord with native American spirituality. While the Spanish padres could not conceive that the

Christian message might coexist with another religion, the native peoples saw no contradiction in having two religious systems side by side. They were not bothered, for instance, when confronted with two versions of a myth that the European mind would view as contradictory or mutually exclusive. If one native said that the world was created by Fox, whereas his neighbor said that some other animal had done the work, it simply meant that there were two versions of the story. The European would want to know which was true; the native American saw the truth in both.

The initial native response to the new religion was to see it as another view of the world, certainly a very exotic one to their eyes, that might live together with their own, with the people partaking of both. The earliest pueblo churches, which stood alongside the pueblos themselves, can be seen as a sign of this accommodation. Not until a generation or two had passed, when the padres' teaching threatened traditional native American social customs, altered their marriage practices, broke their ancient alliances, and interfered with the most intimate details of their personal lives, did the native Americans realize the exclusive nature of the Christianity that the Spaniards had come to preach. Some reacted violently; others tried to continue to participate in both systems. After all, an echo of many elements of native religion could be found in the Christian message. The indigenous peoples were familiar with a sacred cycle of seasons, a life of prayer, the healing power of music, the high value of art in the service of God, the spiritual significance of natural objects, the symbolism of colors, and other elements common to both systems. Some native peoples who placed special emphasis on the importance of initiation and had elaborate theories about life after death found an additional expression of these beliefs in Catholic practices such as baptism and prayers for the dead.

Although there were other areas in which the two systems of belief never approached one another, the mission churches are the artistic record of the meeting of these two cultures and may be the greatest treasure created by the Spanish presence among the native Americans. Throughout these buildings we encounter the work of the native artists in the use of geometric ornament, in the symbolic representation of plants, birds, the morning stars, the rainbow, and other details. Both the Spaniards and the native Americans could read them as they pleased.

While a study of history, iconography, symbolism, and theology may help us understand and appreciate the monuments the missionaries left behind, the greatest puzzle about the missions remains: the attitude and behavior of the clergy toward the indigenous population of the Americas. These men came as representatives of a religion that they believed to be the revelation of God to the human race. They were convinced that their religion was destined for all humankind, and in going out to spread it among the peoples of the globe, they were following the orders of the Savior himself. How this solemn injunction could be reconciled with a view of the native peoples that saw them as less than human seems incomprehensible.

There was no pattern to the behavior of the clergy. Sometimes they were silent in the face of the most outrageous behavior by the army or the government; sometimes they used whatever means were at their disposal to defend the native Americans. And sometimes they were willing participants in the process of enslavement and the destruction of indigenous culture.

Neither was there a pattern to the behavior of the native Americans. Some have resisted the missionaries' message to this day. Others accepted it wholeheartedly, while still others adapted it to their beliefs as they saw fit. Some slaughtered the clergy in their rage against the white conquerors; others refused to leave the missions when they were secularized in the first part of the nineteenth century.

This puzzle may never be solved, but the mission churches, dedicated to God, remain as monuments to the historic confrontation of two disparate cultures, two visions of the world bound together by circumstance to produce beautiful works of art. The Spanish Catholic missions of the Southwest challenge us to define our own response to the spiritual values that are embodied in these precious structures.

THE CHURCHES

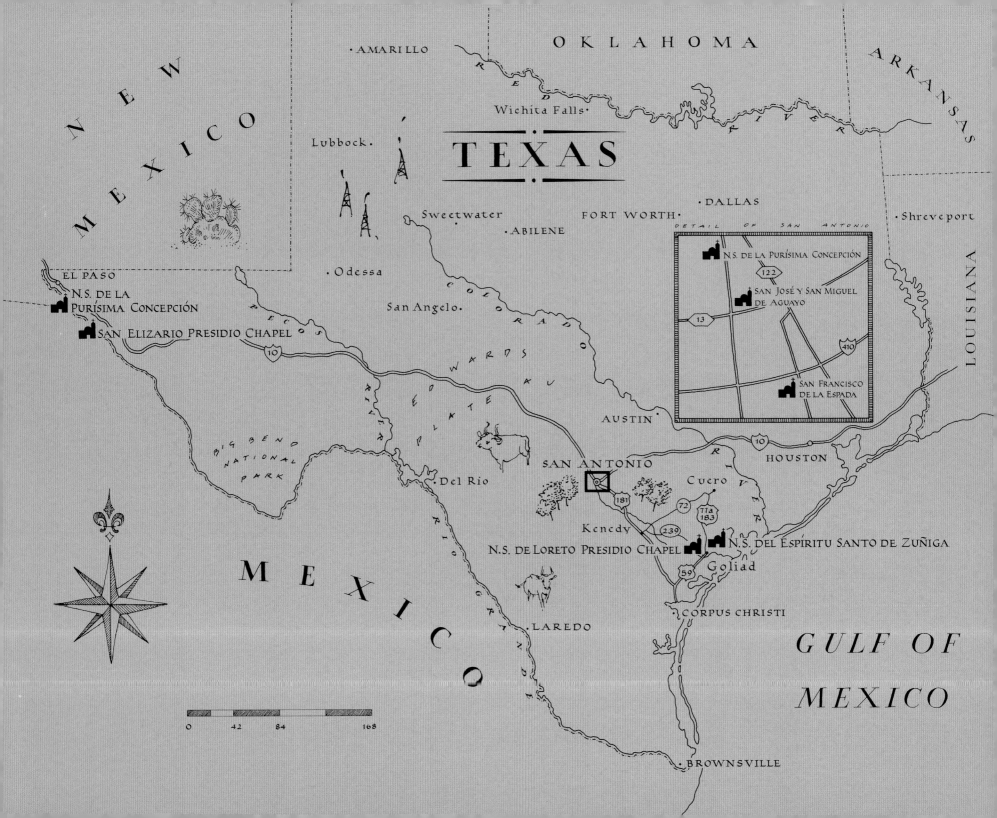

CHURCHES OF TEXAS

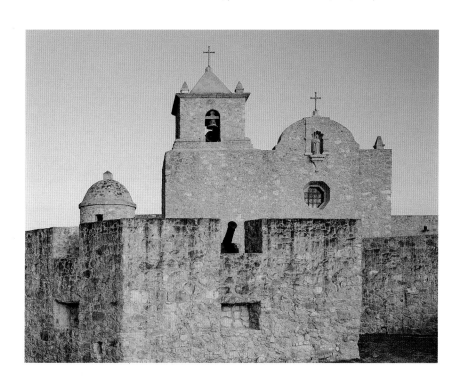

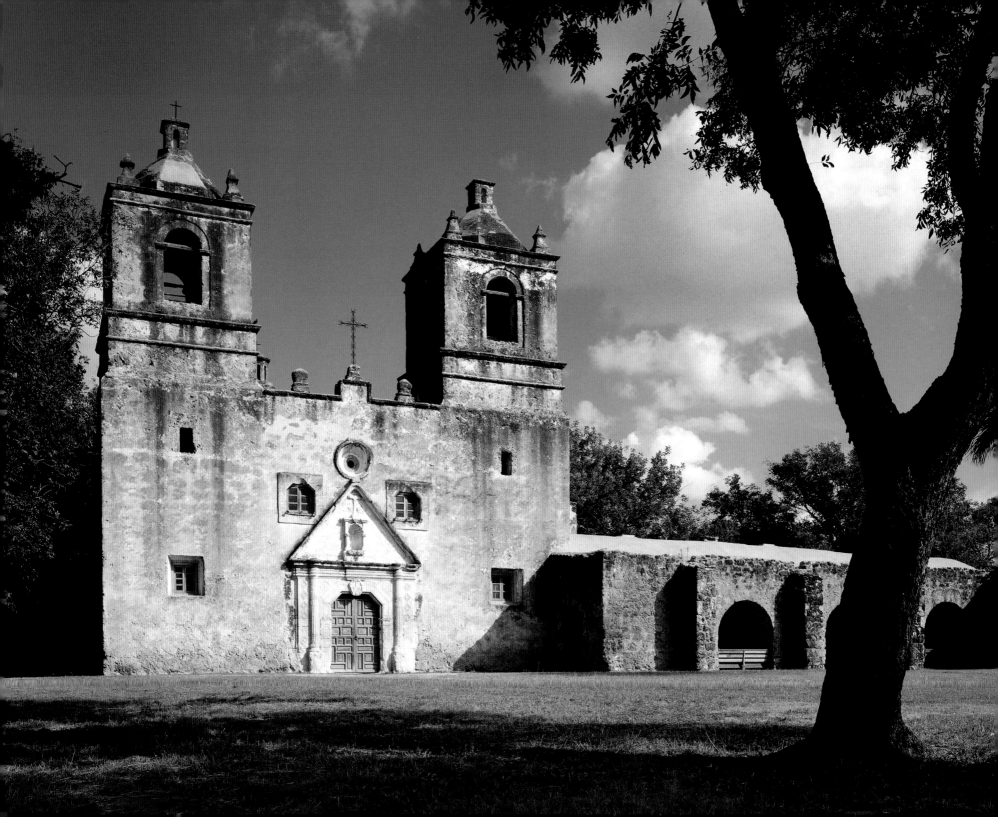

MISSION NUESTRA SEÑORA DE LA PURÍSIMA CONCEPCIÓN
San Antonio Missions National Historical Park
San Antonio, Texas

Nuestra Señora de la Purísima Concepción was one of several Texas missions originally founded in the eastern part of the state. The priests had little success converting the Tejas Indians there and faced constant political pressure from the French in nearby Louisiana. In 1731, the mission was moved to its present site, where the padres were more successful among the Coahuiltecans, who were attracted by the protection and regular supply of food provided at the mission.

The clergy at Concepción tolerated some expressions of native American culture forbidden at other missions. Elaborate native American performances were allowed into Christian holiday celebrations and processions, and the costumes and masks were stored at the mission.

A stone church was begun here about 1740 and completed in 1755, and the community continued until 1794, when the process of secularization began. The mission struggled on until 1824, when it was completely secularized and abandoned. In the middle of the nineteenth century, it was restored to religious use.

Except for temporary brush shelters, the local natives had no tradition of building, so the church is built in European style as it came here via Mexico. It is thought to be the oldest unrestored stone building in the United States.

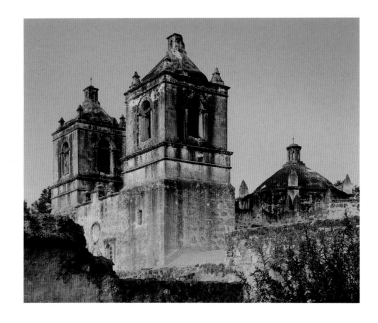

ABOVE *The church of Nuestra Señora de la Purísima Concepción is a good example of Colonial Baroque style. Details like the pinnacles at the base of the dome and at the top of the tower were carved from Concepción stone, a local limestone with a finer grain than the local tufa used for the walls. These derive from Moorish influence on Spanish prototypes.*

FACING PAGE *The ornament around the entrance of the church seems rather restrained when compared with Spanish or Mexican work of the same period. The original effect was much different, since the entire façade was painted. Painted quoins marked the corners, painted pilasters flanked each opening in the bell tower, and each stone in the towers was ornamented with a cross-in-circle design, while the mortar was picked out in red earth. The painted decoration suggested that the building was covered with tiles.*

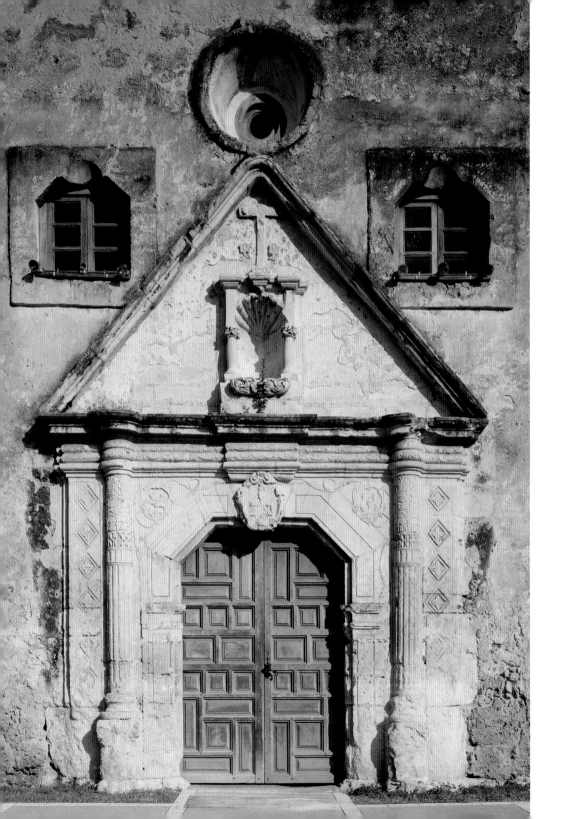

LEFT *In Christian architectural symbolism, a circular window, called an oculus, or eye, represents the eye of God and an opening to the orb of the heavens. The pediment supporting this one frames a decorated niche that once held an image, very likely a statue of the Virgin Mary. A Spanish inscription here states that this church honors "her purity," a reference to the doctrine of the Immaculate Conception. In addition to the floral and geometric ornament, the carving includes the Five Wounds of Christ joined by a knotted Franciscan cord to the Franciscan coat of arms on the other side of the door.*

FACING PAGE *A vaulted chamber in the friars' residence, the* convento, *still bears traces of frescoed decoration. Pigments capable of resisting the destructive effects of the lime in this plaster were ground and applied to wet plaster in a true fresco technique.*

BELOW *This sun, with its curiously twisted ochre rays, is painted on a vault in the* convento. *While a rising sun is common enough in European art and has a long history in Christian iconography, the face is a recurring motif in the native art of Mexico even today. It was probably brought here by mestizos and other Mexicans who came to help construct the stone church.*

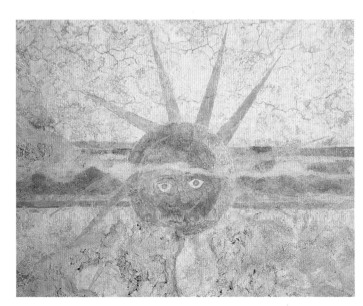

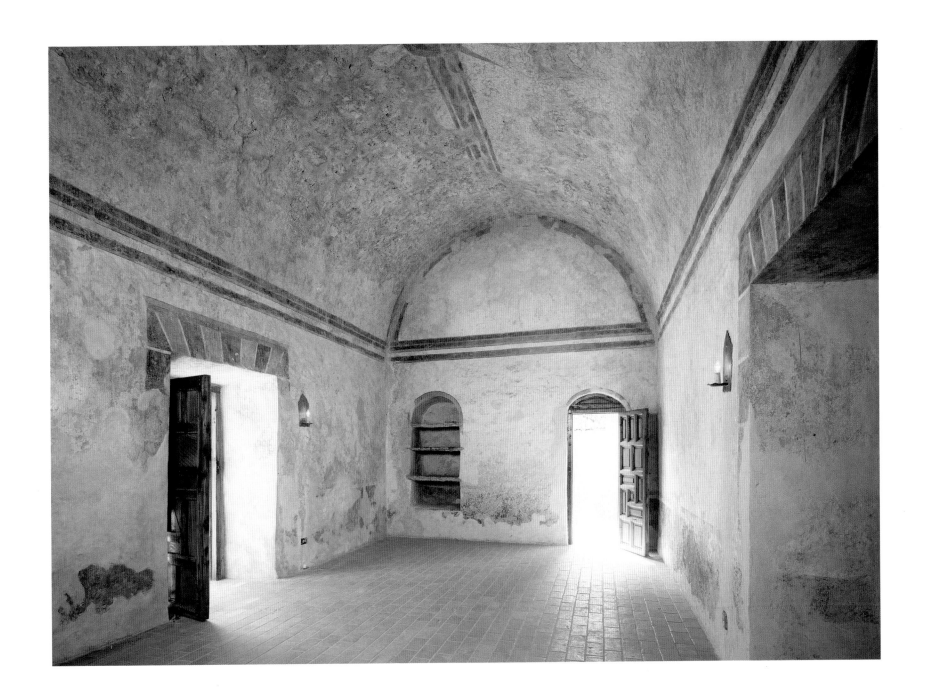

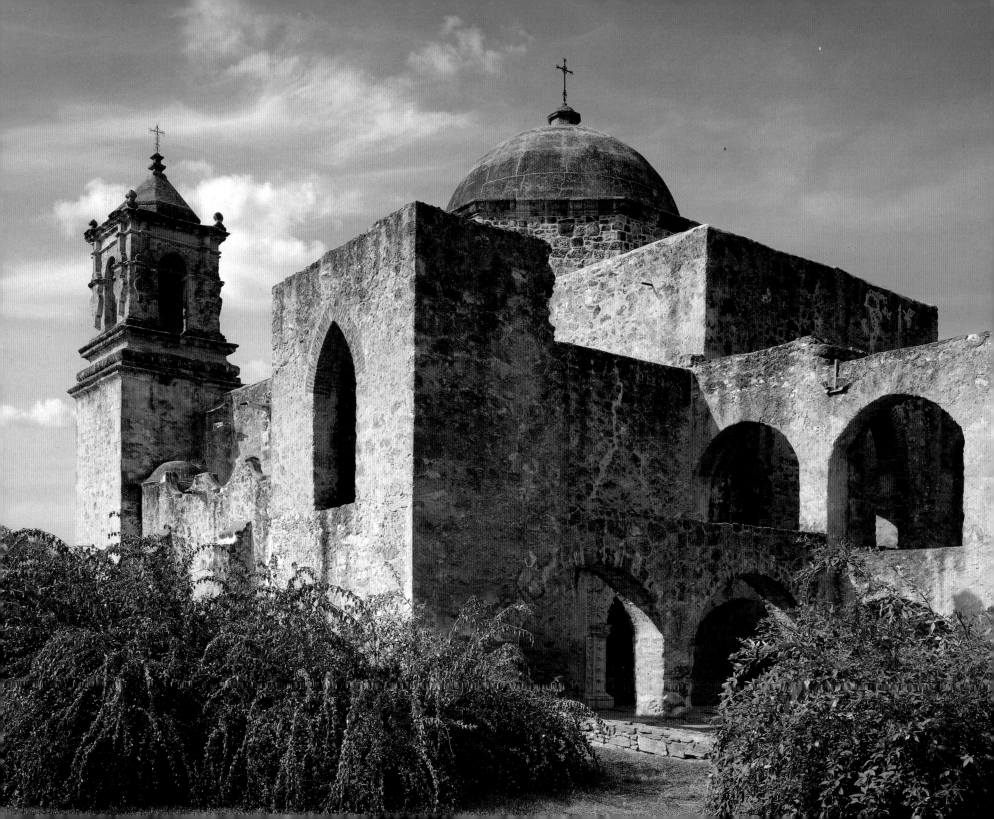

MISSION SAN JOSÉ Y SAN MIGUEL DE AGUAYO
San Antonio Missions National Historical Park
San Antonio, Texas

The church of San José y San Miguel was founded by Father Antonio Margil de Jesús. By the time he arrived in Texas, Margil had a reputation as a very holy man, for he had literally walked the length and breadth of Central America before being recalled to found the Franciscan Missionary College at Zacatecas, Mexico, in 1706. Ten years later, this remarkable man was assigned to eastern Texas and, when the missions there were abandoned, he went to San Antonio.

Margil was also something of a diplomat. He told the governor, the Marquis de Aguayo, that he had brought a statue of San José for a new mission, and that such a mission could also be named for the Marquis, as indeed it was. The Marquis provided financial support and assisted at the founding of the mission.

RIGHT *The entire architectural idiom of the church of San José y San Miguel de Aguayo is European. The interior of the octagonal drum is smoothed to a circle; the dome rests on pendentives; the nave is roofed with a barrel vault. The beautiful southern light entering through windows placed high in the walls is constant through the day.*

FACING PAGE *The massive ruins of the convento in the foreground indicate the scale of the church, which is nearly 250 feet long. Spaniards called this a "half-orange" dome. The surface of the original was painted with vivid chevron stripes to resemble tiles.*

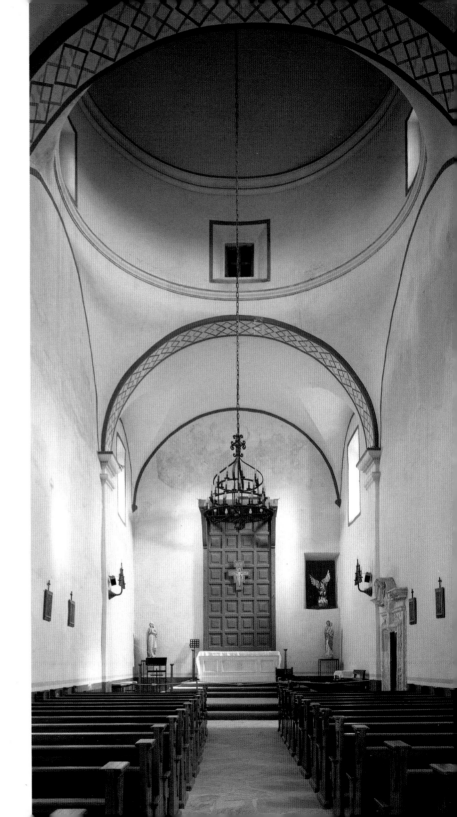

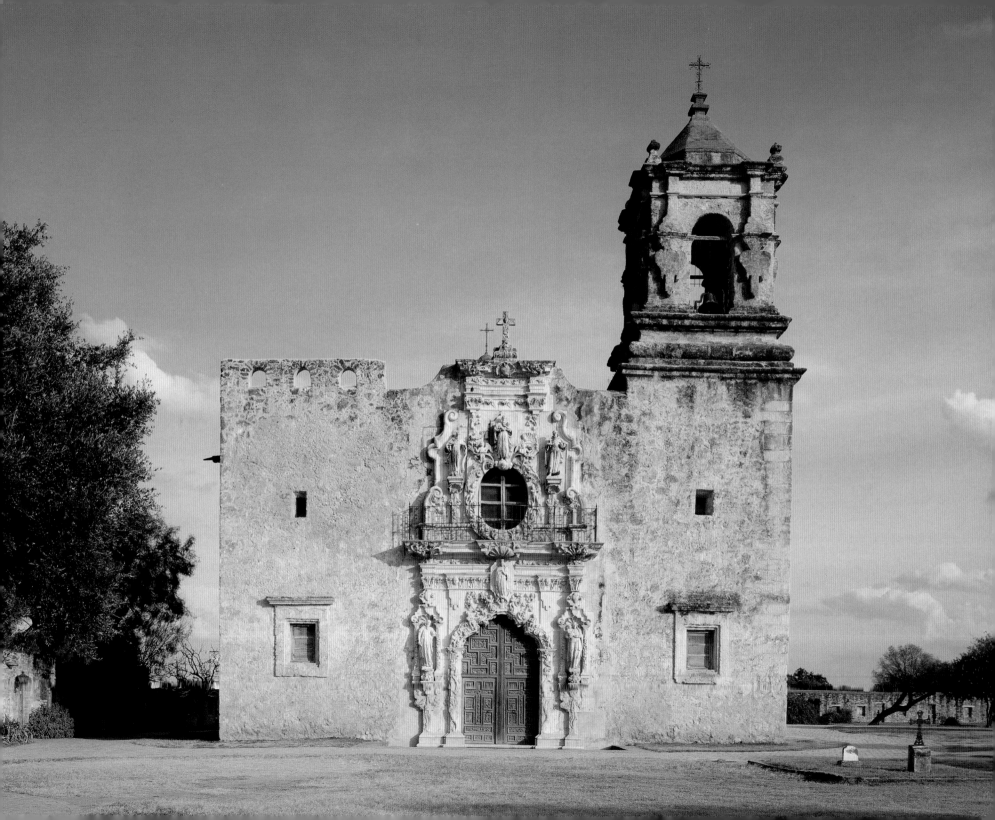

The mission was moved twice, and at each location an adobe church was erected. In 1768, however, the first stone was laid for a new mission on the present site. Conceived on a magnificent scale, when construction was completed in 1782 the domed and vaulted interior could accommodate two hundred worshipers.

After the secularization of 1824, the *convento* and outlying buildings — workshops, mills, storage buildings — fell into ruin. But even the ruins of the two-story residences, covered walks, and enclosed patios give a good idea of the scale of the economic, social, and religious complex this once prosperous mission represented.

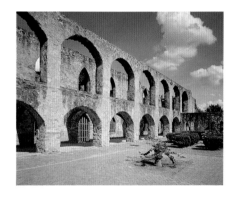

LEFT *The ruins of the* convento *show the spacious provisions made for the mission population. The first floor housed the refectory, community rooms, and offices, as well as storerooms for the costumes and masks for the* mitotes, *the native dances the Franciscans here allowed as part of the Christian feast-day celebrations.*

RIGHT *The tower leading to the bells not only shows the skill of the stonemasons, but also houses a remarkable circular stair. Each of the steps is of solid local oak, swung on a central pivot.*

FACING PAGE *The façade of the church is sixty-two feet wide; the single bell tower rises to a height of more than seventy-five feet. Originally, the entire façade was plastered and painted to resemble bright tiles.*

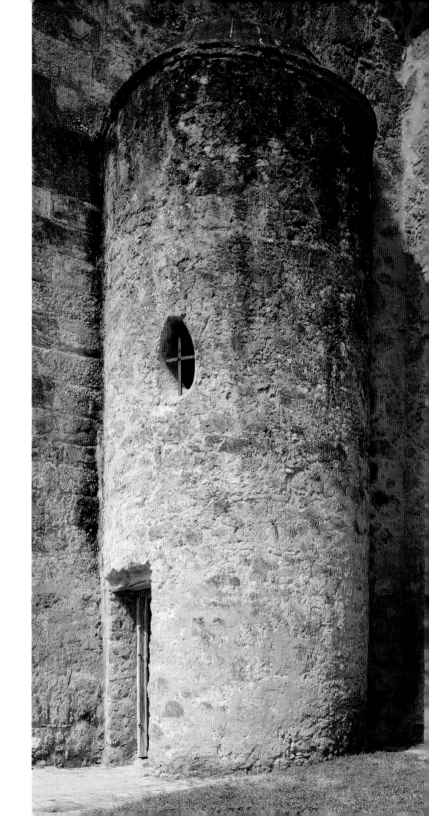

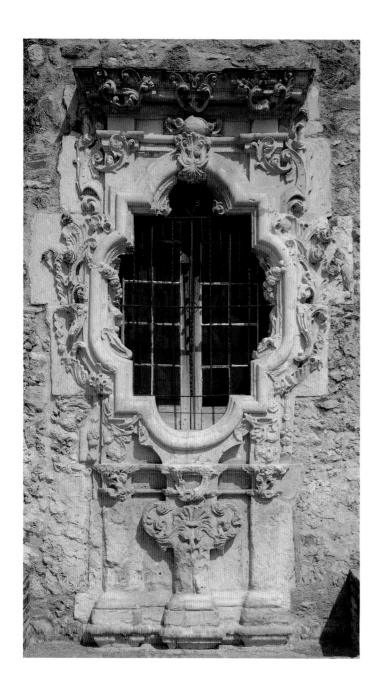

FAR LEFT *This decorated window frame, like all the carved stone in this church, is the subject of local legend. The story tells of the mason's romantic involvement with a woman named Rosa in whose honor he carved this decoration. It is still occasionally called the "Rose Window" after her.*

LEFT *To the right of the entrance is the statue of Saint Ann holding the Virgin Mary as an infant. All of the classical elements that constitute this decoration have been seriously modified. The niche, pilasters, pediment, and pedestal are loaded with ornament; even the drapery seems to have received a slight electric charge.*

BELOW *The small portion of the exterior painted ornament is part of the restoration. Executed in true fresco, the brilliant white background is lime plaster; the colors are ground pigments applied while the plaster was still wet.*

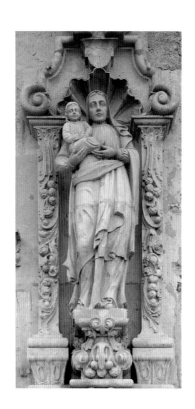

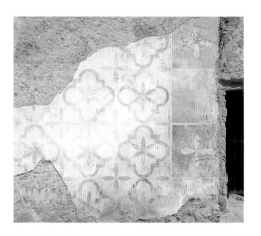

FAR RIGHT *This eighteenth-century statue of Saint Joseph tenderly holding the Infant Jesus is Mexican work of very high quality. The design of the polychrome gilt brocade of the saint's robes corresponds perfectly to the scale of the image. This statue is now kept in the sacristy of the church.*

RIGHT *This carving of Our Lady holding the Infant Jesus, also kept in the sacristy, has lost much of its gesso and painted decoration.*

BELOW *This version of the image of Our Lady of Guadalupe found in the sacristy is rendered in carved and painted wood. The niche is filled with potted cactuses, reminiscent of the site of her apparition on a barren hilltop outside Mexico City.*

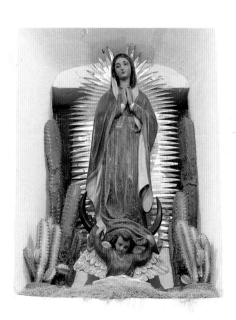

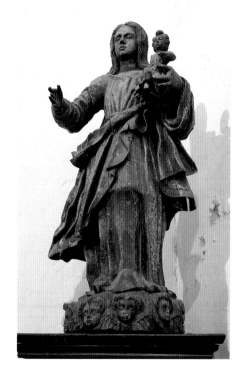

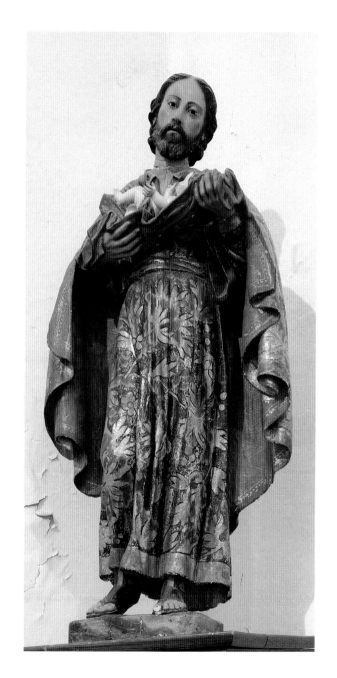

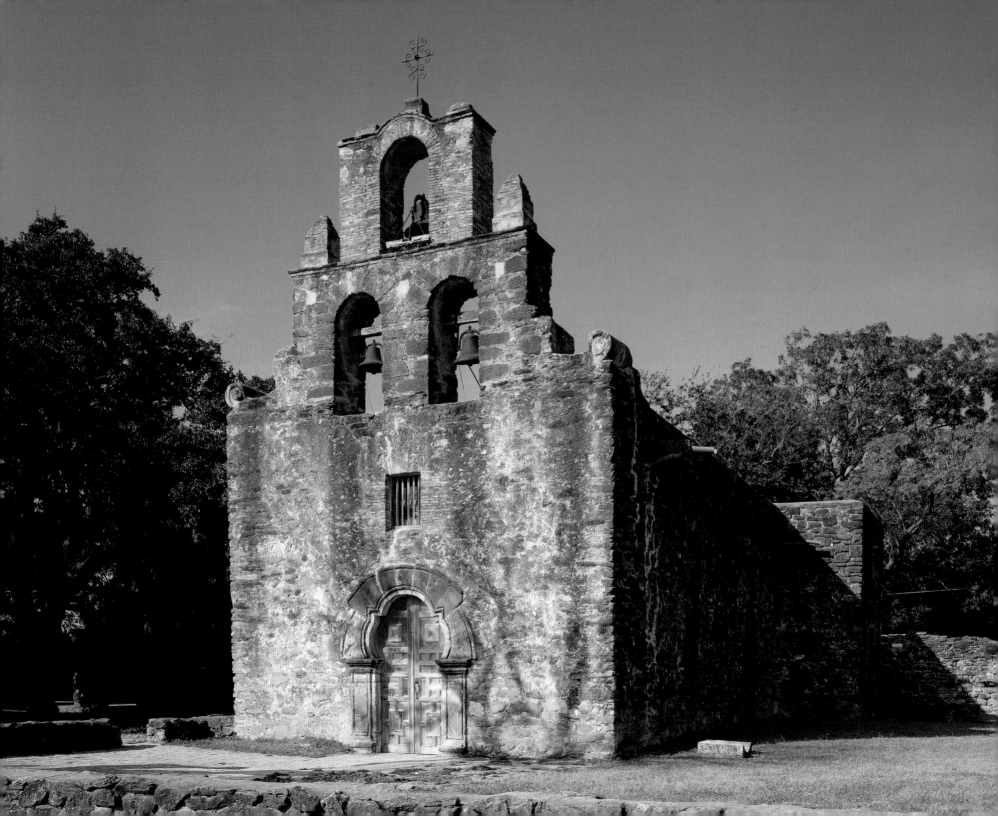

MISSION SAN FRANCISCO DE LA ESPADA
San Antonio Missions National Historical Park
San Antonio, Texas

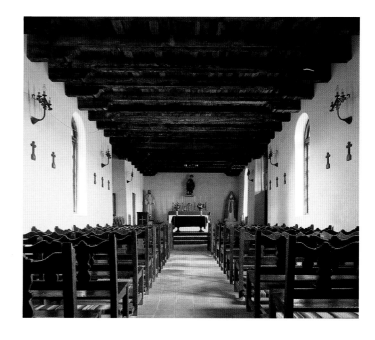

The oldest of the east Texas missions was San Francisco de los Tejas, established in 1690. It was relocated several times before the community finally moved to San Antonio to found this mission of Saint Francis of the Sword in 1731. The meaning of the title is unknown. One suggestion is that the old *bulto* of the patron, Saint Francis, once held a sword, but iconographically this seems very unlikely.

The mission was heavily fortified, and its inhabitants successfully warded off frequent Apache and Comanche raids. During the Texas Revolution of 1835, James Bowie and James W. Fannin fought off two hundred Mexican troops with one hundred Texas recruits here.

The stone church seen today at Espada was begun in 1745 and completed in 1756. A stone church of more impressive size was begun in 1762 but never completed. Like the other Texas missions, it was partially secularized in 1794, and by 1824 it had been abandoned.

In 1858, François Bouchu, a young French priest assigned to Espada, found the church in ruins. With his own hands, he rebuilt the side walls, roofed the building, and even built the furniture. We owe the survival of this mission church to his efforts.

ABOVE *The interior of the church of San Francisco de la Espada is attractively simple. Two vested* bultos *of Jesús Nazareno and Our Lady of Solitude flank the altar. The image of Saint Francis dates from the late eighteenth century. Plain wooden crosses mark the Stations of the Cross.*

FACING PAGE *A number of explanations have been proposed to account for the shape of the entry arch. One theory suggests that the order of stones at the top of the arch was reversed. The larger stones should have been on the sides rather than at its apex. Whether produced by error or not, it recalls a Moorish arch, a familiar element of Spanish architecture since Visigothic times.*

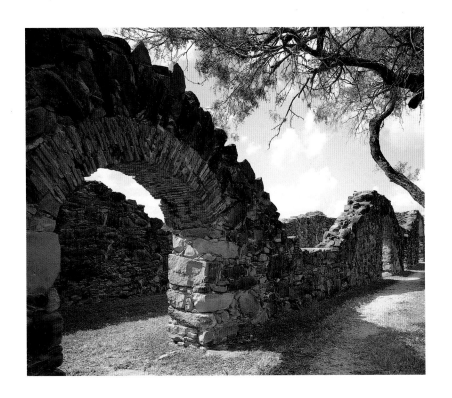

LEFT *These stone arches at the perimeter of the mission complex are still impressive, even in ruins. Scholars are undecided if this is work from the early mission period or from the period of occupation by the Mexican army in the 1820s.*

BELOW LEFT *The holy water stoup at the door is made of stone. A simple cross is scratched in the plaster of the wall. Throughout the Southwest, the native Americans were fascinated by the Christians' holy water and attributed strong magical power to it.*

BELOW RIGHT *The ruins in the foreground are the foundations of the great stone church begun in 1762. The scale of the proposed construction is impressive.*

FACING PAGE *Water played a crucial role in the life of all the missions. In Texas, farmland was measured by the areas that could be watered in a single day, called* suertes. *The Espada Mission irrigation system, built between 1731 and 1745, is the oldest in the United States. Seventy gravity-flow channels, called* acequias, *a series of five dams, and an aqueduct irrigated thirty-five hundred acres belonging to the five missions now at San Antonio. These systems were based on Spanish models, which relied on technology brought to Spain by the Arabs.*

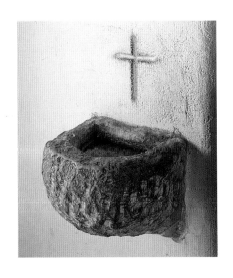

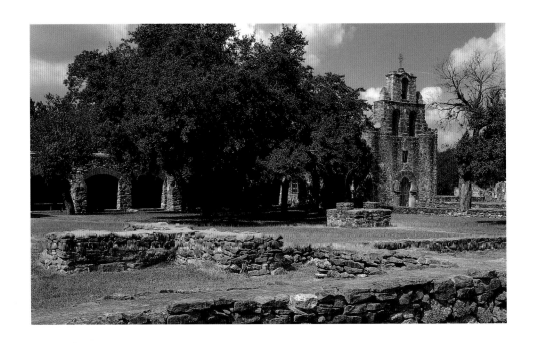

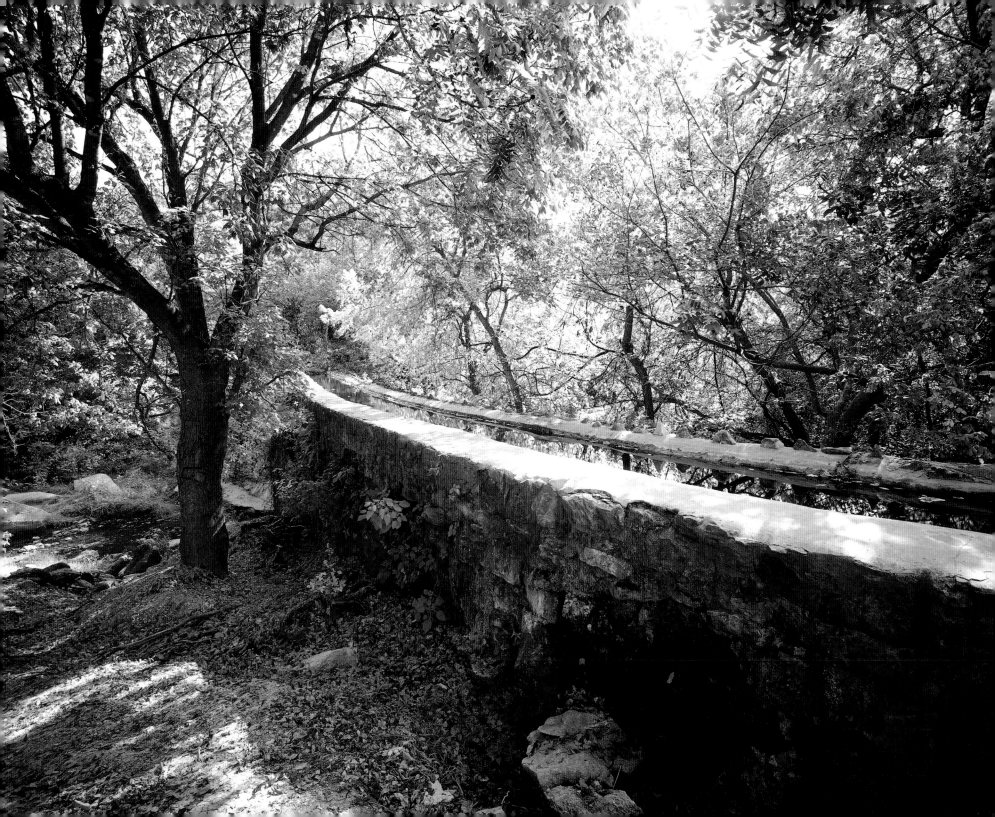

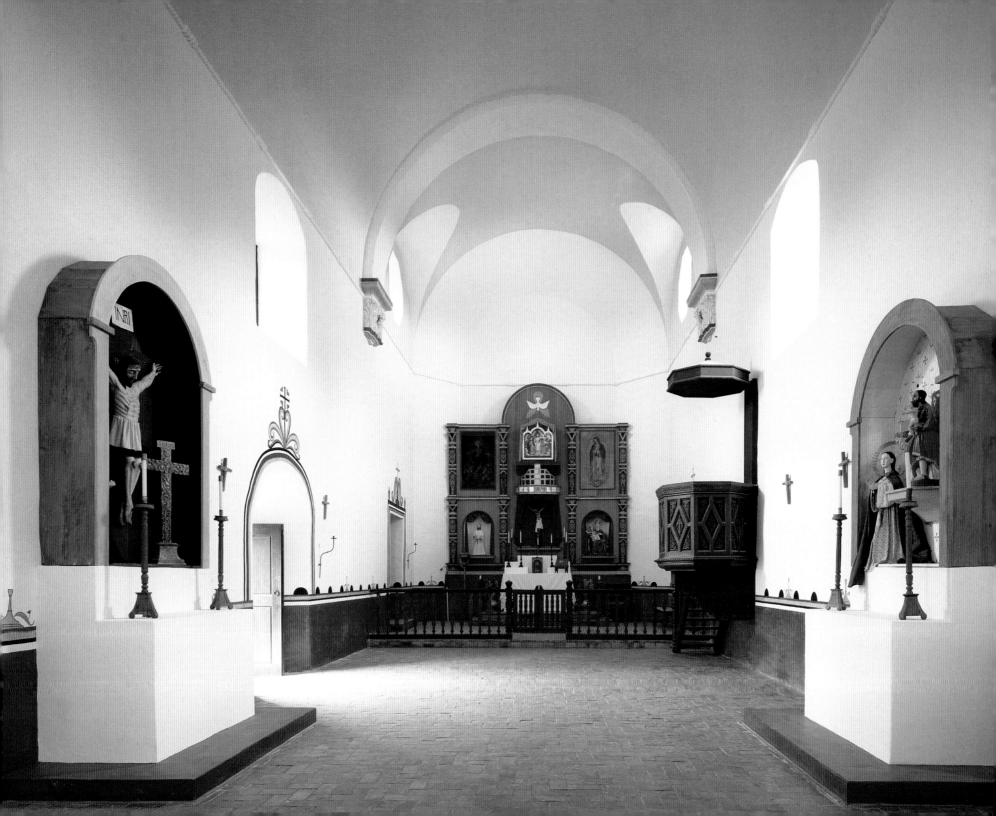

Mission Nuestra Señora del Espíritu Santo de Zuñiga
Goliad State Historical Park, Goliad, Texas

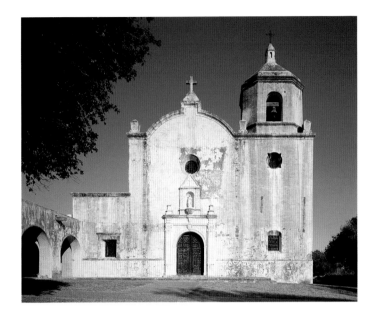

Mission Espíritu Santo was founded in 1722 near Lavaca Bay on the Gulf of Mexico, to serve the Karankawa tribes and their allies. By 1749 the mission had been moved to its present location within sight of the Presidio la Bahía. The mission was granted jurisdiction over enormous holdings of land on which it raised cattle, sometimes as many as forty thousand head. This gives Mission Espíritu Santo the distinction of being the first cattle ranch in the state of Texas. At its height, this prosperous community provided for the material needs of Spanish communities as far away as Louisiana.

The church was restored in the 1930s under the direction of the architect Raiford Stripling and the archaeologist Roland Beard.

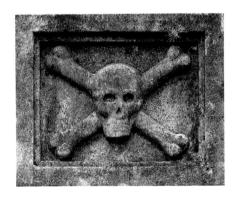

ABOVE *The façade of the church of Nuestra Señora del Espíritu Santo de Zuñiga shows the line of the vaulted ceiling behind.*

LEFT *The skull and crossbones over the door are an iconographic reminder of death. Apocryphal accounts of the Crucifixion say that Golgotha stood over Adam's grave. When the hole was dug to erect the cross, the grave was opened and his skull and bones were exposed at the base of the cross, where medieval artists traditionally depicted them.*

FACING PAGE *Light from the high windows and the absence of pews make the restored interior of the church look particularly spacious and elegant. Side altars face each other across the nave. Plain wooden crosses on the white wall mark the Stations of the Cross, in remembrance of stops along the road Jesus walked to Calvary in Jerusalem.*

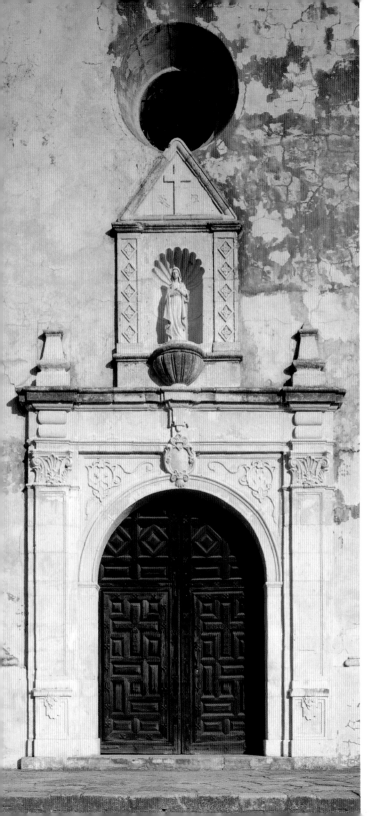

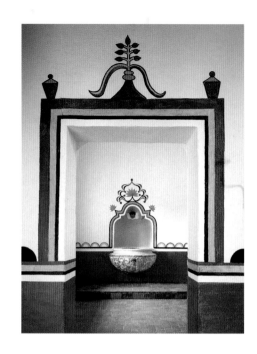

LEFT *The stone carving at the entrance repeats most of the decorative elements from La Purísima Concepción in San Antonio, but in a simpler fashion. The statue of the Blessed Virgin stands in a decorated niche. The paneled doors are set below an architrave carried on pilasters in Mexican Baroque style. To the left and right of the arched opening are the Franciscan coat of arms and the Five Wounds of Christ surrounded by a Franciscan knotted cord.*

RIGHT, ABOVE AND BELOW *The baptismal font and the holy water stoups are basins set into the wall, with niches above them. Early travelers described a number of Texas churches painted in much the same fashion as this one. A wainscot the length of the wall provides a base for painted lattices, flowers, urns, columns, and arches. The geometric elements of this decoration show the influence of native American art.*

FACING PAGE *The sacristy walls finish in a unique pattern of scallops, a strong design element that is not referred to or echoed anywhere else in the surviving building.*

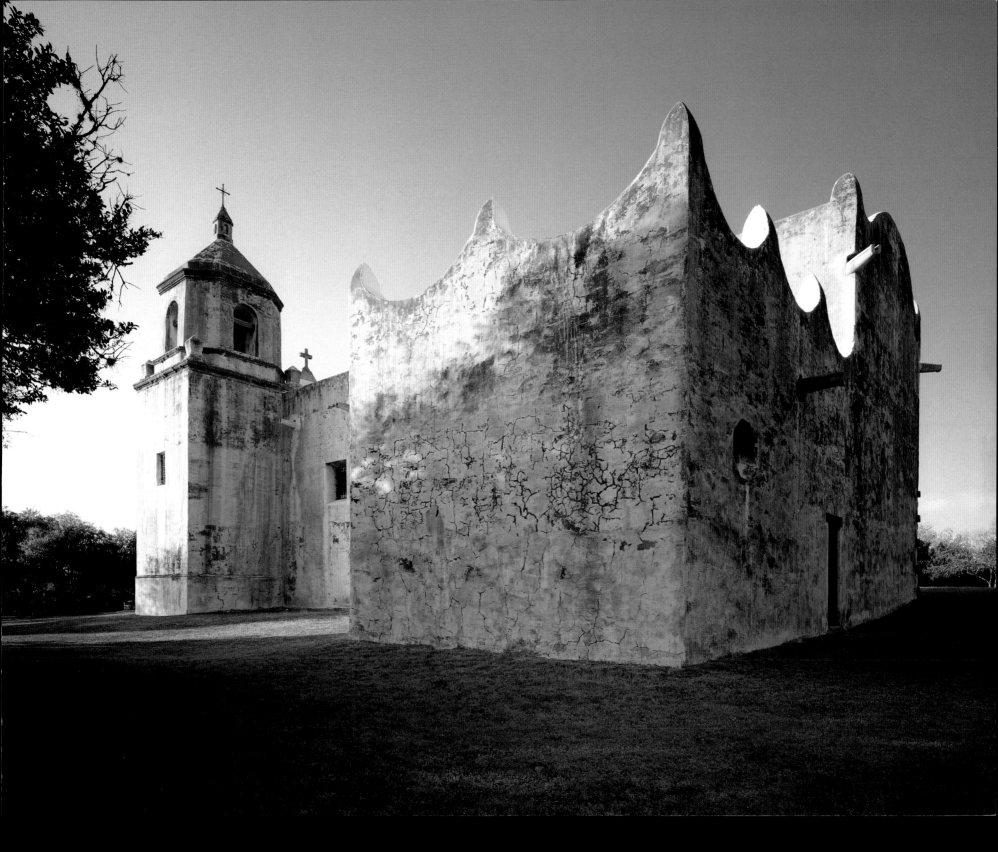

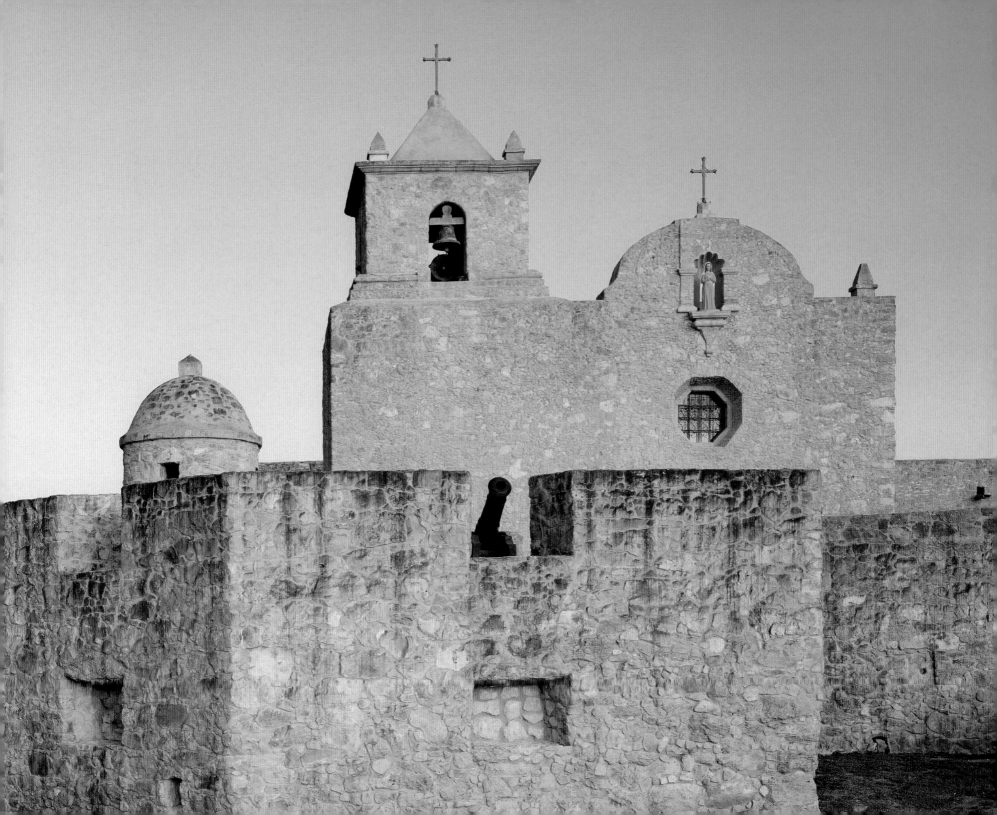

THE CHAPEL OF
NUESTRA SEÑORA DE LORETO
Presidio la Bahía, Goliad, Texas

The *Bahía* in the name of the presidio refers to Lavaca Bay on the Gulf of Mexico, where this Spanish military post was established in 1721 in the ruins of LaSalle's Fort St. Louis. In 1749, the fort and the Zuñiga mission it protected were moved to their present location at Goliad on the San Antonio River. Soldiers from this fort fought with the Spanish Army against the British in the American Revolution.

The first Declaration of Texas Independence was signed in this church on December 20, 1835. Texans know the fort best as the site of the infamous Goliad Massacre of Colonel James W. Fannin and 352 of his troops by Mexican forces on March 27, 1836.

ABOVE RIGHT *The chapel of the Presidio la Bahía was dedicated to Nuestra Señora de Loreto, the most popular European shrine of the Virgin Mary until Lourdes replaced it in the mid-nineteenth century. The statue of the Virgin of Loreto in the niche is the work of Lincoln Borglum, the sculptor of Mount Rushmore.*

RIGHT *Seen from the Quadrangle Parade Ground, the mass of the building speaks of strength and the safety this fort provided for its occupants.*

FACING PAGE *The church, seen here at dusk, hardly differs in style from the fortifications of the presidio in the foreground. The only visible architectural ornaments on the church are the pinnacles on the bell tower, a bit of molding, and the niche for a statue in the arched false front.*

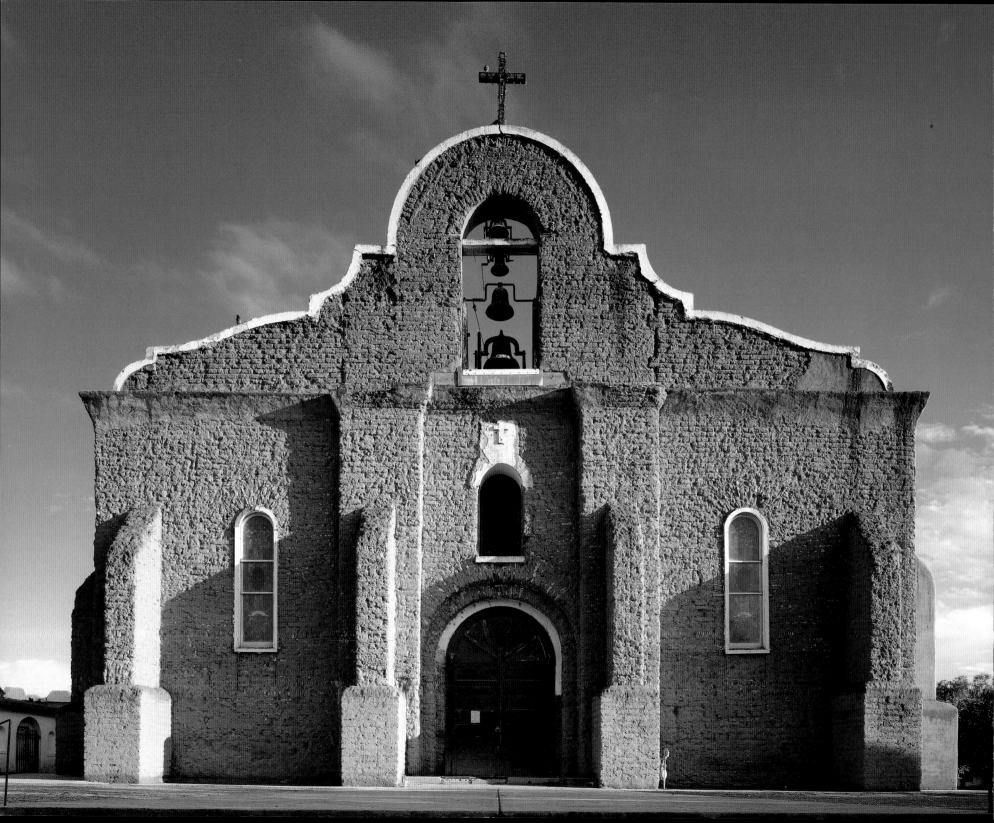

SAN ELIZARIO PRESIDIO CHAPEL
San Elizario, Texas

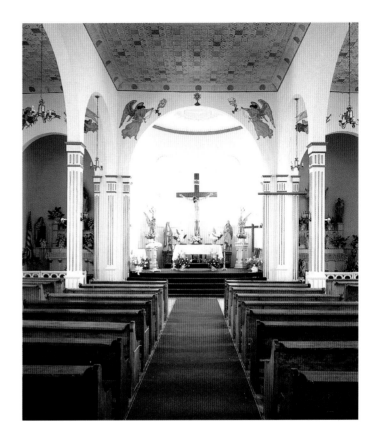

The patron of this church with such a curious name is Saint Elzear of Sabran, a noble French diplomat of the fourteenth century. The church was dedicated to this relatively unknown saint because the Franciscans claimed him and his wife as early members of their Third Order, the association of laypersons who followed the spirit of the Franciscan rule without joining a religious community.

The first church built here was constructed when this was Spanish territory and served as a military chapel for the local presidio. By the time it was replaced in 1840, the territory belonged to Mexico; after 1848 the chapel was on United States territory, because the course of the Rio Grande had shifted in a flood and the national border followed the river. The present church was constructed between 1877 and 1887. The interior was severely damaged by several fires in this century.

Although the church is a nineteenth-century building, the area is associated with the earliest Spanish presence in Texas. In 1581 the Rodriguez-Chamuscado Expedition passed through this region on its way to explore the territory from the Texas Panhandle to what is now western New Mexico. It is thought to be the first Spanish expedition to use the Pass of the North (El Paso) into the American Southwest.

ABOVE *Some changes have been made to the sanctuary of the San Elizario Presidio Chapel to accommodate the current style of celebrating Mass, but the taste of the 1870s shows in the fluted square columns, and especially in the pressed tin ceiling with patterned squares picked out in color.*

FACING PAGE *Plaster has been removed in preparation for restoration of the more traditional smooth mud finish. With the adobe bricks thus exposed, arches appear over the windows, the door, and the opening in the gable. The buttresses, in addition to strengthening the wall, contribute depth and complexity to an otherwise very plain façade. As small as it is, the church boasts four bells.*

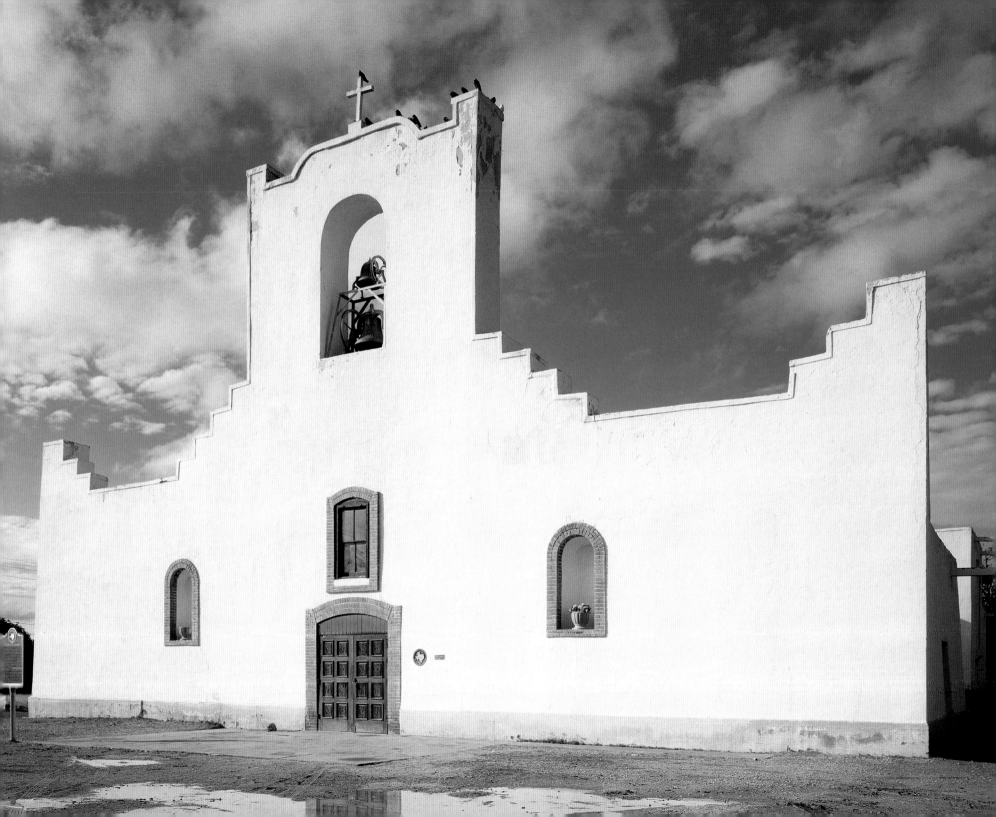

Nuestra Señora
de la Purísima Concepción
Socorro, Texas

Socorro is the second oldest continuously functioning Catholic parish in the United States. The parish was founded in 1680 by Piro Indians who accompanied the Spaniards retreating from the Pueblo Revolt in New Mexico. Construction of the present church began about 1830.

The distinctive shape of the façade has given rise to a number of fanciful explanations. One popular account claims that the profile of the building reproduces the geometric image of one of the old Piro gods.

Although the church is dedicated to the Virgin Mary under her title La Purísima Concepción, many call it San Miguel because it houses a beloved image of the Archangel Michael. Local tradition says that in 1845 this Mexican sculpture was being delivered to a church in New Mexico, when the cart that carried it became too heavy to be moved by any force. The people took this to mean that the archangel preferred his image to be honored in their church, where it was taken and remains.

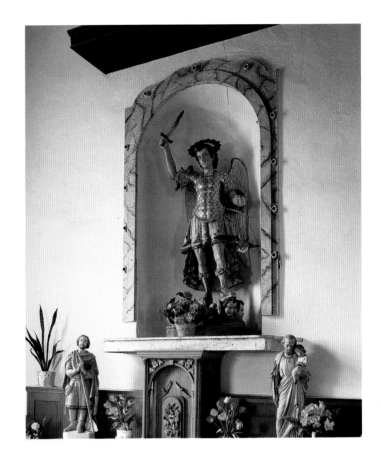

ABOVE *The Mexican statue of San Miguel, which came to the church under mysterious circumstances, is still venerated here. Below the angel in his niche, Victorian carved woodwork supports two plaster statues of Saint Isidore the Farmer and Saint Joseph with the Infant Jesus.*

LEFT *In the construction of the 1840s, the vigas of the original church were reused. Both corbels and vigas are painted with simple geometric decoration. The latias are laid in a herringbone design of alternating bands of stripped and painted poles.*

FACING PAGE *Niches intended to hold sculpture are the only evidence of European design in the façade of the church.*

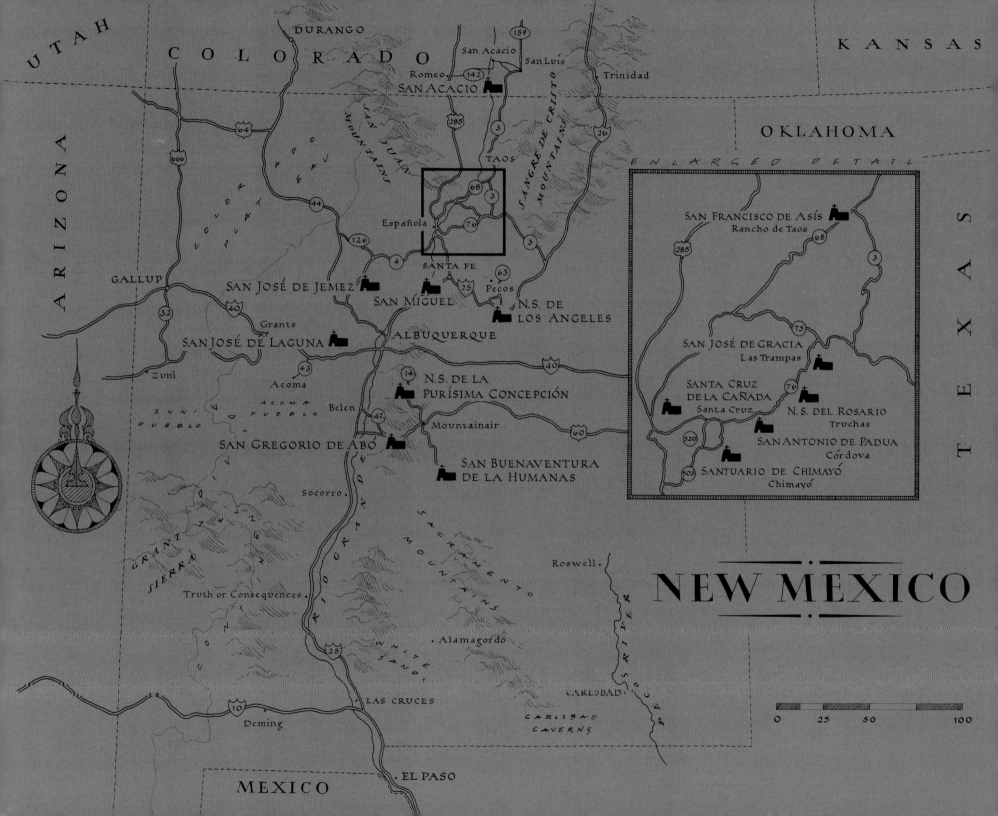

UTAH

COLORADO

DURANGO

San Acacio

Romeo
SAN ACACIO

159

San Luís

Trinidad

142

285

3

KANSAS

64

666

SAN JUAN MOUNTAINS

TAOS

SANGRE DE CRISTO MOUNTAINS

26

OKLAHOMA

44

ENLARGED DETAIL

Española

68

3

San Francisco de Asís
Rancho de Taos

285

68

3

76

126

GALLUP

4

SANTA FE

63

285

San José de Gracia
Las Trampas

75

SAN JOSÉ DE JEMEZ

SAN MIGUEL

25

Pecos

N.S. DE
LOS ANGELES

32

40

Grants

SAN JOSÉ DE LAGUNA

ALBUQUERQUE

40

Santa Cruz
De la Cañada
Santa Cruz

76

N.S. DEL ROSARIO
Truchas

Zuni

43

Acoma

ZUNI PUEBLO

ACOMA PUEBLO

Belen

14

47

N.S. DE LA
PURÍSIMA CONCEPCIÓN

40

60

520

San Antonio de Padua
Córdova

503

Santuario de Chimayó
Chimayó

Mountainair

SAN GREGORIO DE ABÓ

Socorro

RIO GRANDE

GRANT SIERRA

SACRAMENTO MOUNTAINS

SAN BUENAVENTURA
DE LA HUMANAS

Roswell

NEW MEXICO

TEXAS

Truth or Consequences

WHITE SANDS

Alamagordo

PECOS RIVER

25

CARLSBAD

LAS CRUCES

CARLSBAD
CAVERNS

0 25 50 100

10

Deming

MEXICO

EL PASO

CHURCHES OF NEW MEXICO AND COLORADO

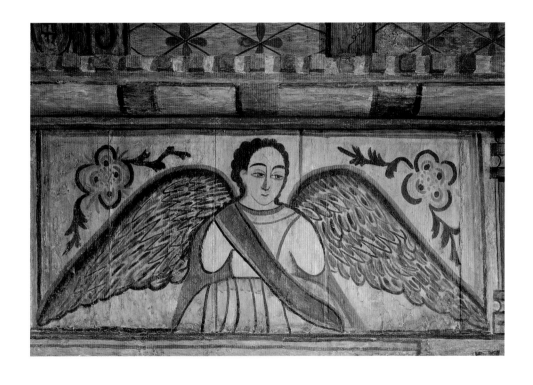

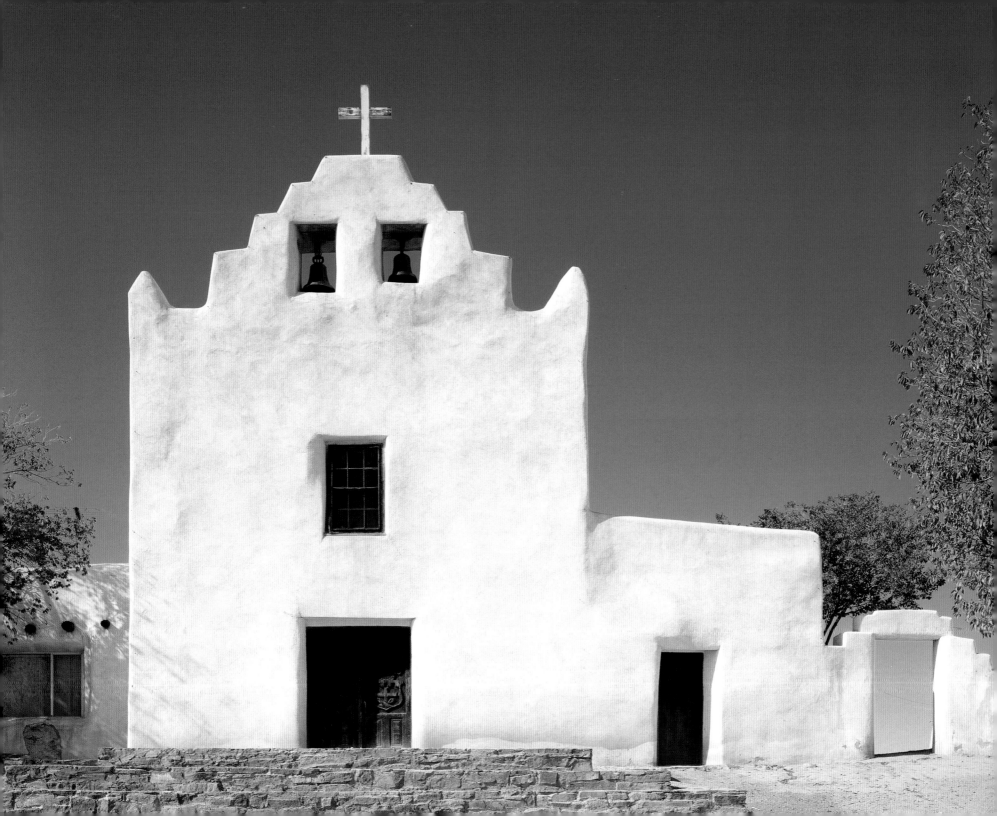

SAN JOSÉ DE LAGUNA
Laguna Pueblo, Laguna, New Mexico

The Pueblo of Laguna, named after a lake a short distance from the village, is the only pueblo that was founded after the arrival of the Europeans in America. Acoma, Zuni, Isleta, and Queres people from Santa Fe established it in 1699. Soon after arriving, the community petitioned Pedro Rodriguez de Cubero, the Spanish governor at Isleta, to send a priest to minister to them. The governor instructed them to prepare a place of worship and said that a priest would follow. According to local tradition, a portion of the *convento* was built first and, in mid-1699, Friar Antonio de Miranda arrived. Under his direction, construction of the church began. Before the end of the year, the Laguna builders had enough of the church completed for them to celebrate services.

Like the early pueblos, the mission is built of stone laid in adobe mortar with mud plaster on the inside and outside walls. It houses some of the rarest artistic treasures in the Southwest. The 105-foot-long nave ends in a magnificent altar screen. At Christmastime, the pews at Laguna are removed from the church and sacred dancing takes place there through the night.

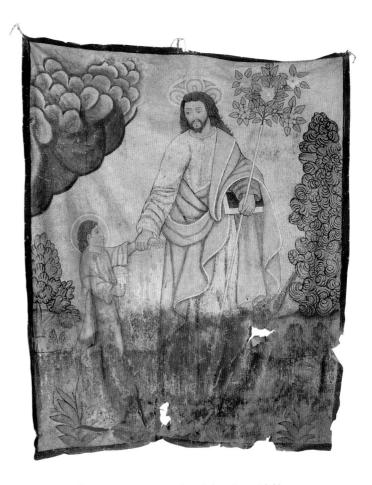

ABOVE *This image of Saint Joseph and the Christ Child at Mission San José de Laguna is the work of the early Franciscans and is one of the few paintings on elk hide remaining among mission artworks.*

FACING PAGE *The striking façade, distinguished by the stepped belfry where the bells are hung in openings pierced through the parapet wall, shows the excellent condition in which the church is maintained.*

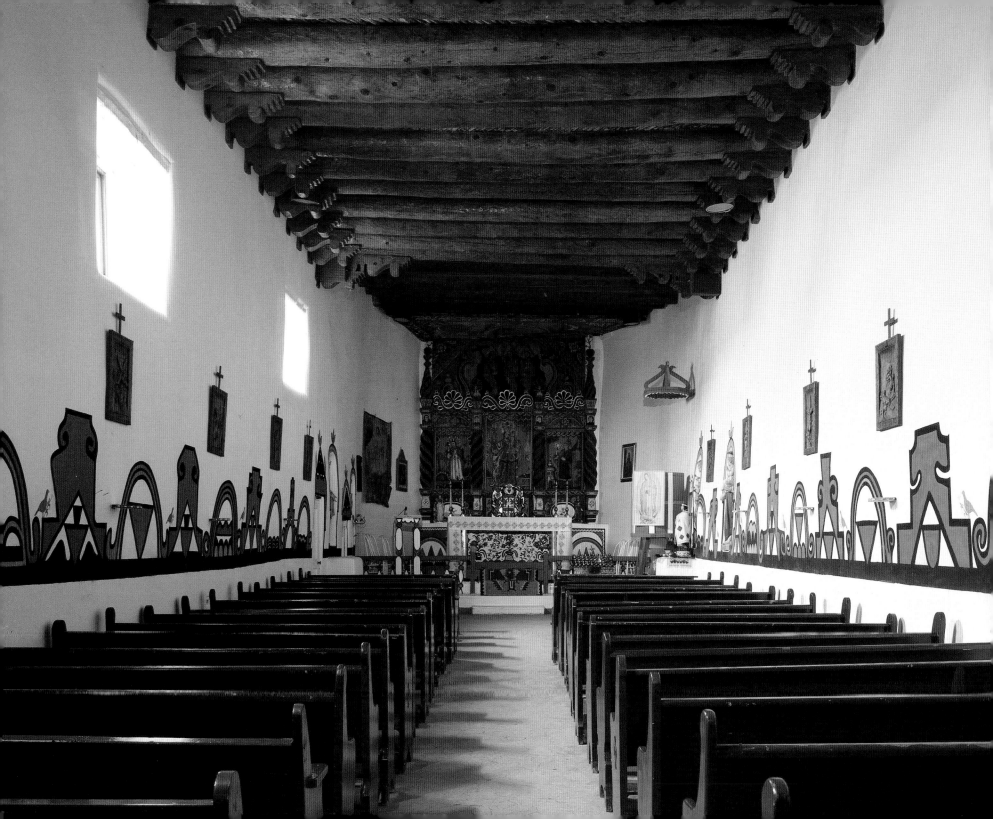

RIGHT *The carved altar is made from native pine and painted by the Laguna santero. In the center is Saint Joseph. On the right is Santa Barbara, patroness against thunder, lightning, firearms, and sudden death. On the left is Saint John of Nepomuk. Above is the Holy Trinity. On the ceiling over the altar is a painted canopy made of animal hide and decorated with symbols from the native American tradition. Two white stars near the sun represent morning, and eight stars near the moon represent night.*

FACING PAGE AND BELOW *According to local tradition, the paintings along the walls of the nave show birds resting on forms representing tombs. The birds symbolize the souls of the people buried under the tamped earth floor. The vigas supporting the roof had to be carried from a location at least thirty miles away.*

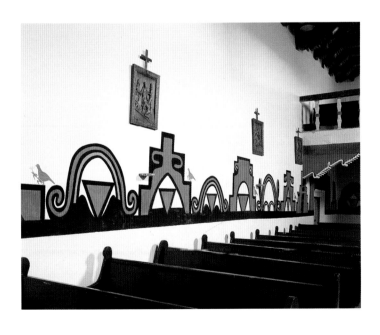

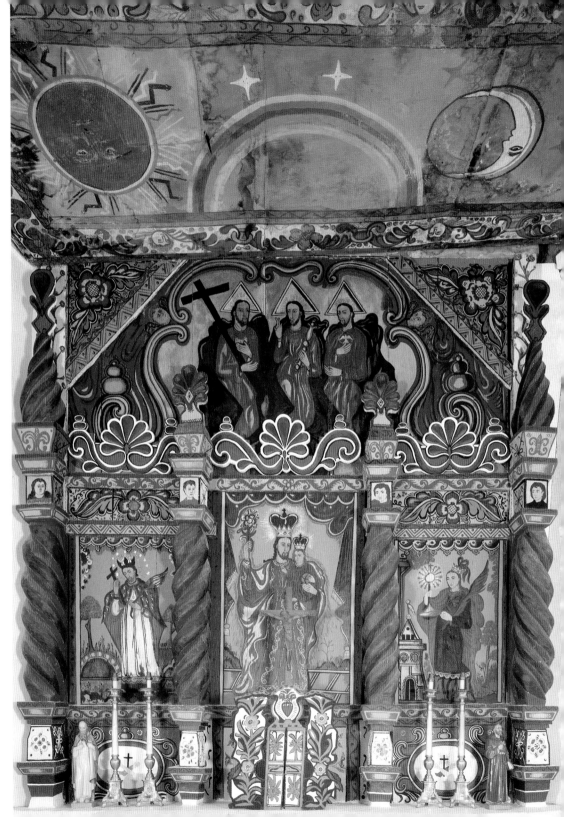

RIGHT *A prominent shrine honors "Little Owl," Kateri Tekakwitha, a half-Algonquin, half-Mohawk woman who died in 1680. This plaster statue wears an embroidered cloak and beaded decoration. Offerings at her feet include a beautiful Pueblo pottery bowl, a vase of lilies symbolizing the purity of her life, and a native American medicine bundle. After examining her holy life, the Catholic Church has recognized her sanctity by giving her the title "Blessed Kateri." This is the next-to-last step in the process of canonization, and there is a widespread movement urging the church to declare her a saint.*

BELOW *The entrance shows the Franciscan heraldic arms on the left door, repeated on the right in the coat of arms of the Bishop of Durango, Mexico, under whose jurisdiction this mission was built.*

FACING PAGE *The uniquely carved corbels support the choir loft. The cedar* latias *above are part of the original ceiling.*

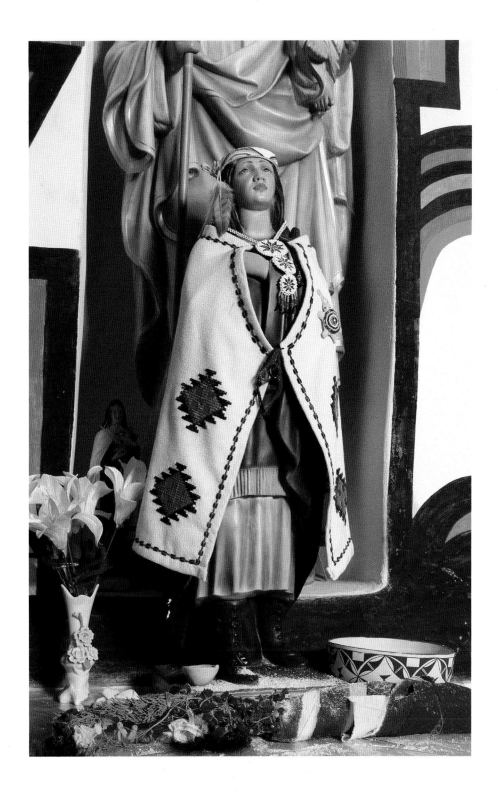

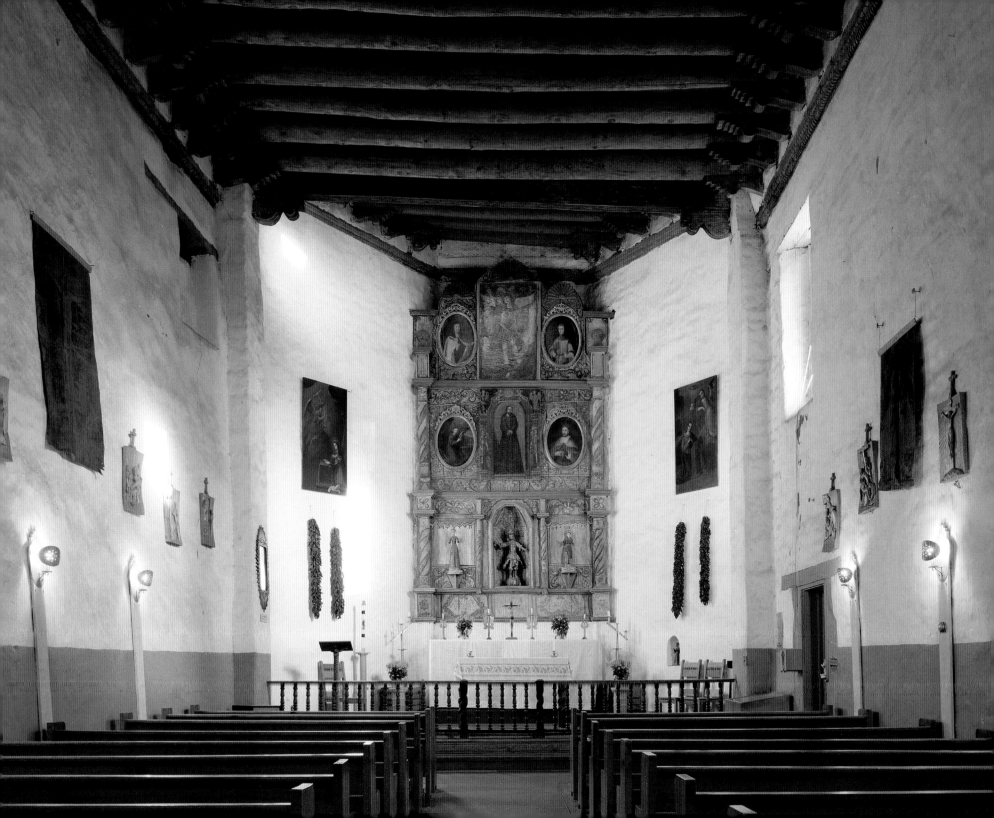

THE CHAPEL OF SAN MIGUEL
Santa Fe, New Mexico

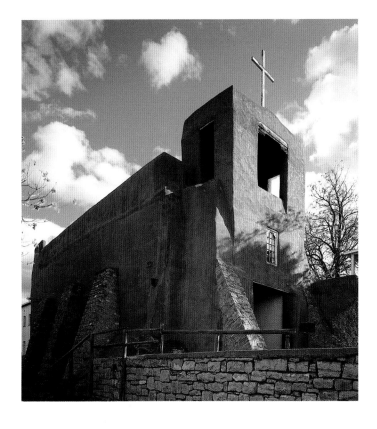

This chapel was the object of one of the first organized attempts to save the historic monuments of the Southwest. In 1883, a public appeal was made for funds to save what the local newspaper called "an historical feature which Santa Fe cannot afford to lose." Support came from the Catholic archbishop, the governor of the state, and people of all faiths and political opinions. The successful campaign saved San Miguel, but the appeal was based on the mistaken notion that the building was constructed in the seventeenth century — an idea that still has wide currency. In fact, the present chapel was built in 1710 as an *ermita,* or outlying chapel, attached to the parish church of Santa Fe. Although it is known locally as San Miguel Mission, it never was a mission. San Miguel was built to serve a poor neighborhood, and many of the original congregation were Mexican Indians.

In the middle of the last century, the building served as a school chapel and underwent a full Victorian remodeling. Those additions have been removed in a sensitive modern restoration that sets off the oldest and best furnishings, including one of the most splendid altar screens in the Southwest. Made by the Laguna *santero,* the altar screen was designed to hold a number of Mexican paintings on canvas and a few local *bultos.*

ABOVE *The tower of the Chapel of San Miguel in Santa Fe has been remodeled several times, but a bell cast in 1856 on the grounds of the parish church by Francisco Luján has survived all the changes, although it no longer hangs in the belfry.*

FACING PAGE *The clerestory window above illuminates the sanctuary, casting light on the altar screen of the chapel.*

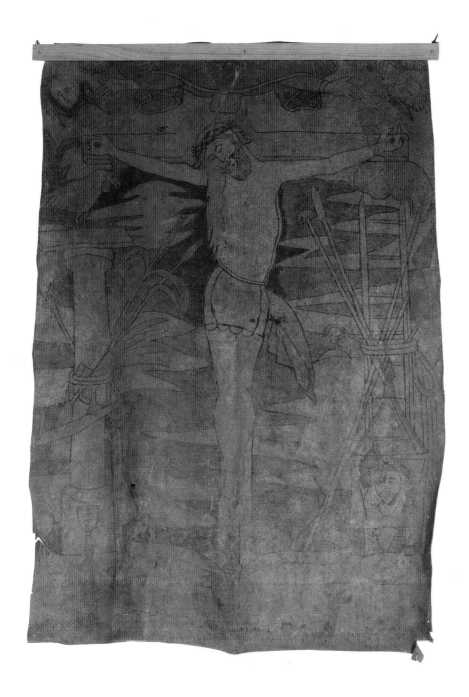

LEFT *Many of the paintings in early missions were done on buffalo hides and other skins, but most of these were destroyed in the nineteenth century. This one, showing the Crucifixion and the Instruments of the Passion, is one of several of these rare artworks kept in this chapel.*

BELOW *The beam supporting the choir loft rests on elaborately carved corbels. An inscription on the beam records that the building was erected by Royal Ensign Don Augustín Flores de Vergara in 1710, with contributions from the Spanish Marquis of Peñuela.*

FACING PAGE *Paintings on the altar screen show Saint Michael in the top center position, with Saint Teresa of Avila to the left and Saint Gertrude the Great to the right. Below are images of Jesús Nazareño in the center, with Saint Francis in prayer to the left and Saint Louis IX, King of France, to the right. An early member of the Third Order of Saint Francis, Saint Louis wears the Franciscan habit under his royal robes.*

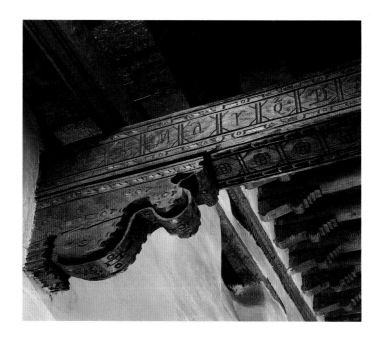

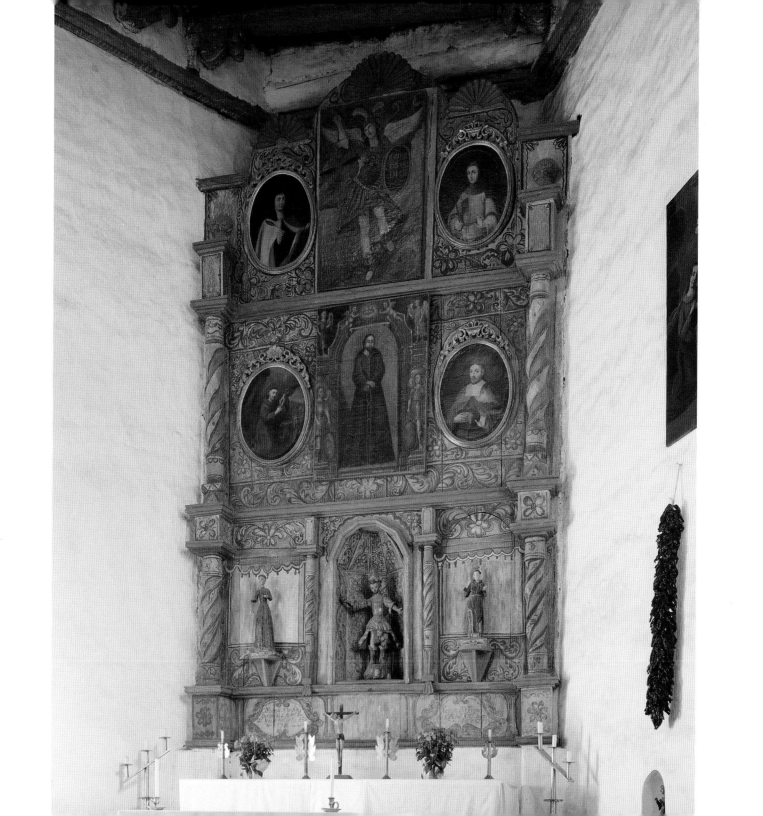

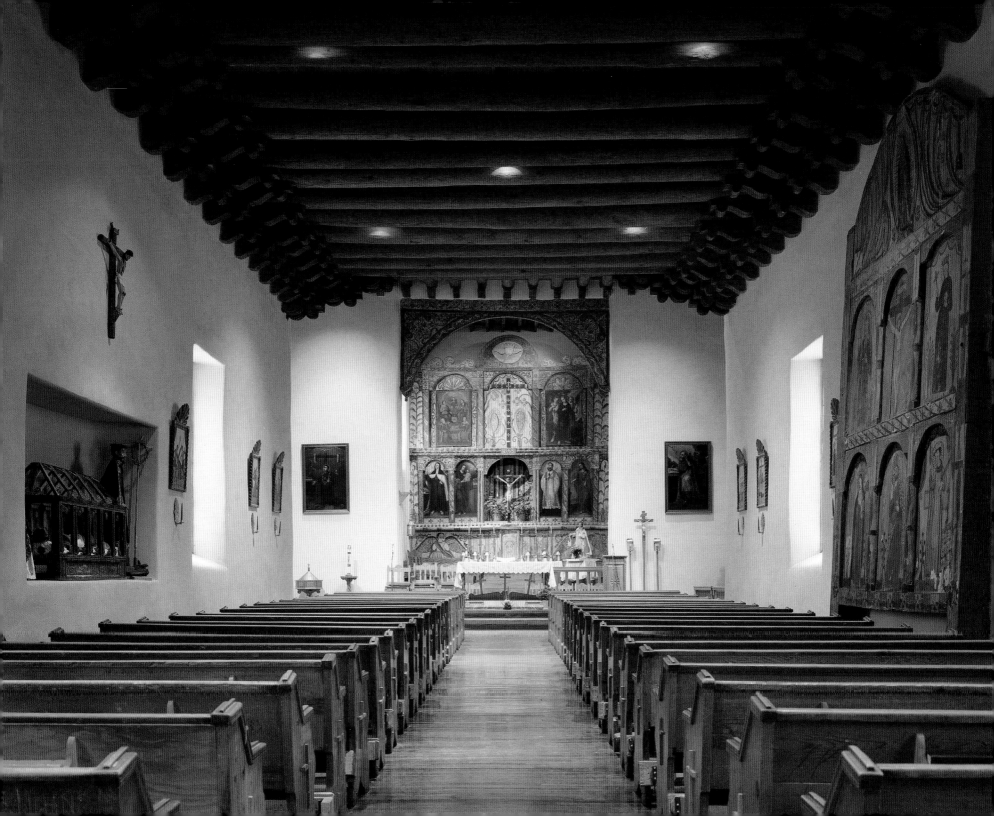

SANTA CRUZ DE LA CAÑADA
Santa Cruz, New Mexico

The *Cañada* in the title of this noble church refers to a fertile valley about thirty miles north of Santa Fe. Spaniards had farmed in the valley before the Pueblo Revolt of 1680. In fact, the settlement was founded by the original Spanish conqueror, Diego de Vargas himself. Tano Indians then occupied the settlement. When the Spaniards returned, they had a chapel built by the Tano for the new European settlers. The Europeans replaced this with another, which lasted until 1732. The next year, construction of a new church began. The work continued until 1748 and proved to be the longest construction project of all the Spanish missions.

Two religious confraternities in this parish had chapels off the transept. To the south was the chapel of the Third Order of Saint Francis, dedicated to the founder. To the north was the chapel dedicated to Our Lady of Mount Carmel, for the Carmelite confraternity. By local standards, the north chapel was luxurious. It contained an altar screen and a *bulto* of the patroness herself, a wooden floor, and even a small choir loft. The church proper had a mud floor and there was no choir loft.

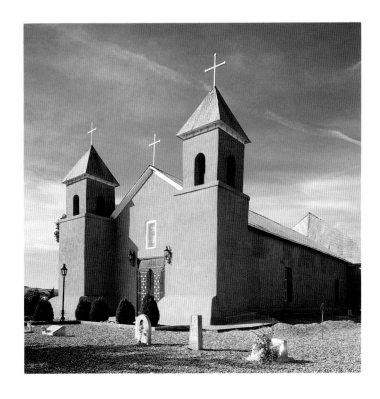

ABOVE *In restoration, the church of Santa Cruz de la Cañada, like so many other adobe churches, acquired a pitched roof over the nave and transept that gives the building a completely different profile from the original design.*

FACING PAGE *A stone floor in the sanctuary was a surprising discovery made during the restoration of the church in the 1970s. It was replaced, the walls were refinished with mud plaster, and the treasured altar screens and bultos of the parish were restored.*

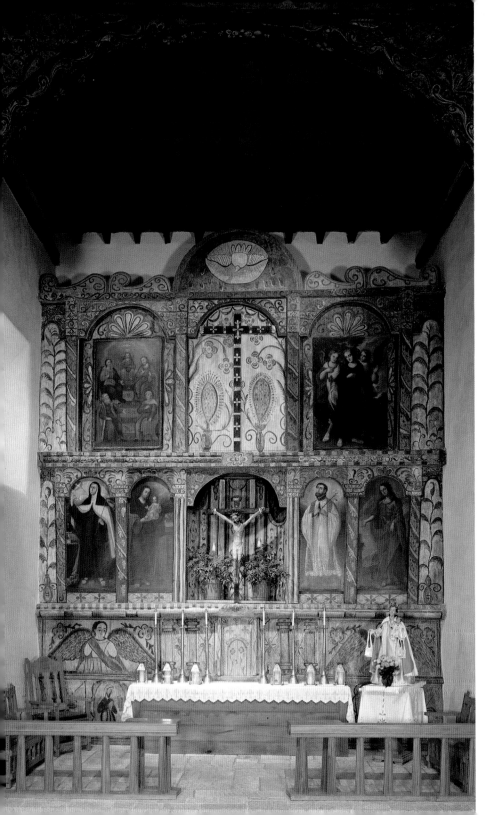

The decoration began in 1765 with the arrival of Father Andrés Garcia, one of the few Franciscan artists of the eighteenth century whose name we know. In the three years of his tenure at this church, working night and day (as parishioners later recalled), he adorned the church with a decorative altar rail, a variety of carved images, an altar screen (probably for the main altar), a decorated arch at the entrance to the sanctuary, and the Santo Entierro, an image of Christ in his tomb now kept in the niche in the south wall of the nave. An inventory at the end of the eighteenth century listed four altar screens. In the next century there were as many as seven, five of which were the work of the famous *santero* Rafael Aragón.

A sensitive restoration undertaken in the 1970s stabilized the building and restored its treasures, and they now are beautifully presented.

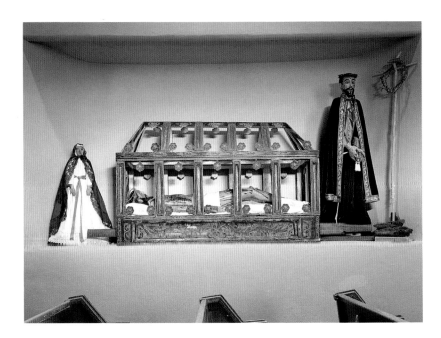

RIGHT *Aragón also painted this altar screen in the nave. At the top is the image of Our Lady of Guadalupe. Below, from left to right, are Saint Gertrude the Great, Christ Crucified, and Saint Rosalia of Palermo. The lowest row shows the Virgin of Sorrows, a crowned Saint Joseph tenderly embracing the Infant Jesus, and Saint Lawrence the Deacon, his dalmatic and gridiron reduced to abstract patterns. Such tall, elegant figures are typical of Aragón's work.*

FACING PAGE, LEFT *Aragón's work on the main reredos consisted in overpainting an existing screen and carving the crucifix in the lower niche. The cactuslike trees and other floral decoration are an Aragón signature. The other images are Mexican oil paintings of the Holy Family, Saint Rosalia of Palermo, Saint Teresa of Avila, Saint Joseph, Saint Francis Xavier, and Saint Barbara the Martyr. The painted arch at the entry to the sanctuary is the work of Father Andrés Garcia. Aragón made the* bulto *of Our Lady of Mount Carmel, to the right of the altar, to pay the expenses of his burial. He is buried in the Carmelite chapel here.*

FACING PAGE, RIGHT *The niche in the nave holds the Santo Entierro, a* bulto *by Father Andrés Garcia. Christ reposes inside an openwork coffin decorated with carved flowers. Poles at the base enable it to be carried in the burial procession during Holy Week. Restorers found that some tenderhearted soul had placed candies in the mouth of the Savior. Two vested* bultos *of the Virgin of Sorrows and Jesús Nazareño share the niche with the Santo Entierro. Although no one knows why two fingers were missing from one hand of this carving of the Savior,* bultos *were considered to have miraculous powers, and local stories tell of pieces of statues being thrown into rising floodwaters to make them subside, or being burnt into ash for signing the faithful with a cross during an epidemic.*

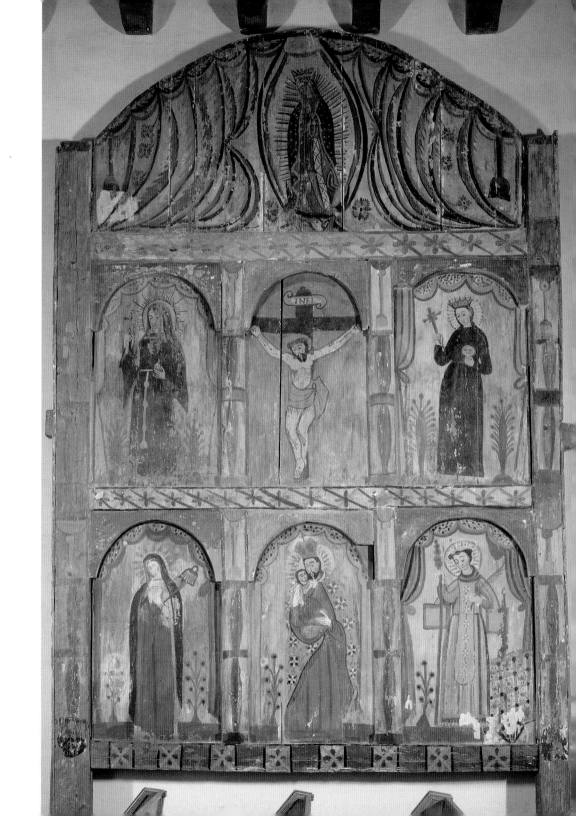

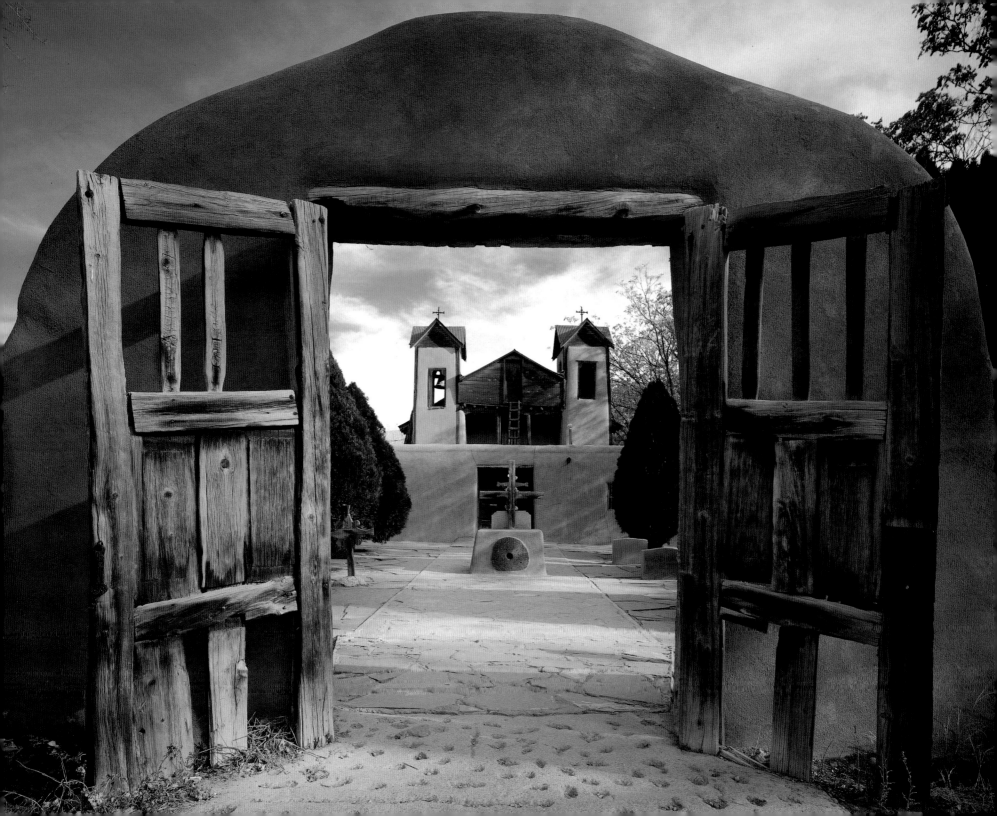

El Santuario de Chimayó
Chimayó, New Mexico

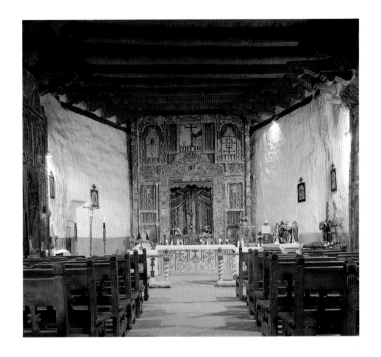

Set among the piñon pines in the rocky New Mexico landscape, El Santuario de Chimayó is considered to be one of the truly holy places of North America. Although the church was built only in 1813, it stands at the center of an entire constellation of nearby points of prayer and pilgrimage that have been honored for hundreds of years. Legend has it that these holy sites produced mud with healing powers that was eaten, applied to the skin for healing, or carried away as a kind of blessing from the place by the native pilgrims.

Similar practices were followed at the Catholic shrine of Esquípulas in distant Guatemala, where a miraculous crucifix, Nuestro Señor de Esquípulas, was venerated. There, local kaolin was pressed into cakes stamped with holy images, blessed and, dissolved in water, used much like the New Mexican mud. Travelers brought the fame of this shrine and pictures of the miraculous crucifix to Chimayó and, in 1813, Don Bernardo Abeita requested permission from church authorities to construct a chapel in honor of Our Lord of Esquípulas, a dedication probably suggested by the parallel customs of using the healing powers of the earth.

ABOVE *El Santuario de Chimayó is still the destination of thousands of pilgrims each year, many of whom travel great distances to visit the shrine that honors Nuestro Señor de Esquípulas and El Santo Niño de Atocha. The nave contains reredos painted by the* santeros *José and Rafael Aragón, and Molleno, "the Chili Painter."*

FACING PAGE *The* atrio *is the first of the sacred spaces the pilgrim enters. It is a typical enclosed yard, part garden and part cemetery, which serves as a passage to the shrine itself.*

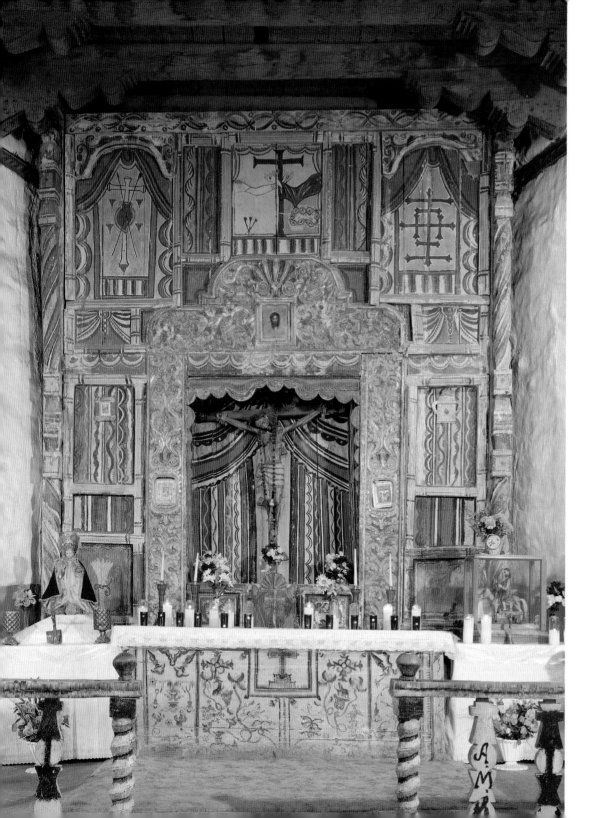

Many local legends ascribe the origin of this shrine to the miraculous appearance of a crucifix here. One version says it arrived on the back of an unaccompanied mule; most tell that it was discovered in the earth by the founder, Don Bernardo, and the shrine was built around the hole where it had been buried.

The popularity of the Santuario grew when a statue of the Santo Niño de Atocha was added to the shrine, and its healing power came to be attributed as much to the Infant Jesus as to Our Lord of Esquípulas.

In 1826, an ecclesiastical visitor found most of the original images here unworthy because they were painted on rough boards or hides and ordered them removed. Don Bernardo, the founder, replaced them with work by painters such as José and Rafael Aragón, and the *santero* Molleno. The main altar screen is the work of Molleno. He was formerly known as "the Chili Painter" because his typical rendering of acanthus-leaf molding resembles chili peppers. This screen was painted to frame Our Lord of Esquípulas, the large crucifix in the central niche. As in the Guatemalan prototype, the cross is shown as a tree with golden leaves growing from it.

RIGHT *Painted curtains frame each image on this reredos by José Aragón of Córdova. In the top row, Saint Francis and Saint Anthony of Padua are shown in customary poses to left and right. In the center, Saint Jerome, the translator of the Bible, listens to the trumpet of divine inspiration. The bottom row is devoted to the archangels. At the left, Raphael carries the staff of a traveler, while on the right, Michael defeats the devil with the weapon of the cross and holds the scales of Judgment Day. The* bulto *of Saint Raphael in the center holds the large fish described in the Book of Tobit in the Holy Scriptures. The archangel's wings are not carved, but painted on the back of the niche.*

FACING PAGE *The altar screen frames a single image: the Esquípulas crucifix. Other panels show the Franciscan coat of arms, the Instruments of the Passion, and the Five Wounds of the Savior. Additional altar screens with more customary displays of images of the saints stand against the walls of the nave. In a glass case to the right of the altar is a* bulto *of Santiago (Saint James), who was believed to have led the reconquest of Spain from the Moors. Two images of the Infant Jesus are honored at the Santuario. The Infant of Prague, shown in the clothed statue to the left of the altar, is a version of a miraculous image in the Carmelite monastery in Prague. A statue of the Santo Niño de Atocha is kept in the chapel where the healing earth is found.*

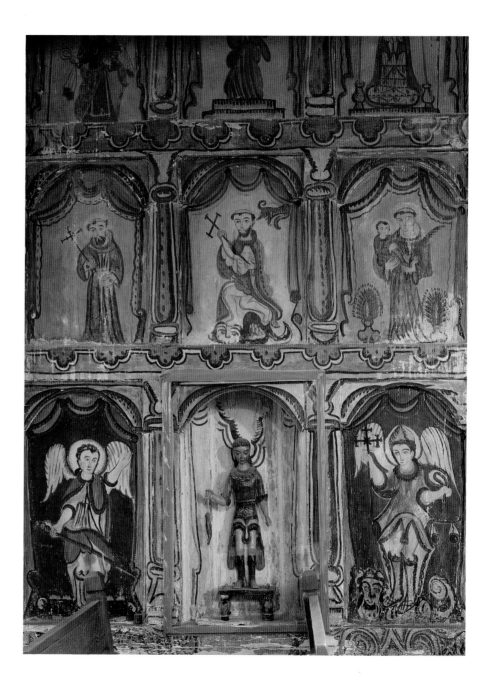

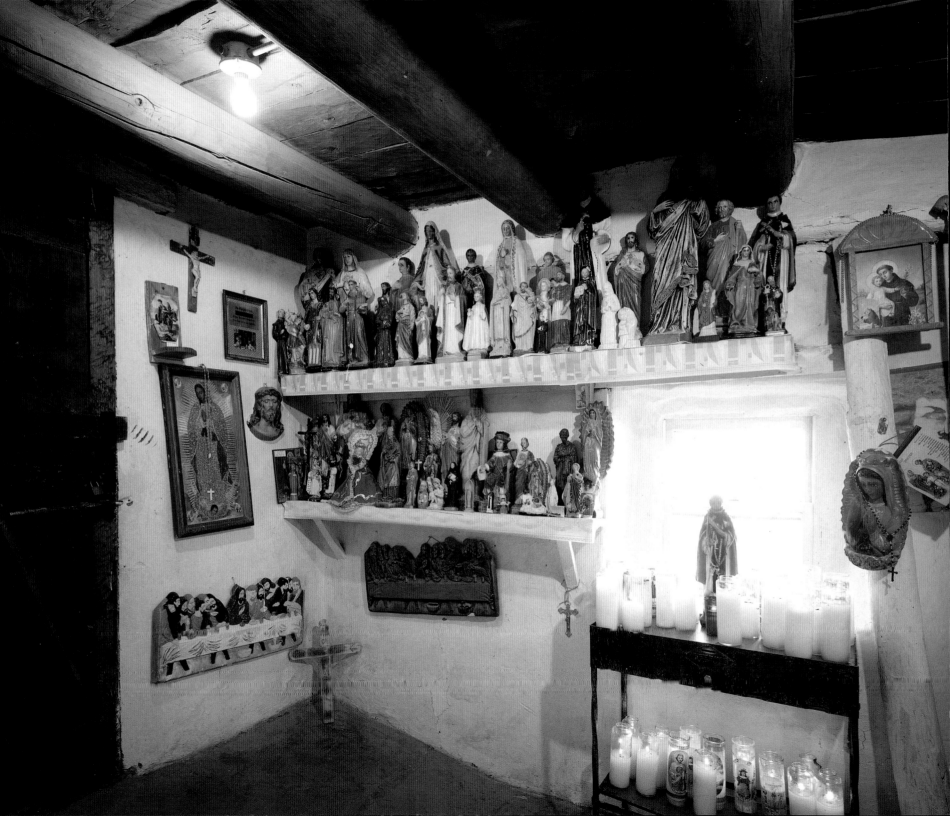

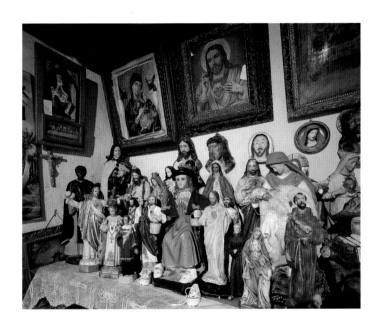

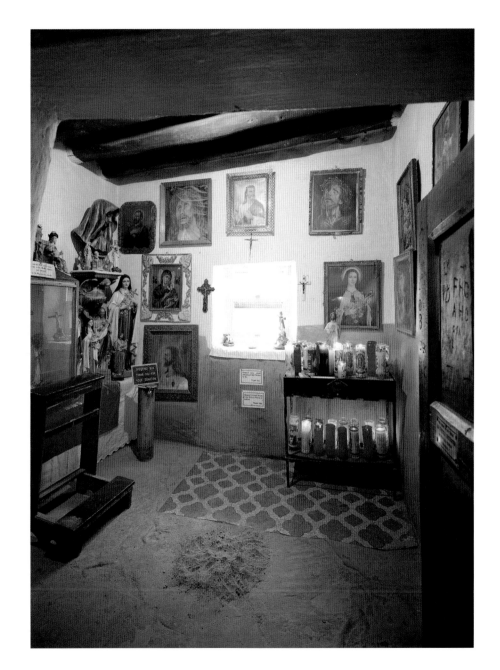

ABOVE AND FACING PAGE In their devotion, pilgrims have left every sort of image in the side chapel. The baby shoes near the seated image of the Santo Niño de Atocha are popular offerings reflecting the belief that the Holy Infant wears out his shoes at night as he goes about doing good.

RIGHT A little chapel shelters El Posito, the hole in the floor from which the healing earth is taken. Some records are kept of healings attributed to using or eating the earth from Chimayó, but no systematic investigation has been undertaken. Pilgrims leave votive lights and a collection of devotional items in the chapel as evidence of their faith.

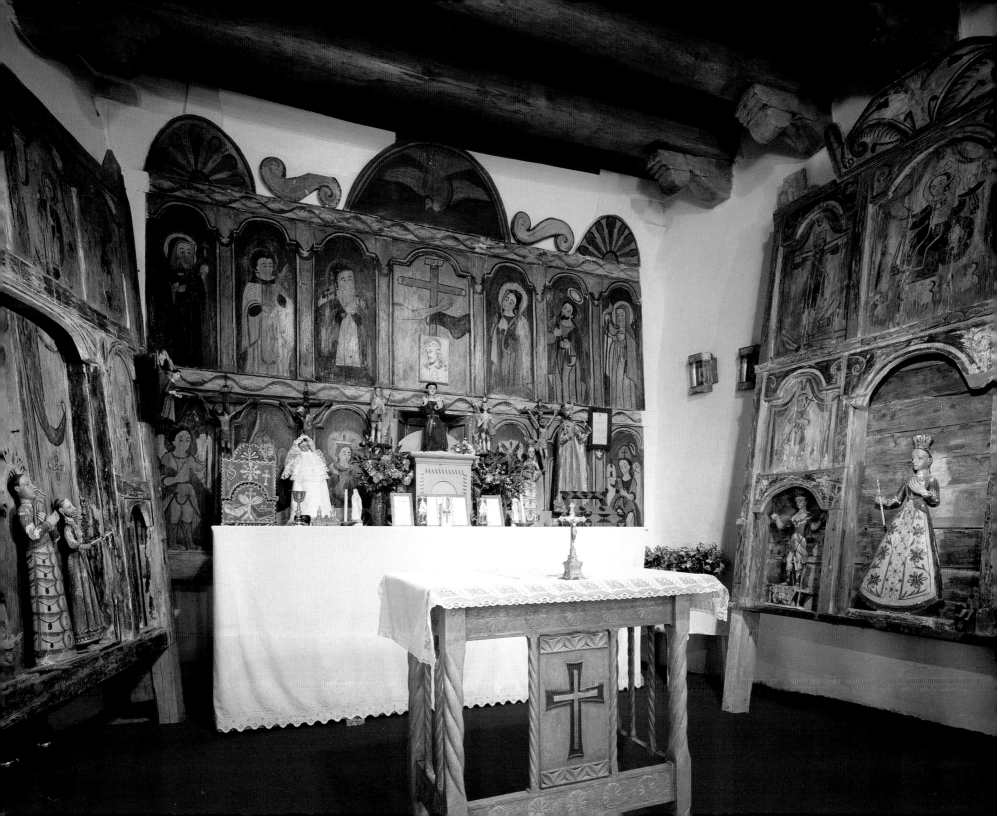

SAN ANTONIO DE PADUA
Córdova, New Mexico

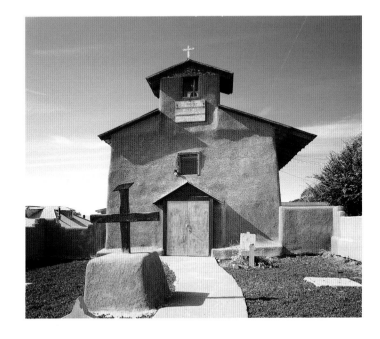

Córdova, originally called Pueblo Quemado, was a new village in 1832 when the residents requested permission from the bishop to build a public chapel dedicated to Saint Anthony of Padua. The chapel was to be a dependency of the parish church of Santa Cruz de la Cañada. Don Bernardo Beitia (or Abeita), who had built the Santuario at Chimayó, assumed responsibility for the expenses of construction and promised to provide the chalice, paten, and other sacred vessels.

The building was a humble affair, but the interior was filled with the work of a local resident, Rafael Aragón, one of the greatest *santeros* of the Southwest, and three of his altar screens are still found here. Aragón's work is characterized by elegant, elongated figures, and this signature is evident in the images he made for this church.

Córdova is still a mountain village, its buildings clustered around a small plaza, and it is still known for its *santeros*. Dozens of artists work here, as is indicated by the signs hanging outside their doors, continuing the tradition of carving and painting sacred images.

ABOVE *The entrance to the church of San Antonio at Córdova is through a walled enclosure (the* atrio*). This was once a common feature of early Christian buildings and is preserved in the layout of many mosques in Spain.*

FACING PAGE *The tabernacle covers the central niche in the altar screen and serves as a pedestal for the* bulto *of San Antonio, whose Franciscan habit has been replaced by a bright purple robe. The Franciscan coat of arms appears at the center of the screen. At the far left is Saint Gertrude the Great. Next to her is Saint Stanislas Kostka, a Polish Jesuit canonized in 1726. Rafael Aragón was the only* santero *to paint this subject. Two images of the Virgin stand on either side of the heraldic panel, followed by Saint Peter the Apostle and Saint Mary Magdalene.*

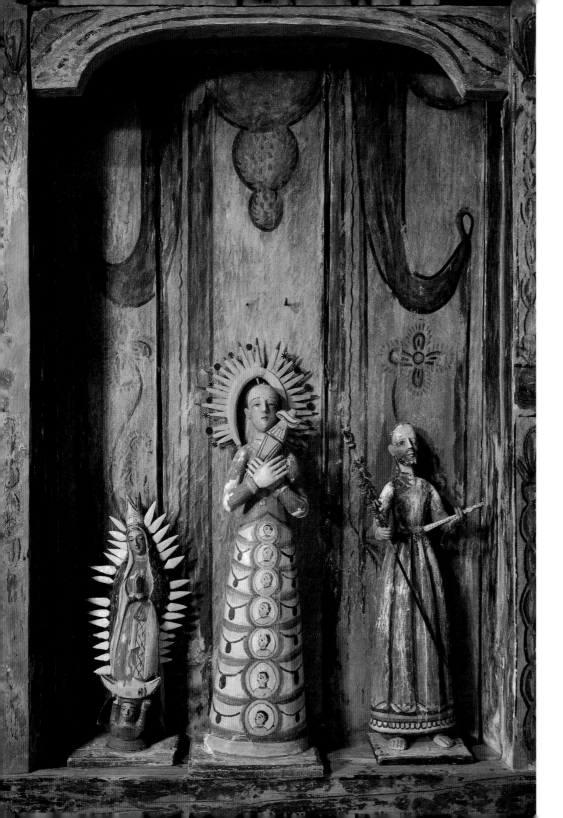

LEFT *The Virgin of Sorrows, in the center, wears unusually bright colors. Her skirt, with its coinlike decoration, resembles the dress of Nuestra Señora de Begoña, patroness of the Basque Provinces and Bilbao, whose image was known in New Mexico. Saint Joseph stands to the right, without the figure of the Infant Jesus he once held. On the left is a carved version of the beloved Mexican painting of Our Lady of Guadalupe.*

FACING PAGE, ABOVE LEFT *The original altar, like a shelf in front of the screen, is no longer used to say Mass. Instead, it holds vessels and books necessary for the service and serves to display sacred images. The blue case with the arched door marked "Sagrario" is the cabinet to store the holy oil used in the sacraments. The vested image in white is a statue of the Virgin Mary.*

FACING PAGE, ABOVE RIGHT *Three niches frame brightly painted* bultos. *Saint Michael the Archangel, on the left, still wears Aragón's version of ancient armor. The other figures represent the Virgin Mary. Statues of the Infant Jesus to the right can be placed in the arms of his mother or kept separately as is the Santo Niño de Atocha, seated in a chair. The paintings on the screen above show Saint Raphael the Archangel to the left and Saint John of Nepomuk to the right.*

FACING PAGE, BELOW LEFT *The curious ornaments on the head of the Holy Child Jesus are called* potencias *and represent the powers of the soul: memory, will, and understanding. They usually appear as emanations of light, but here they are shown as heavenly bodies, and look very native American in their design. The figure of La Purísima to the right has the crescent moon painted on the hem of her skirt. Saint Peter the Apostle, holding his symbolic key to the kingdom of heaven, stands to the right.*

FACING PAGE, BELOW RIGHT *An adobe shelf along the wall of the nave is filled with a collection of images. Only a few of these statues are the work of* santeros; *most are cast and painted plaster from religious-goods stores.*

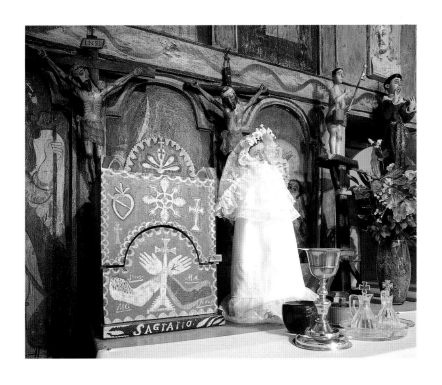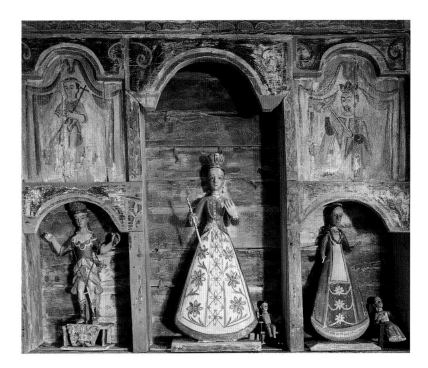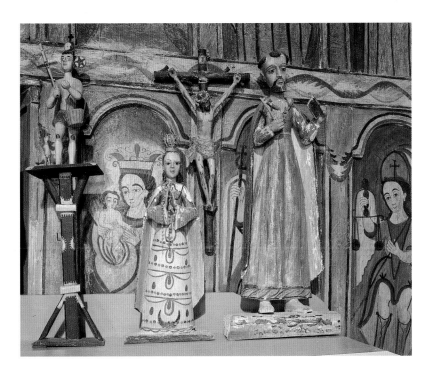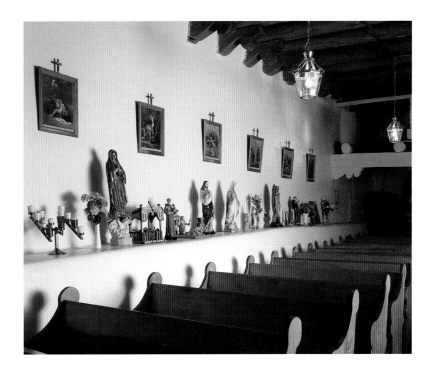

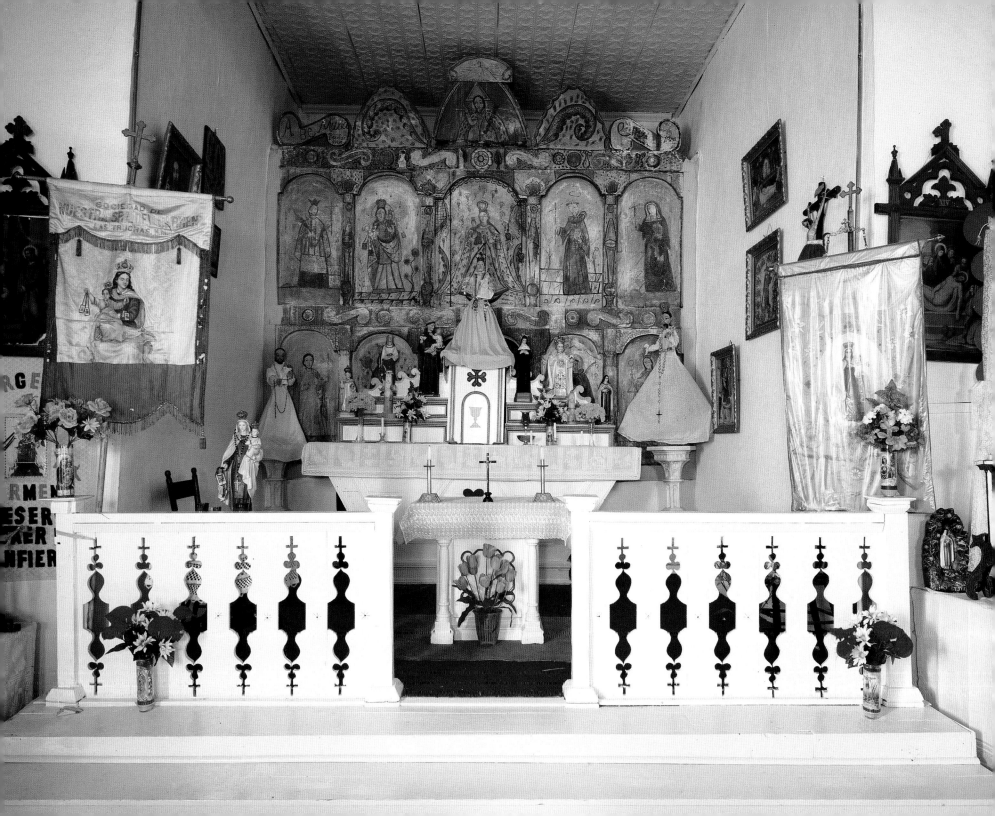

Nuestra Señora del Sagrado Rosario
Truchas, New Mexico

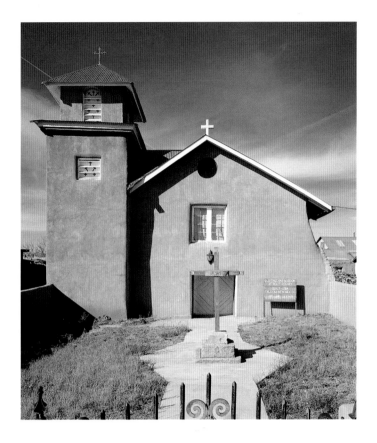

Truchas, a breathtakingly beautiful village perched on the rim of a deep canyon on the high road to Taos, was settled in 1754 by twelve families. Soon afterwards a dam and an elaborate irrigation system were constructed, which guaranteed agricultural prosperity, and by 1776 the population had grown to twenty-six families — about 122 people. Early visitors make no mention of a church, although the bishop had granted a license for a chapel, renewed for the last time in 1805 "in virtue of having all the necessary furnishing." The chapel is dedicated to Our Lady of the Rosary.

In 1809, the wealthy Ortiz family commissioned an altar screen by Pedro Fresquís, a *santero* and resident of Truchas. For years this painter's name was unknown, and his work was attributed to "the Calligraphic Santero" because of the linear quality of his style. But several horses painted by this artist show the initials P. F. as a brand on their rumps, and Pedro Fresquís is thus assumed to be the artist.

ABOVE *The original roof of the church of Nuestra Señora del Sagrado Rosario at Truchas was flat; the pitched roof was built in 1878. The deep overhang of this later roof protects the adobe walls from runoff water and probably contributed to preserving the building.*

FACING PAGE *The altar screen by Pedro Fresquís provides a backdrop for the accumulated artifacts of generations of worshipers: banners, plaster statues, and venerable bultos. Saint Anthony of Padua stands in a plywood arco on the left.*

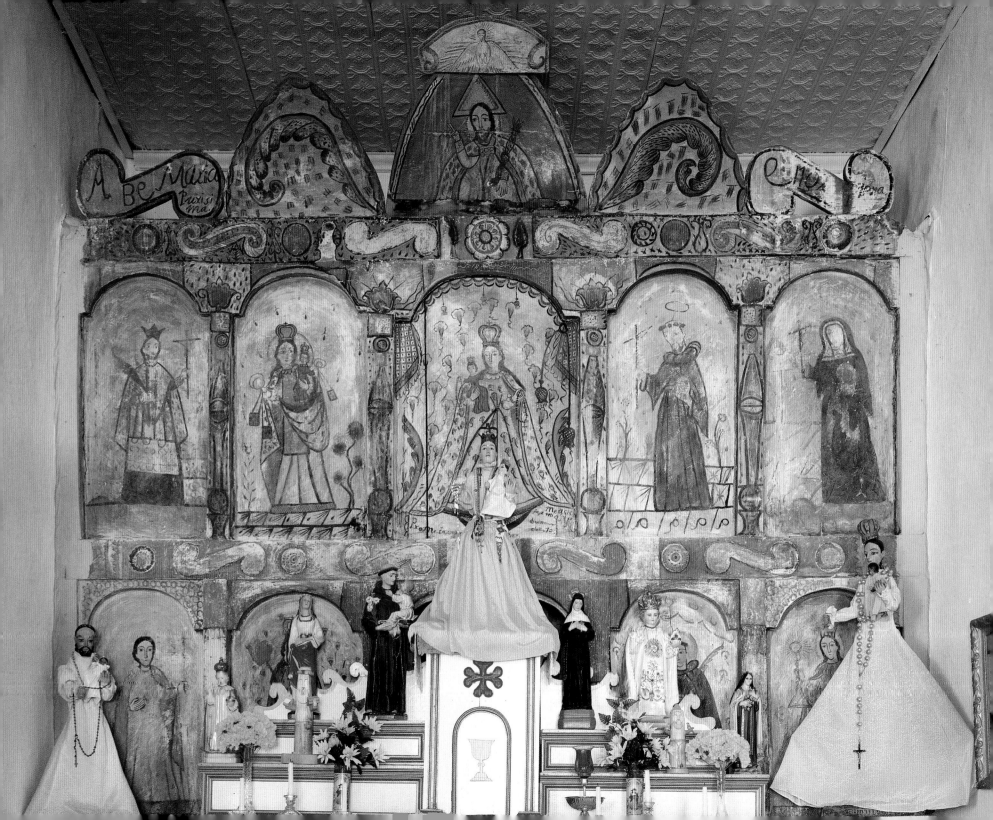

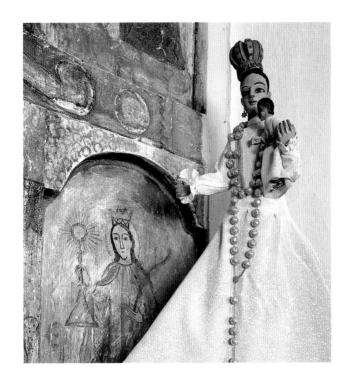

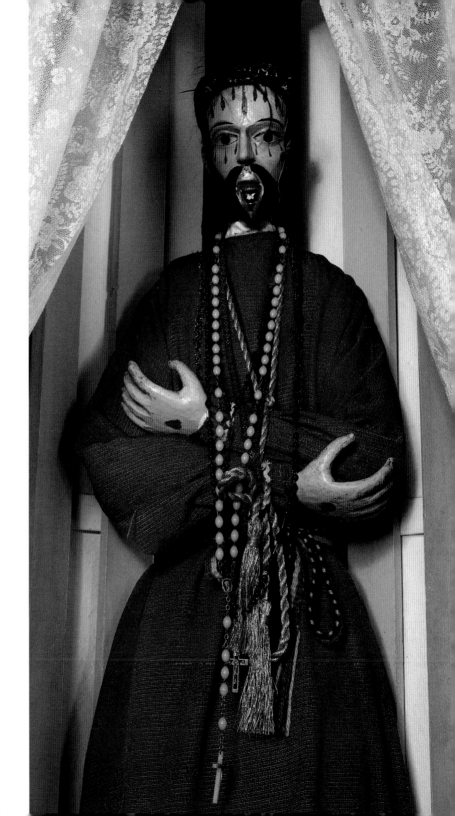

ABOVE The bulto of Our Lady of the Rosary stands in the sanctuary, holding the Infant Jesus lightly on her left arm. Her necklace is a rosary. Behind her skirt, Saint Barbara looks out from the altar screen.

RIGHT Nuestro Padre Jesús Nazareño is one of the most popular bultos of the Passion. Jesús is crowned with thorns and wears a purple robe, to mock his supposed claim to royal rank, as the Gospels describe. An expression of deep humility marks this carving. The cords gathering the robe and tying the hands are almost invisible under a collection of rosaries and an Indian beaded necklace.

FACING PAGE Fresquís followed a traditional arrangement of images on this altar screen. The dove of the Holy Spirit at the top hovers over the image of God the Father, with his scepter. Scrolls to left and right carry prayers to the Blessed Virgin. The image of Our Lady of the Rosary, the patroness of the church, occupies the central panel below. Our Lady of Mount Carmel is placed to the left of the central picture, and Saint John of Nepomuk is at the far left. To the right of the center panel stands Saint Francis of Assisi, and at the far right is Saint Gertrude the Great.

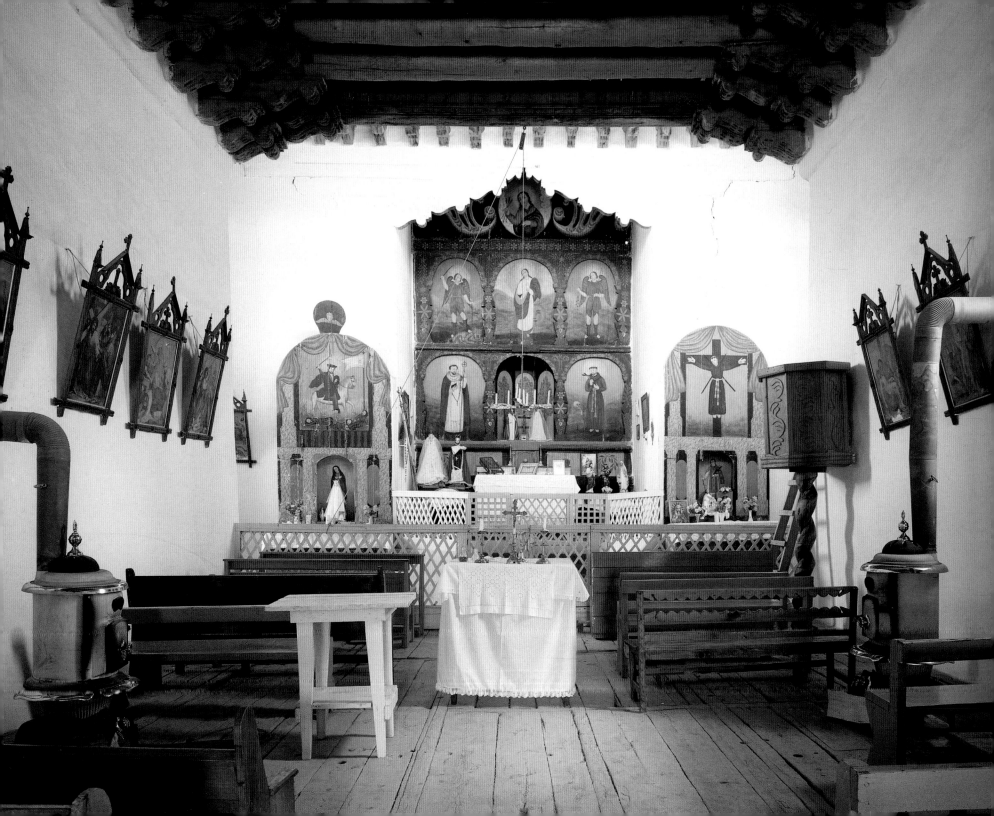

San José de Gracia
Las Trampas, New Mexico

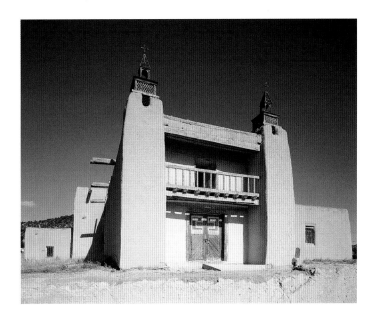

To enter this building is to step back in time by centuries; it has been called the most perfectly preserved Spanish Catholic church in the United States. In 1760, the bishop gave his blessing for a church here in honor of Saint Joseph, and construction was completed about 1776.

Several features make San José de Gracia remarkable. The transverse clerestory window at the meeting of the nave and the transept, once a feature of many New Mexico churches, is still intact. In addition, the full set of paintings for this church survives. We know the names of all the artists who decorated this church. The original painted decoration was the work of Pedro Fresquís, the renowned eighteenth-century *santero.* His work was re-painted, probably in 1864, by José de Gracia Gonzales, a *santero* originally from Sonora, Mexico.

The balcony over the entrance is another special feature of this church. Several New Mexico churches have balconies like this, but their use remains a puzzle. They are too shallow to hold many people, and they can be reached only through the choir loft. They may have allowed musicians to accompany outdoor services or processions. They may simply have been ornamental.

The vested figure of Saint Joseph with the Infant Jesus, now to the left of the altar, stood in the niche over the altar when the church was founded. It is the work of another famous *santero,* Bernardo Miera y Pacheco.

ABOVE *The wooden superstructures on the towers of the church of San José de Gracia at Las Trampas are modern replacements. Like all bells in Catholic churches, these are named:* Gracia *(Grace) has the sweeter tone and summons the faithful to Mass;* Refugio *(Refuge) is more somber and announces a parishioner's death.*

FACING PAGE *The transept of the church is some three feet higher than the nave. This allows a transverse clerestory window facing south to admit steady light throughout the day. The wood plank floor covers graves of the founders, benefactors, and parishioners of this church.*

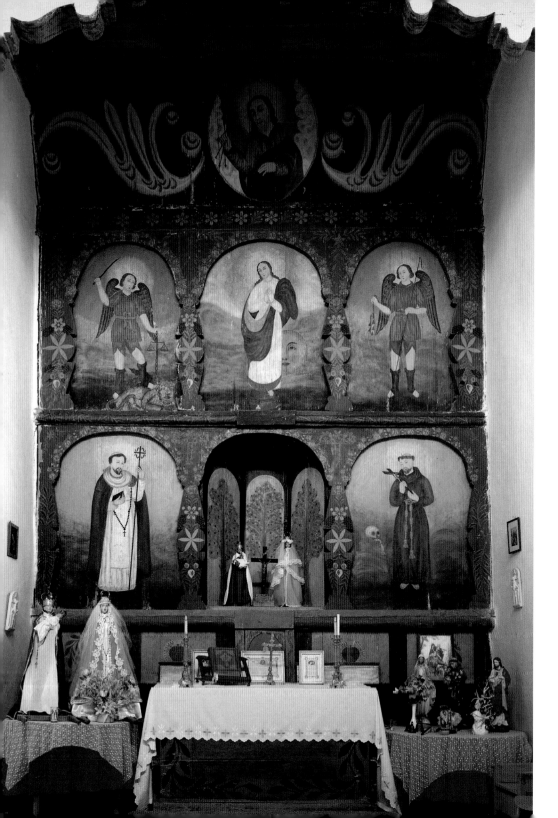

LEFT *An unusual image of God the Father holding three arrows appears at the top of the altar screen. Below this stands the Virgin of the Immaculate Conception, with Saint Michael the Archangel to the left and Saint Raphael the Archangel to the right. The lowest row holds pictures of Saint Dominic on the left and Saint Francis on the right, shown as an ascetic in his retreat on Mount Alvernia in the Apennines. The skull is a reminder of death; it rests on a "discipline," a little whip of knotted cords that many early friars and their followers used to mortify their flesh in a ritual fashion.*

FACING PAGE, LEFT *A side altar honors Santiago Matamoros: Saint James the Apostle crushing the Moors. This saint, who was believed to have preached in Spain in the first century, was seen, in frequent visions, leading the Christian armies against the Moors during their expulsion from that country. Here he wears the uniform of a Mexican officer of the 1860s. Below is Our Lady of Solitude, wrapped in her dark mantle, mourning the crucifixion of her Son and meditating on his death.*

FACING PAGE, RIGHT *Another side altar is devoted to Saint Philip of Jesus and Saint Lawrence the Deacon. Philip was sailing home to Mexico from Manila in 1597 to rejoin the Franciscan order. A storm forced the ship to dock in Japan, where he was arrested with twenty-five other Christians, all of whom were crucified for their faith at Nagasaki. The Japanese executioners ran them through with spears, as this painting shows. Below is Saint Lawrence the Deacon, who was executed at Rome in A.D. 258. Legend told that he was burnt alive, so he holds the martyr's palm in his right hand and the gridiron on which he was roasted in his left. A vested statue of Saint Joseph and a badly damaged bulto of Saint Anthony in a case (called an arco) stand on the ledge below.*

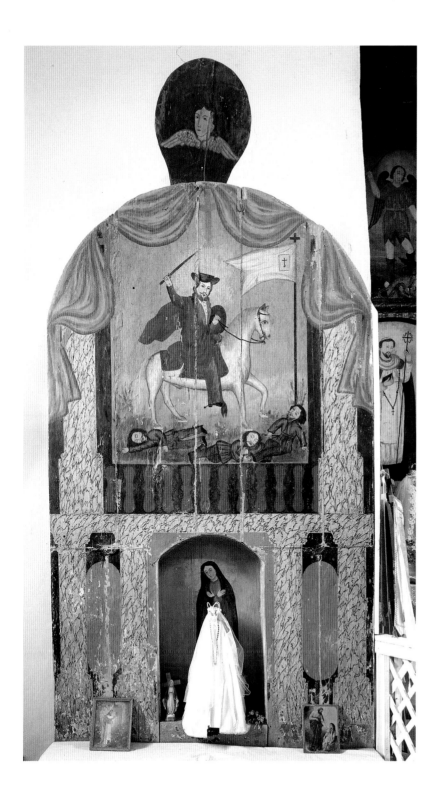

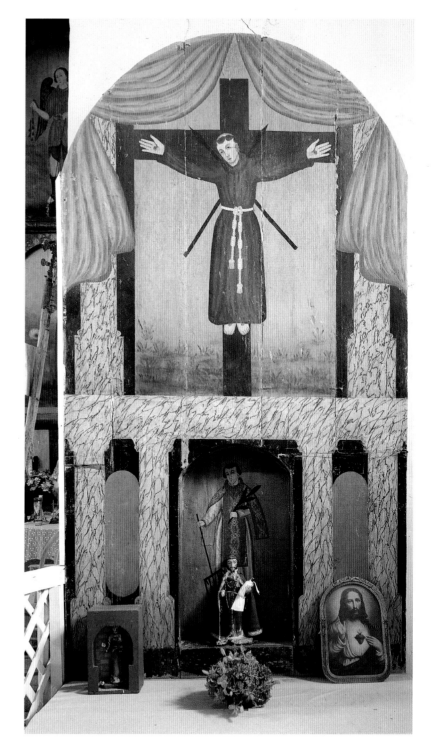

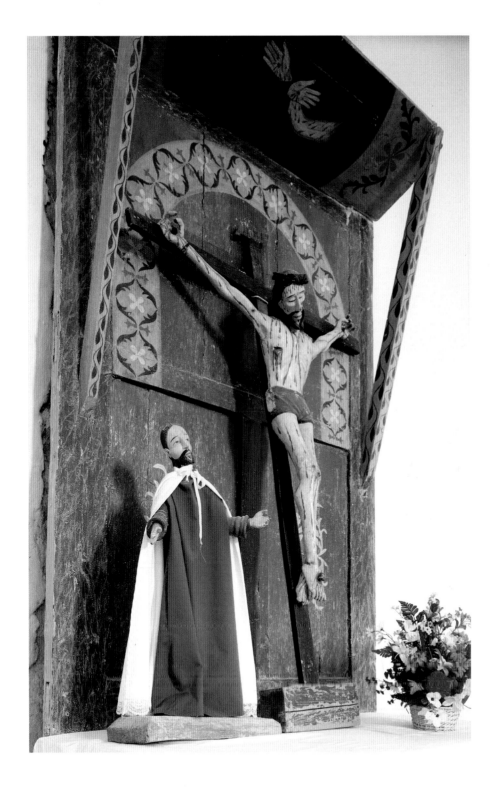

LEFT *Next to the crucifix stands an image of Saint Francis of Assisi, whose religious life was marked by his devotion to the mystery of the Cross. The carved and painted figure of Christ is particularly fine work.*

FACING PAGE, ABOVE LEFT *The underside of the choir loft is decorated with a riot of geometric and floral ornament in red and black. The hand-adzed boards between the beams were probably painted before being set into place. The beams themselves are carved with the monograms of Jesus and Mary, and the name Manuel Montolla, a benefactor of the church.*

FACING PAGE, BELOW LEFT *The vigas in the nave rest on shaped corbels decorated with simple chisel marks that were once picked out in color. The corbels, in turn, rest on a beam with classical dentils carved in low relief. The ceiling beyond shows the vigas of the transept at ninety degrees to those of the nave. The effect of the transverse clerestory window above can be seen in the different light in these two spaces.*

FACING PAGE, RIGHT *The pulpit stands on its pedestal of a twisted column. Such so-called "Solomonic" columns were thought to reproduce the columns that once stood in the Temple of Jerusalem; artists produced versions of them throughout the Christian world.*

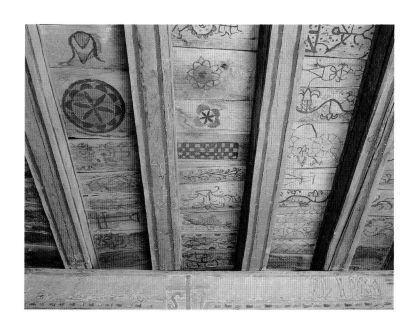

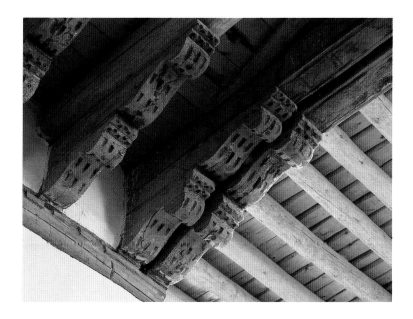

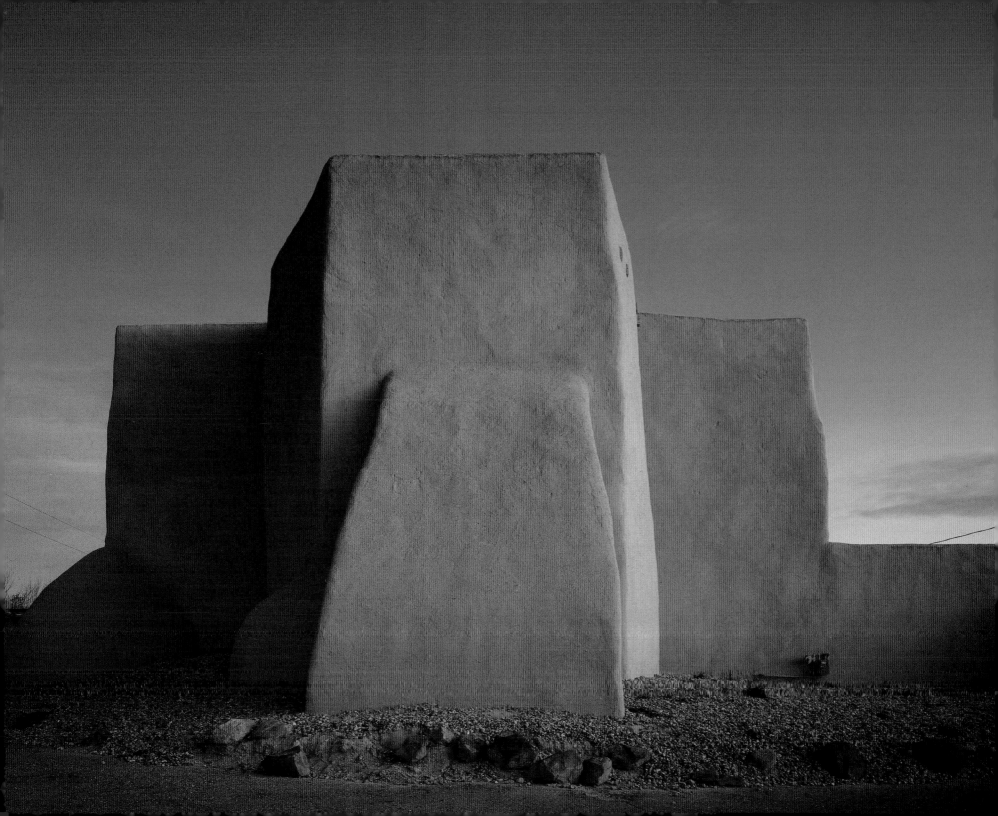

SAN FRANCISCO DE ASÍS
Rancho de Taos, New Mexico

Famous for its colony of artists and writers, Taos is hardly less famous for its architecture. For many people, the church at Rancho de Taos is the quintessential adobe building of the Southwest. Spaniards had farmed in this area since the 1700s, but no permanent settlement was made until early in the following century. A license to build a church was granted in 1813 and construction was completed two years later. The community was served by the priest at the Taos Pueblo.

Today the church at Rancho de Taos is a parish church and is very carefully maintained. The community preserves it as a place of worship; photographs of the interior are not allowed. Every portion of the exterior has been shown in numerous paintings by artists such as Georgia O'Keeffe, Ralph Pearson, Wilfred Stedman, Eric Sloane, and others associated with the famous artists' colony at Taos. Photographs of the church by Ansel Adams, Laura Gilpin, and Paul Strand also have been widely reproduced.

ABOVE RIGHT *The cross in the* atrio *carries an inscription saying that this church is named in honor of Saint Francis of Assisi.*

BELOW RIGHT *The moon rises over the church at Rancho de Taos.*

FACING PAGE *No church shows more eloquently the sense of form that is the chief aesthetic attraction of the adobe churches of the Southwest than San Francisco de Asís at Rancho de Taos.*

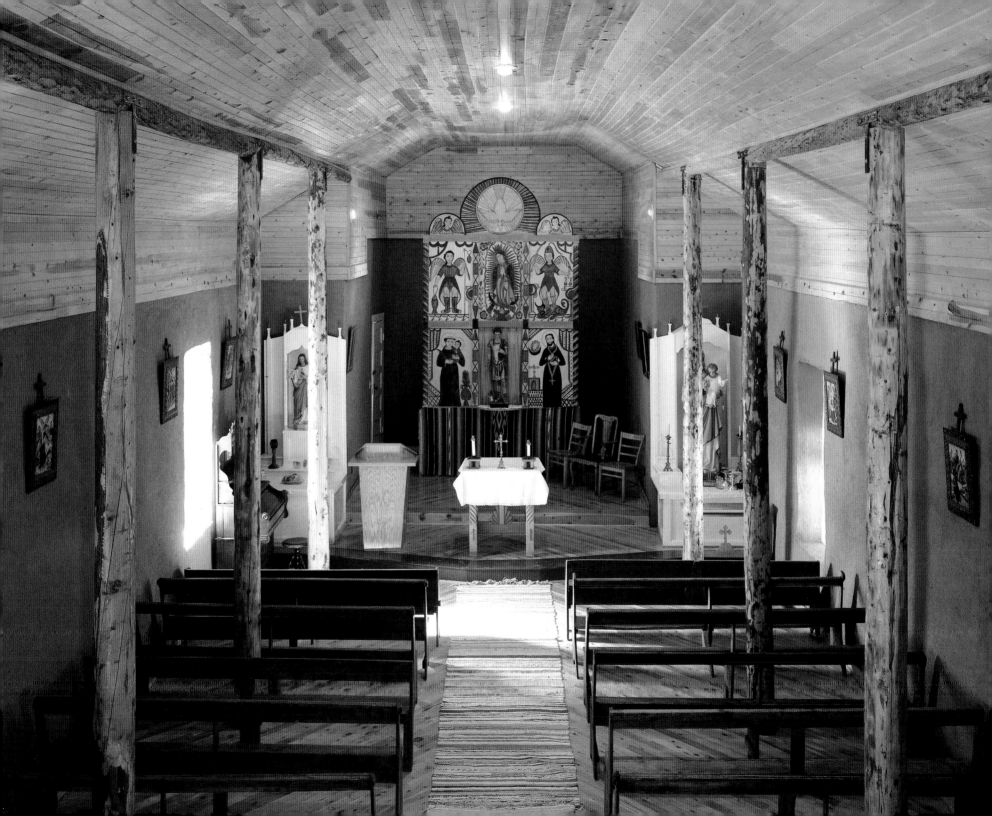

THE CHURCH OF SAN ACACIO
San Acacio, Colorado

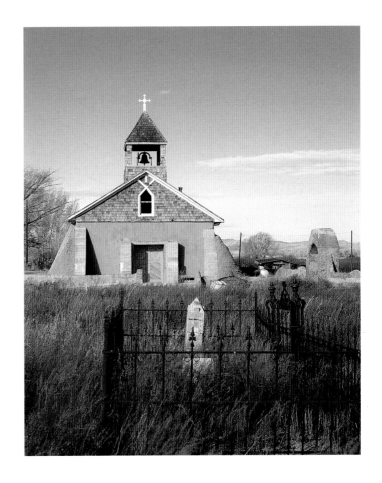

The church of San Acacio is the oldest standing church in Colorado. The village is about sixty miles north of Taos, New Mexico, in the extensive San Luís Valley, which marked the northernmost boundary of Spanish exploration. Missionaries and explorers had traveled here since the mid-sixteenth century, but no permanent settlements were made until the middle of the nineteenth century. Then, as ever, the heart of each new town was the church. The cohesion of these Hispanic communities was short-lived, however. Settlement by Anglo-Americans and other ethnic groups followed agricultural development and the construction of railroads in the area.

Few adobe buildings have survived in Colorado. Those that still stand, although constructed late in the Mexican period, are representative of New Mexican adobe vernacular design. Typical details include glass windows, milled lumber, gabled roofing, and pediments over windows and doors. The church of San Acacio was built in the 1860s and is a very simple affair: Adobe walls some thirty-six inches thick support a pitched wooden roof.

ABOVE *The church of San Acacio stands in a yard surrounded by a low wall. Buttresses at the door and corners help the adobe walls carry the weight of the wooden roof and the little bell housing.*

FACING PAGE *Milled beams from the San Luís Valley support the wooden roof. A long rag runner leads to the remodeled sanctuary. The altar rail has been removed and a new, smaller altar set up. The old pump organ still stands against the left wall. Every detail speaks of the care and devotion with which this church is maintained.*

The ongoing renovation of this church is a joint effort by both paid laborers and volunteers working under the guidance of local designer Arnold Valdez. Many of the features that make this project such a success reflect the community's deep commitment to preservation and the current movement to revive traditional crafts in San Luís Valley. The new altar was built in regional style; the rugs were woven and the walls were mudded by women in the area. The new altar screen was painted by Maria Cash de Romero of Santa Fe, a *santero* who comes from a noted family of traditional artists.

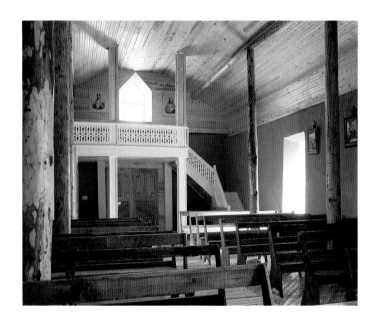

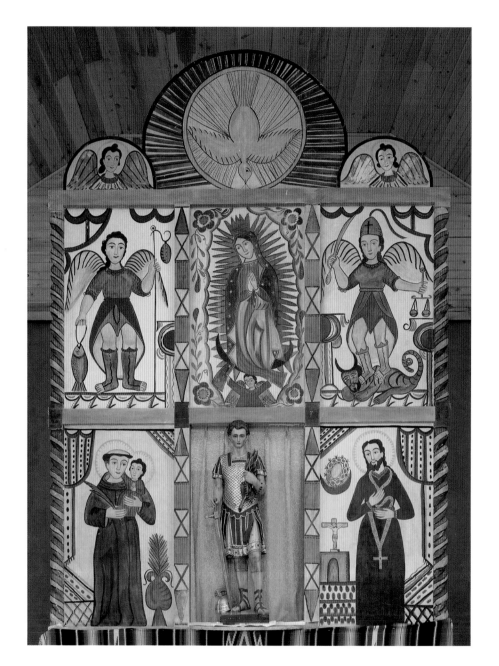

RIGHT *A Catholic graveyard is set apart by solemn consecration. The parish plans to restore the original adobe wall to replace the barbed wire and weathered poles. Inside the cemetery, some family plots called* cerquitas *are further delineated by fancy Victorian fencing. Most of the graves are marked by simple carved stones.*

FACING PAGE, LEFT *The railing of the choir loft at the entrance of the church is typical carpenter's scroll-work. Here and elsewhere, such Victorian details are later additions to the buildings. This railing dates from the beginning of this century.*

FACING PAGE, RIGHT *The altar screen is contemporary work painted by Maria Cash de Romero of Santa Fe. At the top, the Holy Spirit descends in the form of a dove, flanked by angels. Below, the Virgin of Guadalupe stands between the Archangels Raphael, with his fish, and Michael, with the scales of judgment. In the center of the lower row, a modern statue of San Acacio, an early Christian martyr, is joined by Saint Anthony of Padua on the left and Saint Cajetan on the right. Saint Cajetan is depicted because members of the Theatine order, which he founded, serve here and in other Colorado parishes.*

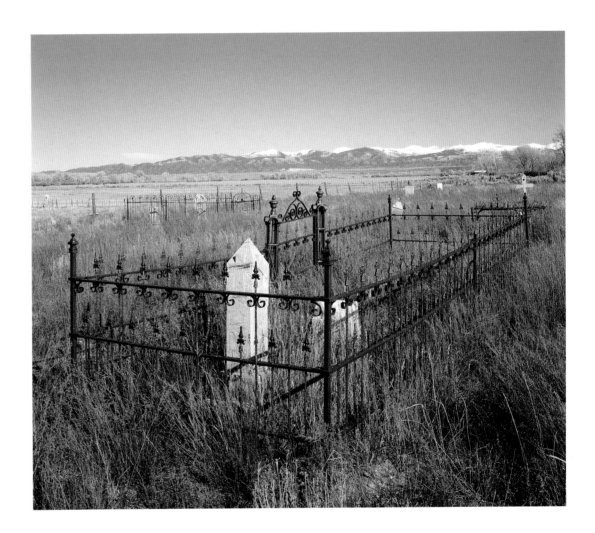

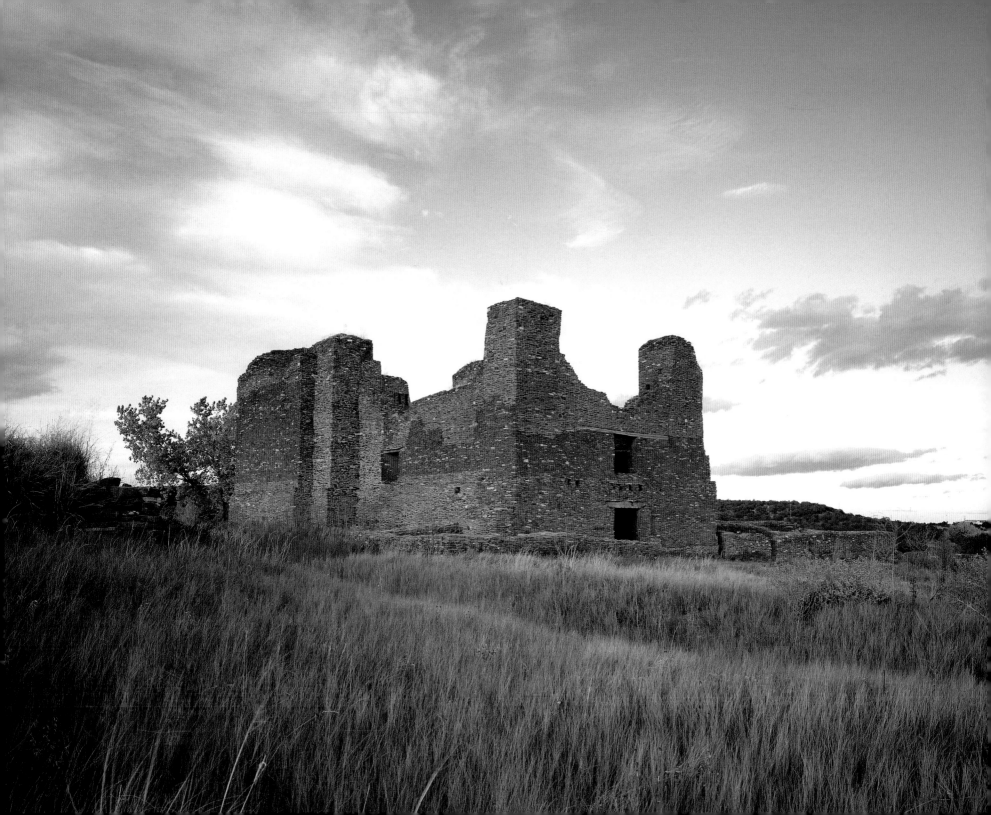

ABANDONED CHURCHES OF NEW MEXICO

Some of the most splendid missions of the Southwest now stand in ruins: mysterious, isolated places that have long been the focus of curiosity, fantasy, and speculation. Although they are presented here as a group, these once-prosperous settlements declined for a variety of reasons before they were finally abandoned, including prolonged drought, constant attack from hostile tribes, and a sharp decrease in economic activity. Modern efforts to stabilize and preserve these abandoned churches have required historical and archaeological study that has shed the light of history on these ruins, but has not stripped them of their romance. They continue to inspire visitors to imagine the once-flourishing life at these still-impressive settlements.

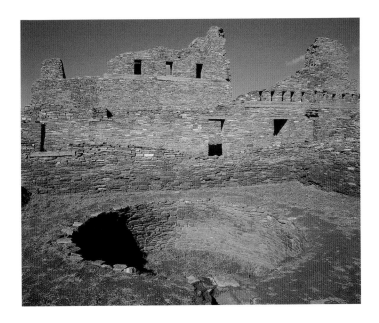

ABOVE *Although this adobe arch at Pecos was constructed by a stabilization crew in the early 1900s, it recalls Spanish stone arches of the Visigothic period.*

LEFT *The kiva in the* convento *at Abó. The scale of the* convento *buildings can be seen from the ruins in the background. The depressions in the wall are sockets for timbers to support the second floor.*

FACING PAGE *The Quarai church was named in honor of the Virgin of the Immaculate Conception. In the courtyards of the* convento *attached to this church are two kivas, one round, the other square. A square kiva is very unusual, and no one has been able to explain its presence here.*

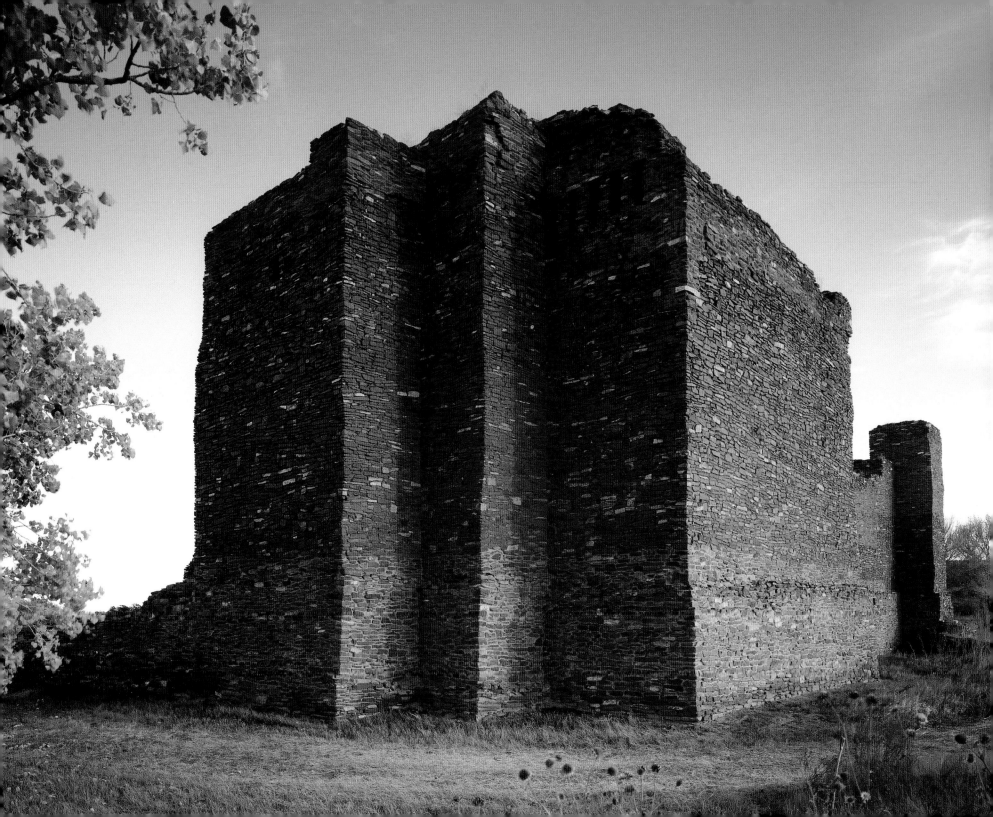

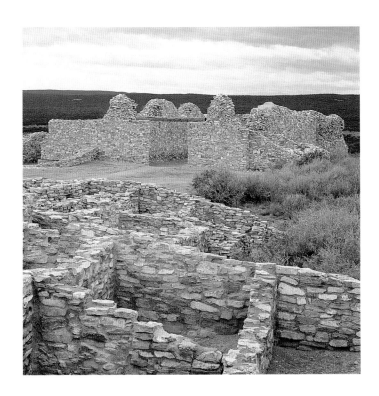

SALINAS PUEBLO MISSIONS
NATIONAL MONUMENT

Three sites of large stone ruins — Abó, Quarai, and Gran Quivira — make up the Salinas Pueblo missions. Built between 1630 and 1660 by the Piro and Tiwa Indians, they were conceived on a grand scale and include some unique features. At Abó and Quarai, kivas were built into the courtyards of the *convento*. They were presumably put in place before the padres' attitudes toward the religious and social activities in the kivas had hardened into active opposition, but scholars can offer only hypothetical explanations and their presence here remains a mystery. These pueblos were abandoned in the 1670s, after serious droughts, epidemics, and increased attacks by hostile tribes from the plains had decimated their population.

ABOVE *At Gran Quivira, the friars' residence was built first, and work on the church proceeded more slowly than usual. Thus, the church, dedicated to the Franciscan Saint Bonaventure, was unfinished when the site was abandoned. In the foreground are the ruins of the pueblo buildings.*

RIGHT *The Abó Mission was named for Saint Gregory. By reinforcing the exterior of the walls with buttresses and using the* convento *buildings to brace the inner side, the Piro Indian builders were able to make the stone walls of the church remarkably thin.*

FACING PAGE *Foundations seven feet deep and six feet wide were required to support the red sandstone walls of the church at Quarai. The sanctuary and transept, shown here, were higher than the nave, allowing for a transverse clerestory window. The church faces south, so the altar area was bathed in light throughout the day.*

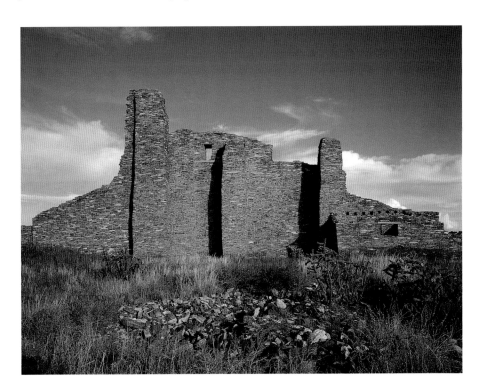

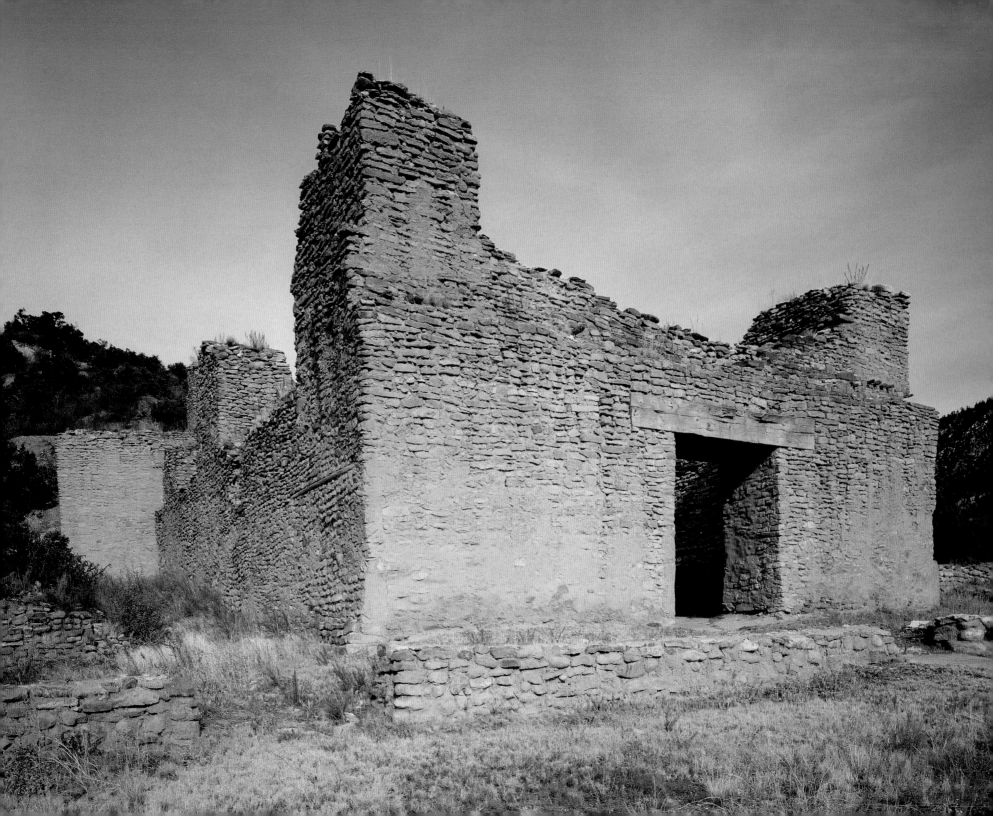

JEMEZ STATE MONUMENT

The church of San José de los Jemez near Jemez Springs seems to have been constructed with defense in mind. Even in ruins, it has a military feeling. Built in 1626, it was abandoned less than a decade later. Missionary efforts at the Jemez Pueblo were not very successful. One of the seventeenth-century Franciscans here, more perceptive than many of his colleagues, said, "We cannot preach the Gospel now, for it is despised by these people on account of our great offenses and the harm we have done them."

One of the attractions of this site, both to the original builders and to contemporary visitors, is the presence of hot mineral springs that continue to be used for bathing.

BELOW *A stone tower with an observation room at the top was part of this complex and must have emphasized the fortresslike character of Mission San José de los Jemez. The lower portion of the tower still stands.*

FACING PAGE *The wood lintels and trim at the doors, although they duplicate original construction, are modern replacements, part of the stabilization of these ruins.*

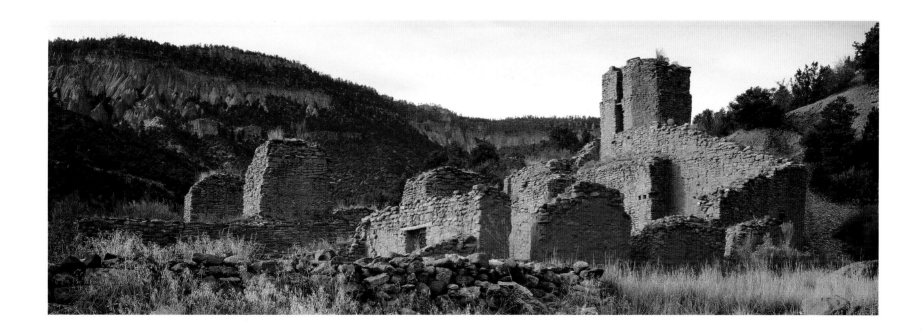

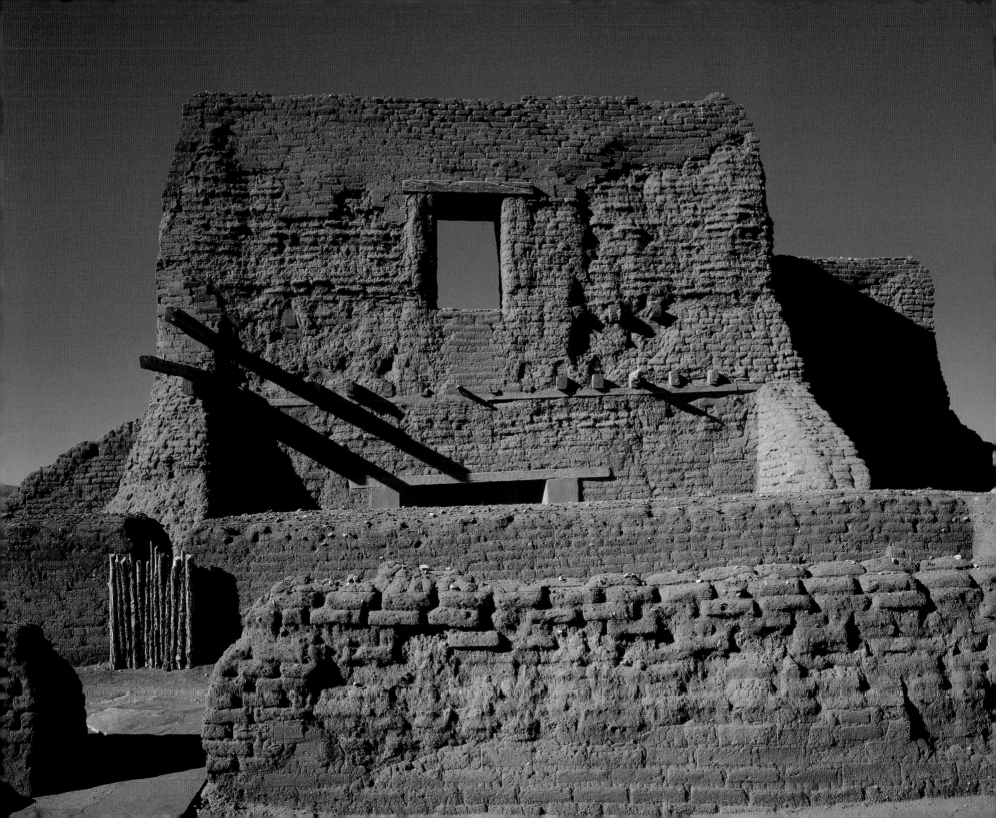

Pecos National Historical Park

Pecos, the largest native American pueblo in the Southwest, was an important center of trade and the site of very early missionary activity. By the 1620s the largest European building north of Mexico stood here. Ironically, this huge church was named Nuestra Señora de los Angeles de Porciúncula, after the first Franciscan church, a chapel in Assisi. In the Pueblo Revolt of 1680, angry native Americans reduced this enormous building to a pile of rubble.

What stands here now are the remains of a church begun in 1706 and constructed entirely on the mound created by the ruins of the destroyed church. When the pueblo was abandoned in 1838, this church was in reasonably good condition. Its present state is the result of settlers plundering the building for its wood and adobe bricks.

In 1967, the foundations of the 1622 church were discovered. Until then, the present ruins had been taken for the seventeenth-century church, and the accounts of its enormous size were thought to be exaggerated.

ABOVE *Visitors to the Pecos Pueblo have the unique opportunity to enter this kiva. Kivas at occupied pueblos are still in use and entry is not allowed. Prayers were offered, religious instruction was given to the young, and initiation rites were celebrated in these underground chambers. A pueblo might have several kivas, serving individual clans and societies, whose members also use the kiva as a workroom and clubhouse.*

LEFT *The rise on which the present ruins stand is what remains of the adobe church of 1622. The foundations of the earlier church can now be seen underneath the later construction.*

FACING PAGE *Until the 1880s the church of Nuestra Señora de los Angeles at Pecos was still roofed and in fairly good condition. Looking across the ruins of the sacristy in the foreground, one can only imagine how the light must have poured into the transept from this high window.*

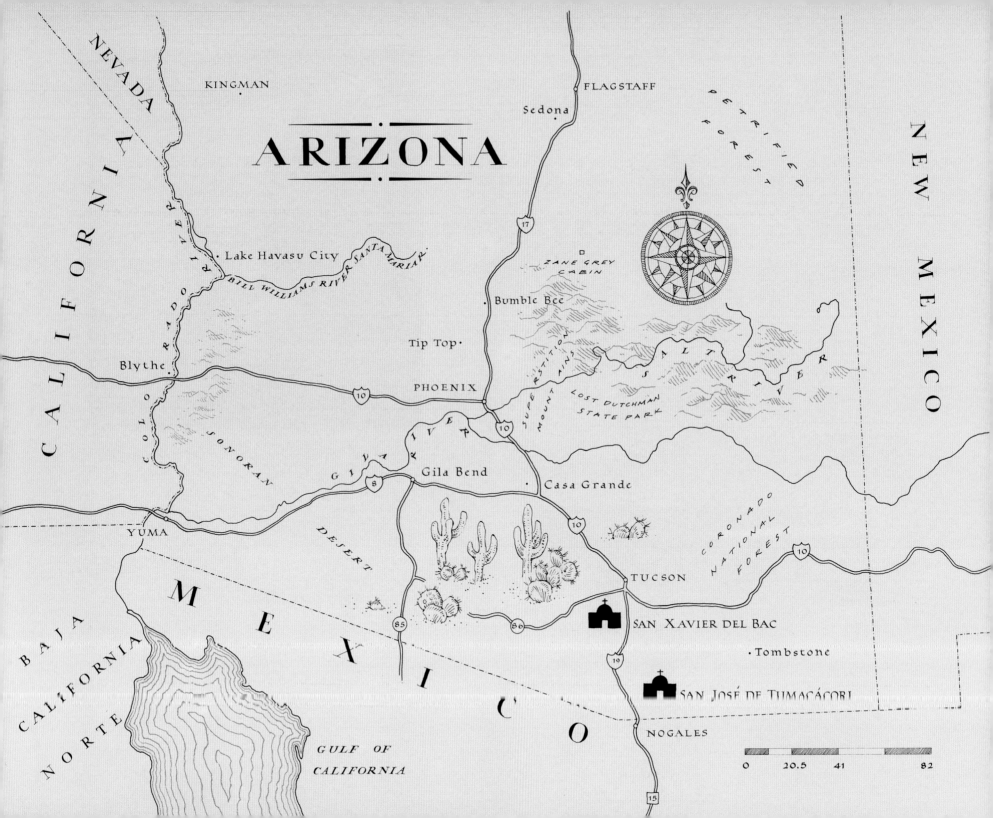

CHURCHES OF ARIZONA

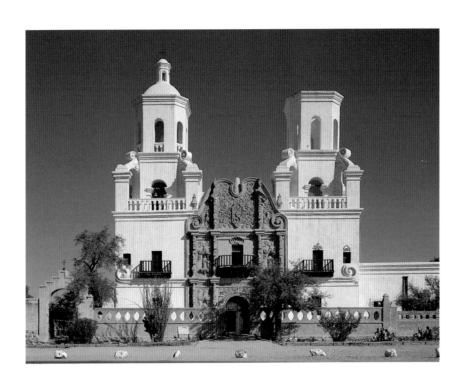

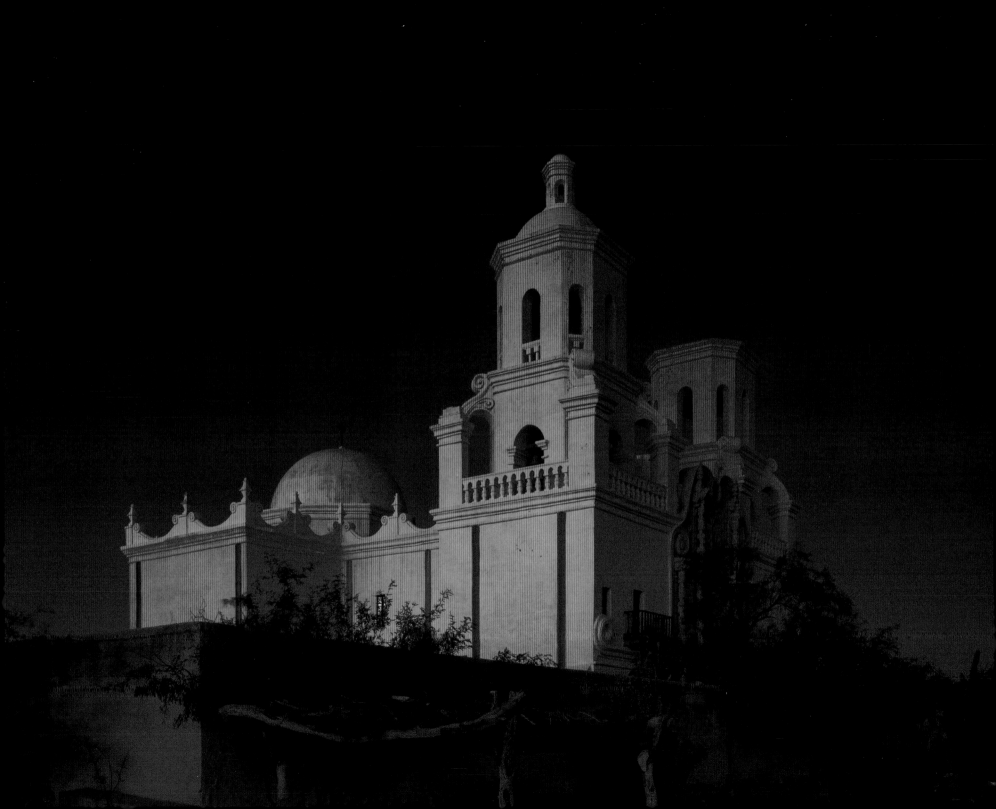

Mission San Xavier del Bac
Tucson, Arizona

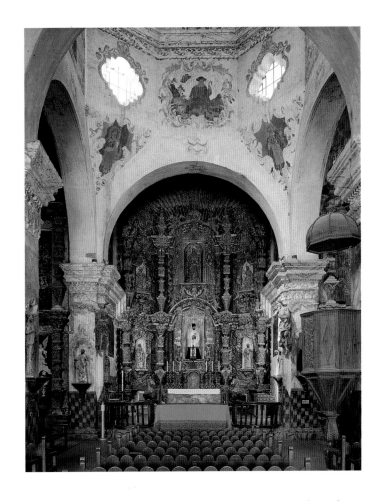

Widely regarded as the most distinguished Spanish Catholic church in North America, San Xavier del Bac rises against the blue sky and the dark mountains in the distance like a gleaming white vision on the desert plain. It is one of the few remaining missions associated with the Italian Jesuit missionary Eusebio Kino. His remarkable intellectual gifts, his respect for native peoples, and the care he took to protect them from abuse by the Spanish military authority characterized his efforts in Pimería Alta, the upper lands of the Piman Indians, where he labored until his death in 1711.

On a visit to outlying villages in 1691, Kino received a delegation that included men from Tumacácori and Bac, inviting him to visit their settlements. The next year, he visited Bac and was so impressed with its possibilities that he named it for his own missionary patron, Saint Francis Xavier, the Jesuit "Apostle of the Indies."

On April 28, 1700, Kino wrote in his diary: "We began the foundations of a very large and spacious church and house of San Xavier del Bac, all the many people working with much pleasure and zeal, some in excavating the foundations, others in hauling many and good stones of tezontle from a little hill which was about a quarter of a league away."

ABOVE *The roof of Mission San Xavier del Bac is a series of domes, but only the one at the crossing rises above the roofline, and it rests on a drum pierced with four elaborately detailed baroque windows. This dome is fifty-two feet high.*

FACING PAGE *A view at sunset shows the elegant proportions of the church. The name of the master builder is not known, but it may have been Pedro Bojorquez, who carved his name and the year 1797 in the sacristy door.*

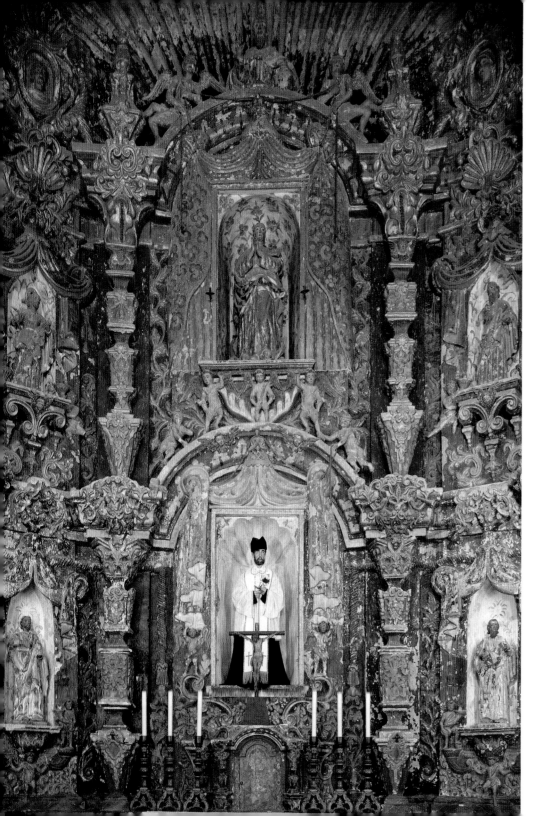

Kino's "very large and spacious church" was apparently never completed. It was only after 1756 that a Jesuit built an adobe church here, one that remained in use until 1767 when the order was suppressed and Jesuits in Spanish territories were arrested and expelled by order of King Carlos III. The Jesuit missions in Arizona were then consigned to the Franciscans, who began construction of the present church about 1778. When the church was completed in 1797, a few furnishings brought to Bac by earlier Jesuits were installed.

The plan of this grand church is cruciform, and it is roofed with a series of five domes on squinches, all carried on high arches. The walls are constructed of burnt brick on stone foundations, with molded brick cornices. The ornamental brick is colored to represent glazed tile and marble.

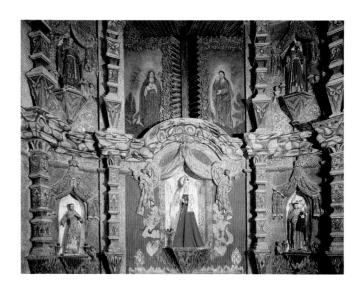

FACING PAGE, LEFT *The reredos looks like carved wood, but is made*
of fired brick, with gilded stucco and plaster. At the top, God the Father gives
his blessing as he holds the orb of the world. The flowered niche holds the
image of the Virgin of the Immaculate Conception, with the crescent moon
barely visible at her feet. A niche below holds the statue of Saint Francis
Xavier, one of the earliest Jesuit missionaries and the patron of this church.
The fully carved head and hands, together with the body frame, were ordered
from Mexico City in 1759.

FACING PAGE, RIGHT *The focus of the splendid altar screen in the*
side chapel is the vested bulto *of Our Lady of Sorrows dressed in silk and*
lace. Wealthy women used to give their ball gowns to the church to be recut
into vestments for both priests and statues. Many of the images to be vested
were only rudimentarily carved, on the principle that the carving would
not be seen under the clothing. Providing clothing for the statues is still
regarded an act of piety; today the lace may be machine-made and the brocade
polyester, but the devotion is as strong as ever.

RIGHT *The baptistry at the base of the west tower is still in use. The*
covered copper basin from the Jesuit period is set into a later stucco base. The
cabinet in the far wall intrudes into a painted dado that imitates tile work.
The rope hanging in front of the cabinet is used to ring the bell in the tower.

BELOW RIGHT *The holy water in this stoup at the entrance represented*
the material and spiritual life force of water, and must have been a potent
symbol in this desert oasis. The stoup, which resembles a conch shell supported
by the bust of a cherub, has been worn smooth by years of people brushing
against it while dipping their hands into the basin to bless themselves. The
design of the dado surrounding the stoup is original to the mission; restoration
has intensified the colors.

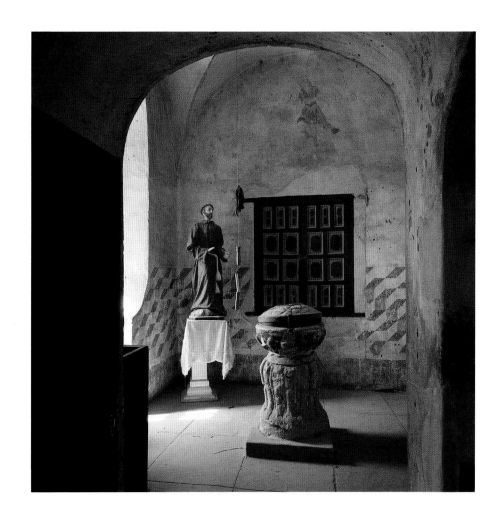

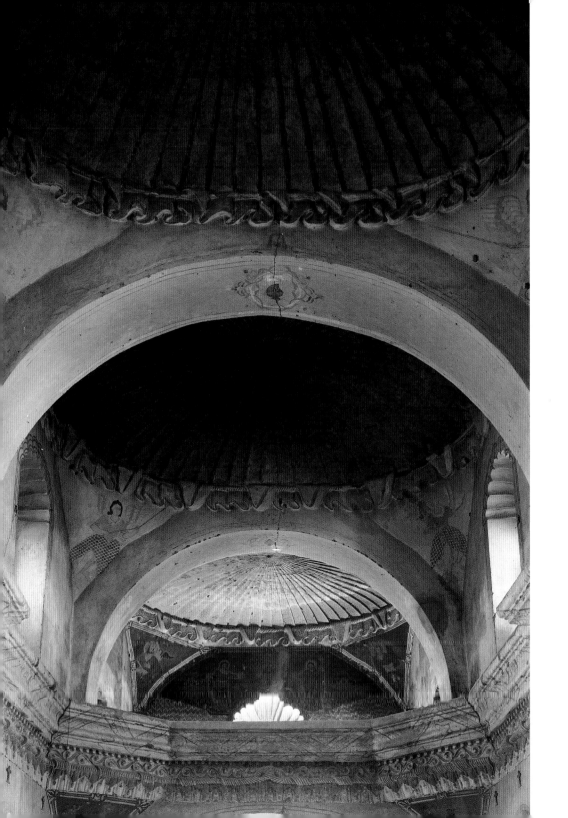

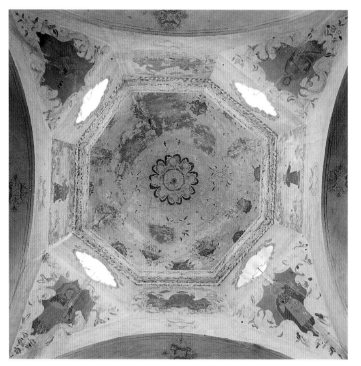

ABOVE *Images of the four Latin Doctors of the Church appear in the supports of the dome over the crossing. Portrait busts of the saints in a stylized floral setting, now barely visible, once covered the interior of the dome.*

LEFT *The domes in the nave are ribbed to imitate folds of cloth that are gathered at the base with a cord. These details are probably meant to recall the Franciscan habit. The cord continues into the painting in the squinches, where it is tied up by angels. The squinches of the far dome over the choir loft carry the traditional pictures of the Evangelists. Matthew, left, and Mark, right, sit with their symbolic images, winged figures of a man and a lion, respectively.*

RIGHT *At the center top of the detailed façade are the Franciscan coat of arms, flanked by the monograms of Jesus and Mary set into cartouches surrounded by plant ornament in relief. Heraldic lions at each side leap away from the center. The tower to the right was never completed.*

BELOW *This molded plaster volute on the tower shows the depth of the raised ornament on the façade. Otherwise, the towers are remarkably plain and make the sculpted façade of the nave appear even richer. The only timber used in the church is trim: the spindles in the windows, balcony railings, doors, and frames.*

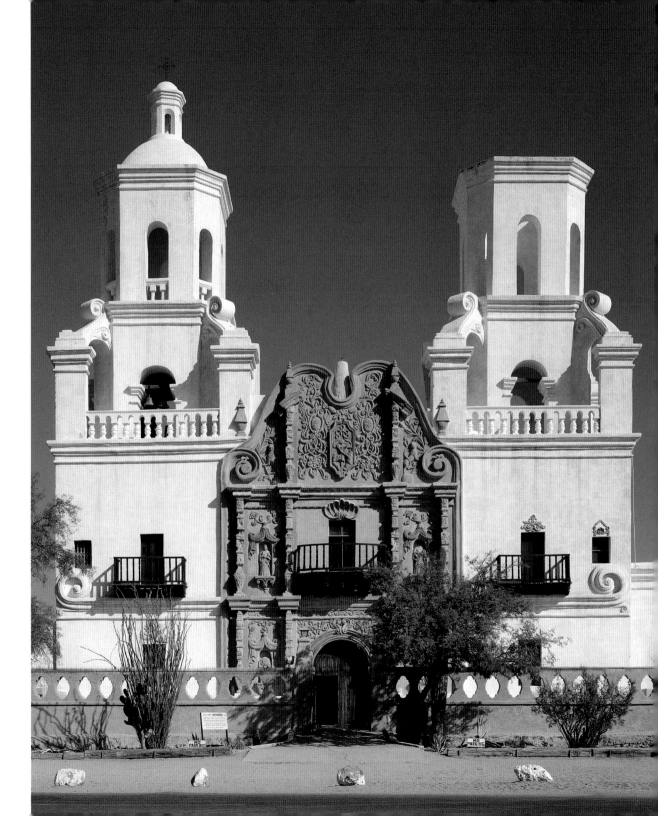

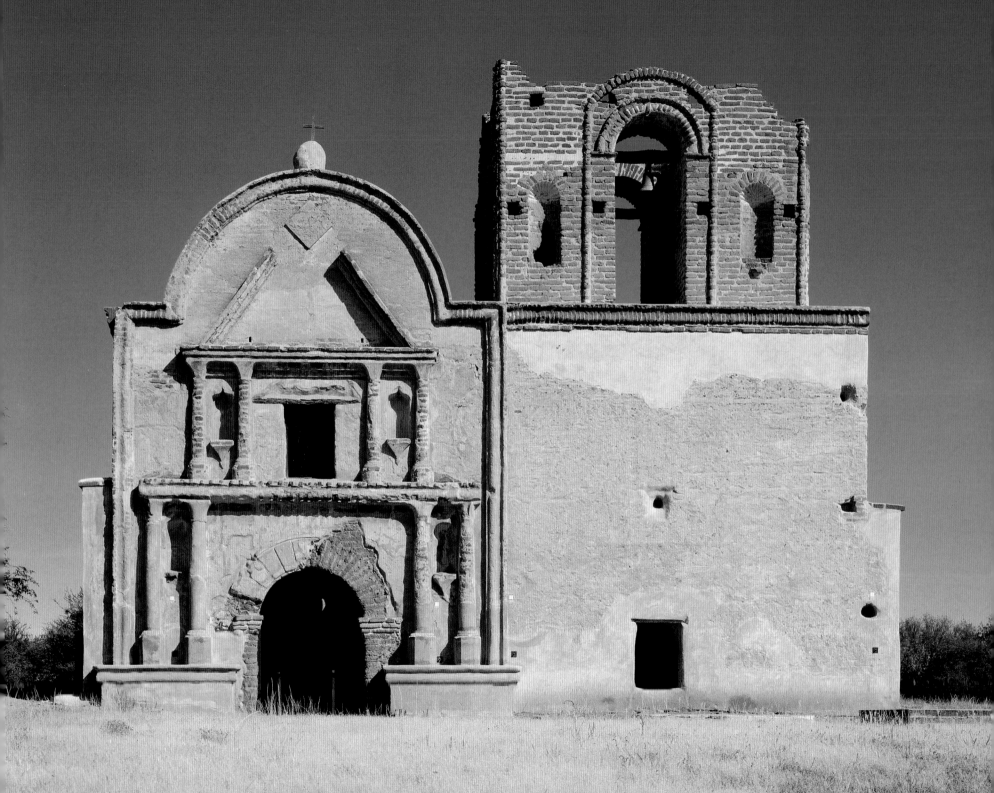

MISSION SAN JOSÉ DE TUMACÁCORI
Tumacácori National Historical Park
Tumacácori, Arizona

The Jesuit Father Eusebio Kino founded Tumacácori in 1692 as one of a proposed chain of missions. The first services were held in a grove of trees until an adobe house was built. Although Tumacácori was an important station both for the Jesuits and for the Franciscans, who assumed responsibility for the Jesuit missions when the Jesuit order was suppressed in 1767, it never prospered, and was overshadowed architecturally and financially by San Xavier del Bac.

In 1799, construction of the present building began. The first plans called for a cruciform church roofed with vaults and domes, with twin bell towers on the façade, as at San Xavier del Bac. Money was scarce, however, and as work proceeded, the scale of the project was reduced. The sanctuary dome was completed, but the nave was covered with a flat roof. The transepts were scrapped entirely and a single bell tower was considered to be sufficient. In 1822, the walled cemetery and its circular chapel were blessed, and the church, although unfinished, began to be used.

The fortunes of the mission gradually worsened, and the last priest had left by 1828, but a small community of native Americans maintained mission life until 1848, when Apache attacks forced them to evacuate. The adobe church fell into ruin until its modern stabilization saved what now remains.

ABOVE *The remains of the sanctuary at San José de Tumacácori, brightly lighted from the high windows under the dome, only hint at the original rich decoration. The outline on the wall marks the location of the altar screen. Remnants of plaster still cling to the adobe brick.*

FACING PAGE *The graceful curve of the false gable on the façade of the church was meant to project above the proposed vault of the nave. An oddly proportioned broken pediment carried by pairs of engaged columns supporting an architrave fills the façade and frames the entry. The building was originally painted.*

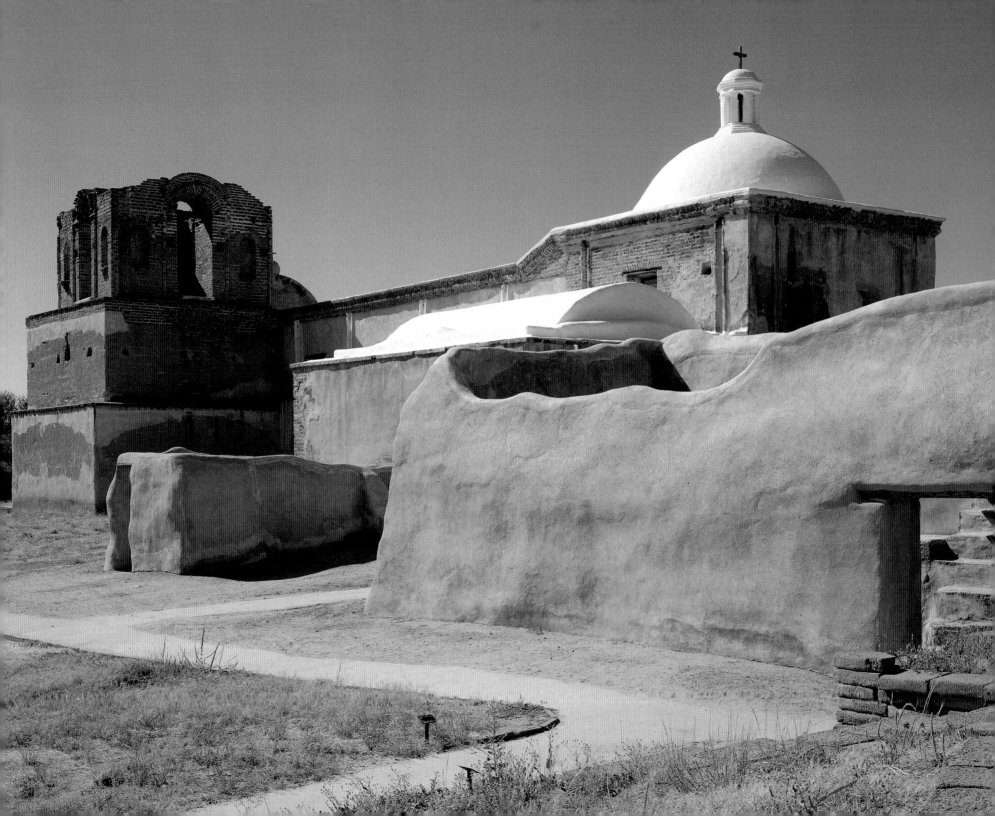

RIGHT *The higher the dome rises, the more it approaches a hemispherical shape, but at its base it is clearly not a true circle. The lantern, an important decorative detail on the exterior of the dome, is false and does not communicate with the interior.*

BELOW RIGHT *The mortuary chapel was a rotunda probably meant to carry a dome. In Christian tradition, such circular buildings almost always recall the Church of the Holy Sepulchre in Jerusalem, originally a similar construction over the traditional site of Christ's grave. A chapel in the shape of the shrine of the Resurrection seems perfectly appropriate for a cemetery.*

FACING PAGE *The sanctuary, under the dome, is higher than the nave. This difference would have been made up by the vaulted nave proposed in the original design. The bell tower, never completed, was possibly meant to rise to a smaller dome. The walls of the baptistry, at the base of the tower, are nine feet thick.*

BELOW *The base of the dome still shows its painted classical detail.*

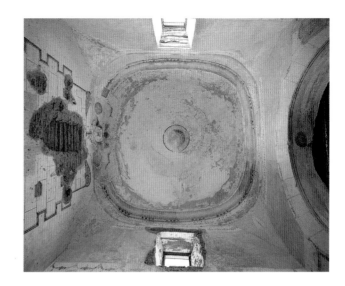

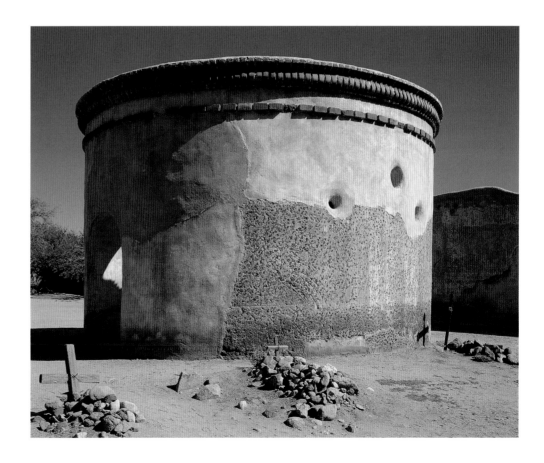

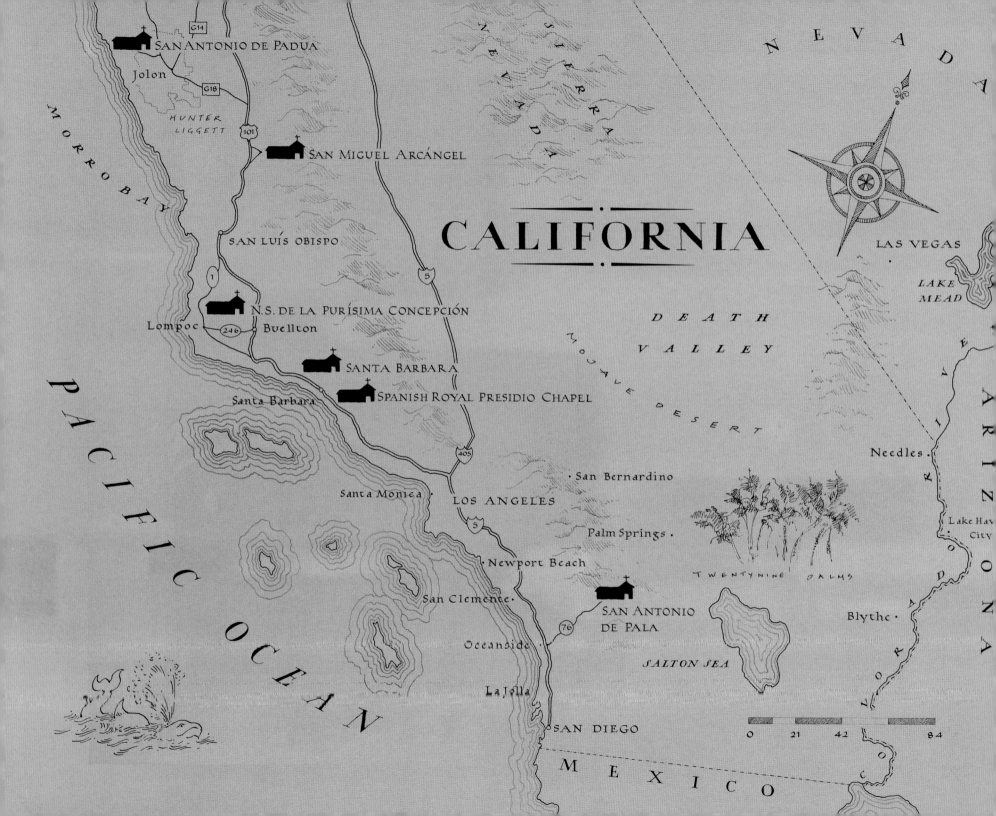

CHURCHES OF CALIFORNIA

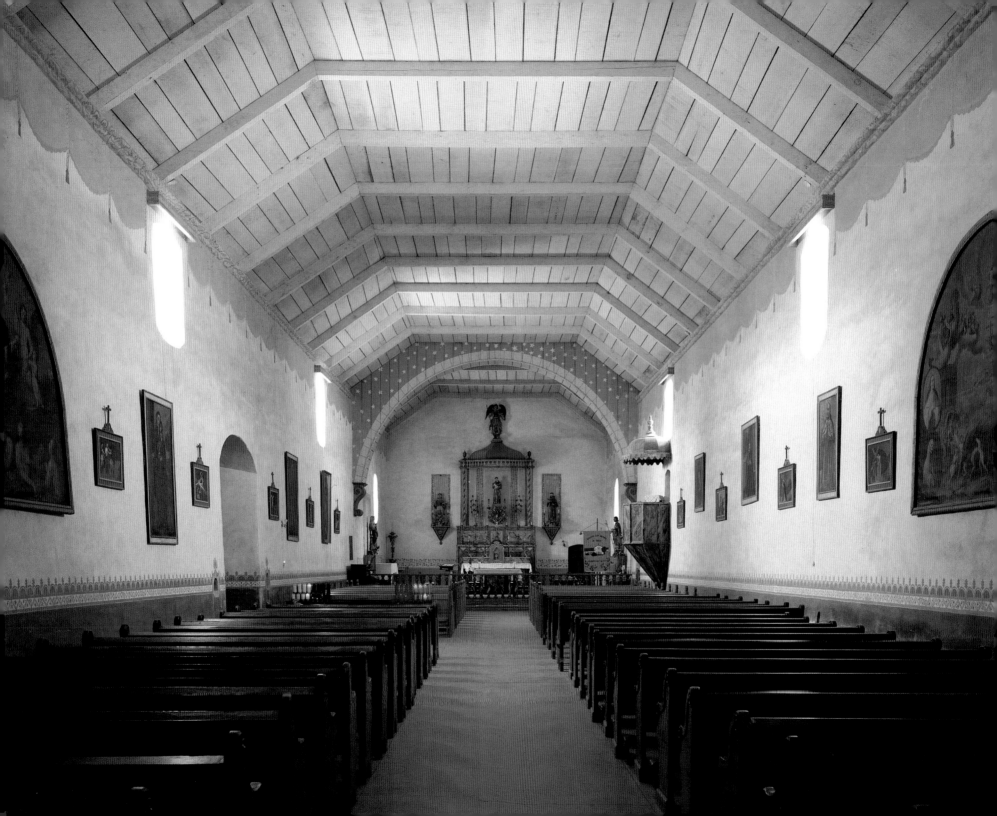

MISSION SAN ANTONIO DE PADUA
Jolon, California

San Antonio de Padua, the third mission in the California chain, was founded by Father Junípero Serra on July 14, 1771. Like the other missions, it was secularized in 1834, but a succession of priests served here until 1882. After that, the buildings fell into complete decay. The California Landmarks League restored the roof and walls of the mission church in 1904–05. Some of their work was destroyed in the 1906 earthquake, but the wooden roof and other repairs lasted from 1907 until 1948, when money from the Hearst Foundation and the Franciscan order allowed a thorough reconstruction. The church was restored, and the foundations of the central quadrangle were used for the mission-style construction of rooms for candidates for the Franciscan order.

One of the priests whom Father Serra assigned to San Antonio was Father Buenaventura Sitjar, who served at this mission for nearly forty years. Father Sitjar was a man of many talents who constructed the elaborate system that brought water to the mission grounds. In addition, he wrote a grammar of the local Salinian language and translated religious books for the use of native American neophytes.

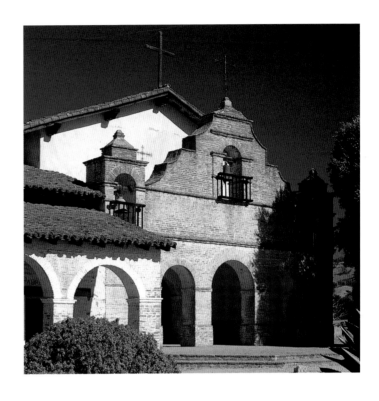

ABOVE *The distinctive campanario is really a bell wall and was an 1820 addition to enrich the plain façade of the church at Mission San Antonio de Padua at Jolon.*

FACING PAGE *The arched ceiling of wooden beams at this mission is unique among the California churches. Many of the images here had been kept in the homes of Salinian native Americans and Spanish settlers until they could be returned to the restored mission in the 1950s.*

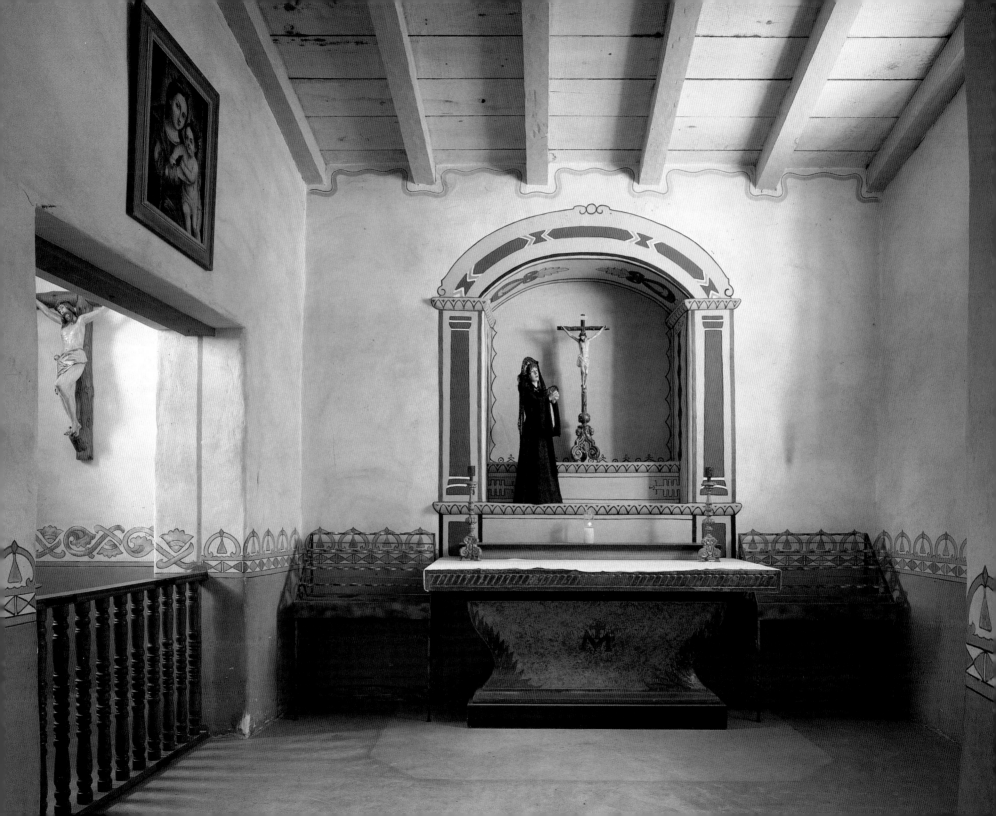

Now located on the Hunter Liggett military base, the mission is once again a Franciscan house, and its quiet setting, among lupine and poppies, delights visitors who are willing to go off the beaten path to find it. The archaeological features of undisturbed soldiers' quarters, native American housing areas, and prehistoric and historic native American village sites have led to a proposal to establish the surrounding area as a Historic Landscape and, eventually, a National Historical Park.

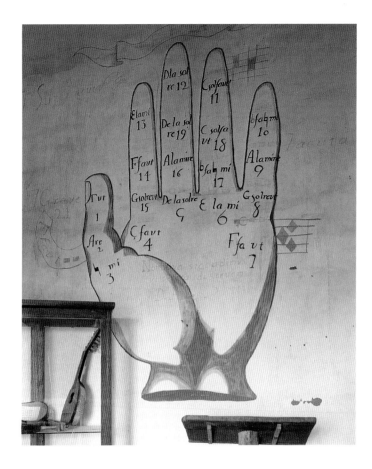

ABOVE *The hand painted on the wall was a traditional device used to teach musical intervals. Music was an important part of mission life, and padres trained the native American neophytes to sing, to play European instruments, and, with visual aids such as this, to learn the rudiments of musical theory.*

LEFT *A holy water stoup is set into the wall near the entrance. The niche is surrounded by painted decoration that combines native geometric ornament and natural details such as oak leaves with some very European drapery.*

FACING PAGE *A baptistry chapel adjoining the church contains an altar with a vested figure of the Sorrowful Mother contemplating a crucifix. The painting of the dado owes much to Indian design.*

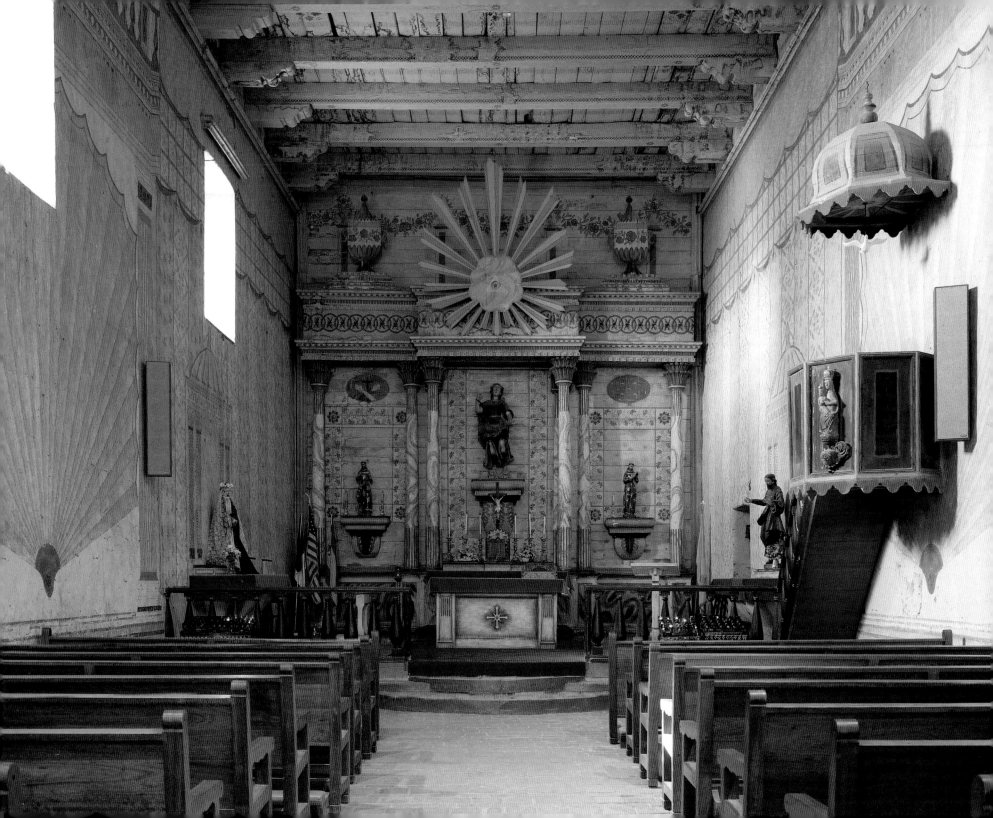

MISSION SAN MIGUEL ARCÁNGEL
San Miguel, California

In 1785, Father Fermin Francisco de Lasuén was officially appointed president of the Franciscan missions to succeed Father Serra. In the single year of 1797, he founded no fewer than four missions. Mission San Miguel Arcángel, named in honor of the Archangel Saint Michael, was located between the missions of San Luís Obispo and San Antonio de Padua. From the very beginning, the mission served a large congregation, and the buildings and ranching enterprises were conceived on a grand scale.

A disastrous fire in 1806 destroyed most of the supplies and many of the buildings, including the church. By the time the building of the new, grander church was begun in 1816, enough adobe and tile had been stockpiled so that construction was finished in only two years.

To decorate the new church, the priest in charge, Father Juan Martín, called on his fellow Catalonian, Estebán Munras, living in Monterey. Together with Indian neophytes whom he trained, Munras painted almost every surface with symbolic and floral designs. He seems to have taken many of his designs, especially the architectural features, from the pattern books used by many of the mission decorators. The result is one of the most richly decorated interiors of all the California missions. Thanks to fortunate circumstances, most of the decorative work we now see is original.

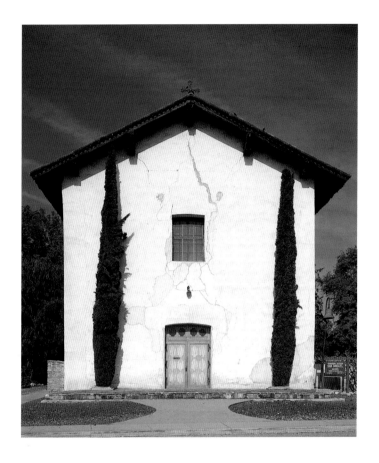

ABOVE *The smooth façade of the church at Mission San Miguel Arcángel, unrelieved by any architectural ornament, now shows a network of cracks, most of which are the result of earthquakes. The damage is a reminder of the fragility of these unreinforced adobe buildings. Several preservation groups help to maintain the mission.*

FACING PAGE *The altar screen against the rear wall of the sanctuary of the church is a rich pastiche of architectural elements. The capitals have a slightly Egyptian flavor, but the rest of the details are more or less classical in style. The all-seeing eye prominently displayed here is a symbol of the providence of God.*

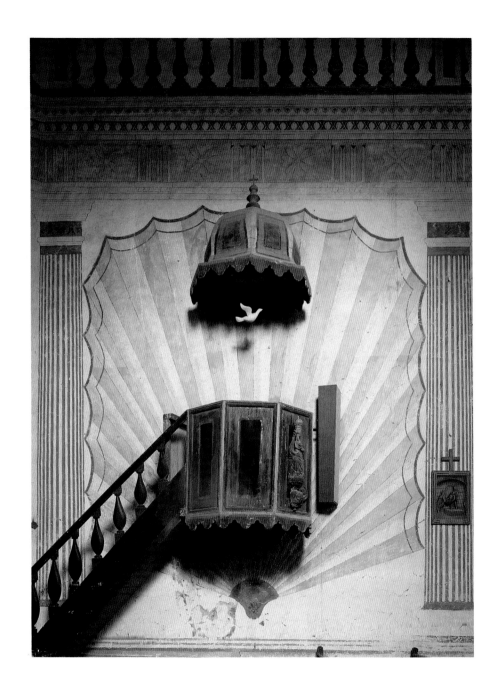

LEFT *To make themselves heard, early preachers relied on the height of pulpits, such as this one mounted halfway up the wall, and an accompanying sounding board. The dove of the Holy Spirit suspended from a burst of light refers to the inspiration of the Holy Scriptures that were read here. The image of the Virgin Mary as the "Seat of Wisdom" on the front panel is more unusual.*

BELOW *In ancient monastic tradition, common areas such as this covered corridor provided quiet places to read, to meditate, and to give religious instruction or counseling. Any monk or friar would feel at home with the order and simplicity of this long porch at San Miguel.*

FACING PAGE *The design of the fountain was based on an earlier fountain at Santa Barbara. It was added in the late 1940s when the courtyard was developed, along with a cactus garden, an olive crusher, and a small gristmill.*

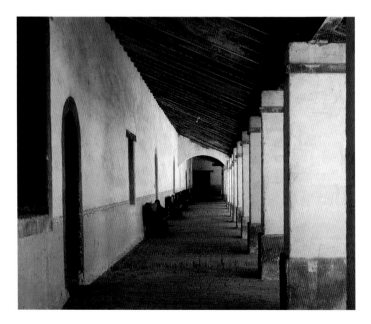

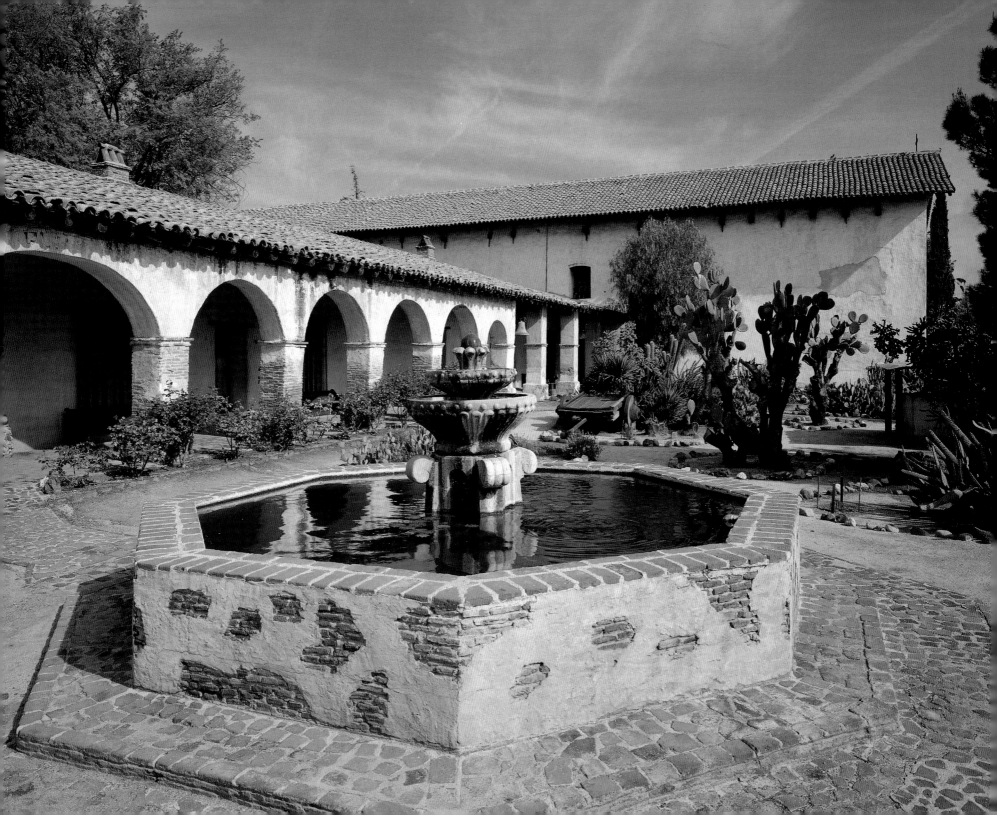

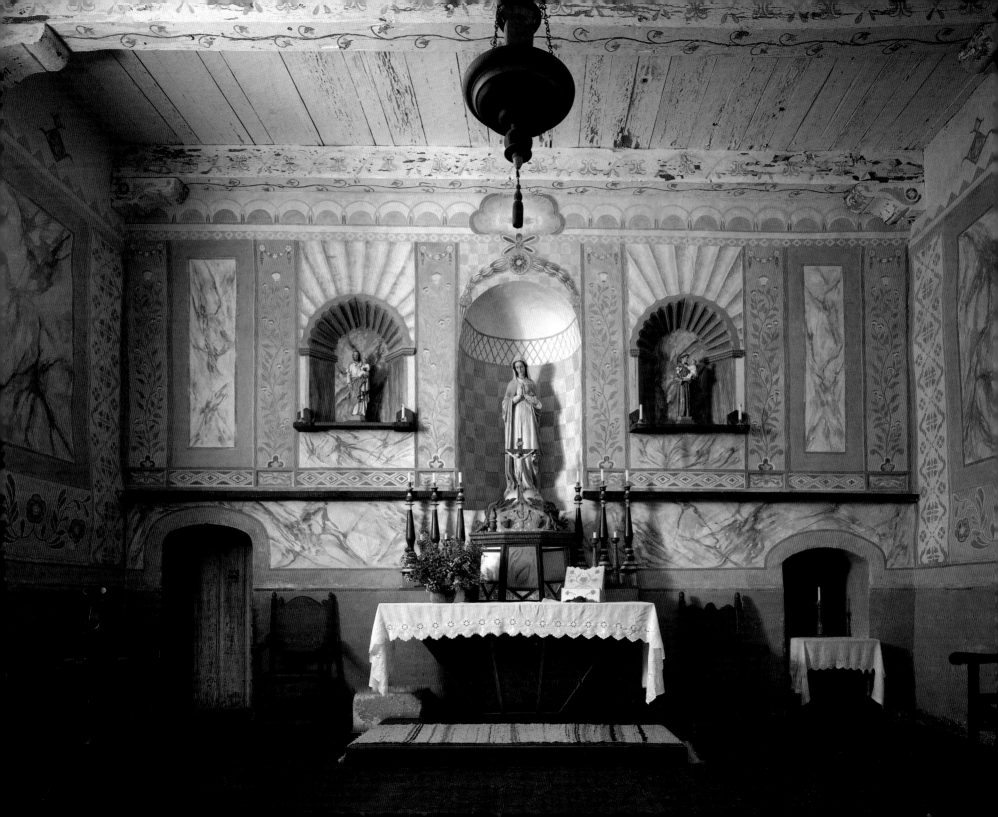

MISSION LA PURÍSIMA CONCEPCIÓN
La Purísima Mission State Historic Park
Lompoc, California

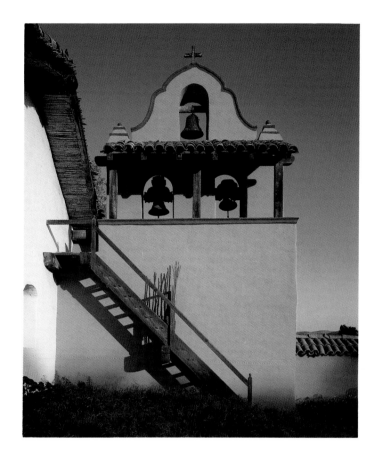

The mission of La Purísima Concepción was the eleventh of the California missions and one of the most prosperous. The first modest buildings constructed after the founding of the mission on December 8, 1787, were destroyed by an earthquake in December 1812. The mission was refounded in 1813, four miles north of the original location. The new site, a beautiful valley, looks much the same today as it did when the mission was built. In the spring, the land is covered with wildflowers, and swallows by the hundreds come to nest in the mission's eaves.

The new buildings were heavily reinforced against earthquake, and the layout of the mission is unique. Rather than being disposed around a court or cloister, the various elements are laid out in linear fashion. The reasons why this unusual plan was adopted are not clear; scholars speculate that the padres may have thought this arrangement would minimize earthquake damage. An elaborate irrigation system brought water from distant springs, and the enterprises of the mission prospered. A series of natural disasters, beginning with a drought in 1816–17, was followed by a revolt by the Chumash Indian community in 1824. The native Americans refused to pay the salaries of the soldiers after Mexican independence from Spain put an end to Spanish support for the army. A peace was negotiated by the pastor, but cruel reprisals

ABOVE *Mission bells were rung by moving the clapper, not the bell itself. Ringers at Mission La Purísima Concepción at Lompoc mounted a platform that provided a low wall to keep them from falling and a tiled roof to protect them from sun and rain.*

FACING PAGE *The false marble paneling, stenciled floral decoration, and painted architectural ornament around the niches of the restored sanctuary duplicate the fathers' attempts to impart the richness of European churches to those of the New World.*

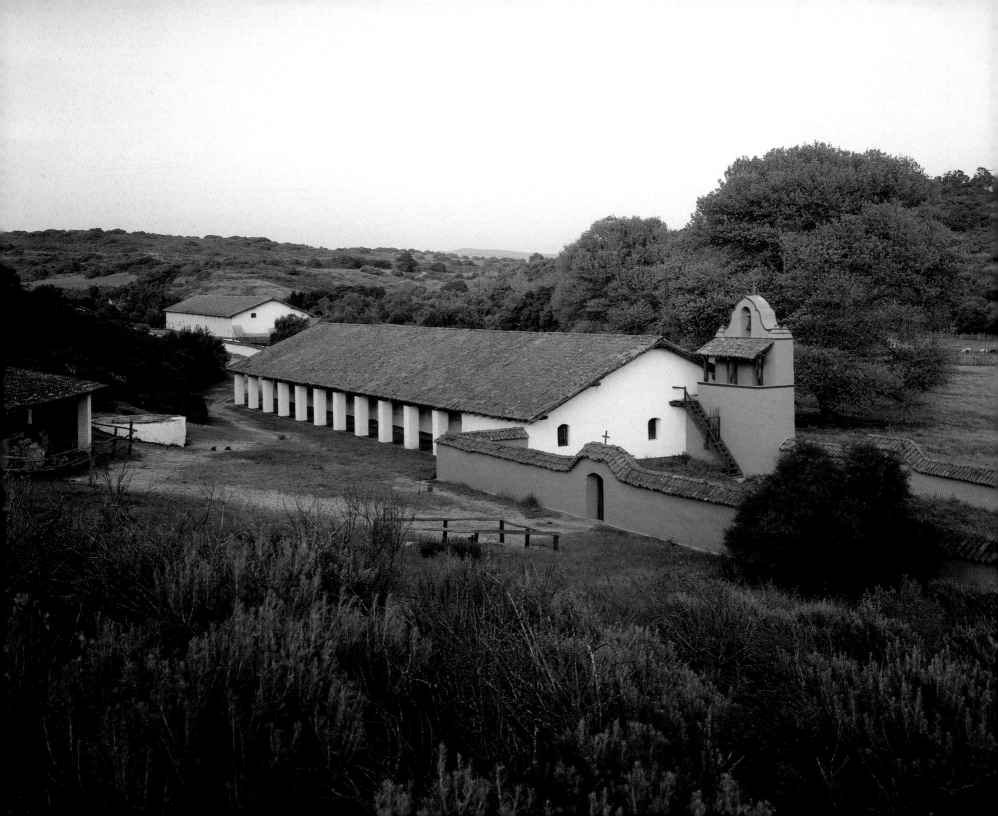

by the civil authorities followed. In 1833 the mission was secularized, and the buildings were sold in 1845 after a smallpox epidemic had virtually eliminated the native population. The buildings then fell into ruin.

The mission was rebuilt by the Civilian Conservation Corps from 1934 to 1941, following the same plan and using the same methods as the eighteenth- and nineteenth-century builders. Now a nine-hundred-acre state park, La Purísima Concepción is the most completely restored mission complex, with its original aqueduct system, and with livestock and planted grounds that reflect the period.

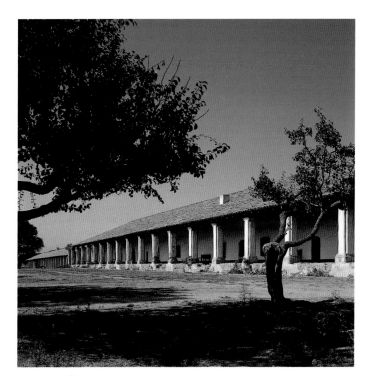

ABOVE *In the restoration of the 1930s, workers of the CCC employed virtually the same simple adobe construction techniques used by the Chumash Indians who built the original buildings.*

LEFT *A California Mission—style bench stands in the nave against a brightly painted wall. The decorative pattern appears to be a European design adapted by the local painters.*

FACING PAGE *No good reason has been given to account for the linear plan of the mission. The usual arrangement placed an enclosure like this one on the long side of the church. The pink paint of the cemetery wall and the campanario was mixed to reproduce the color of the original whitewash, which was tinted with iron oxide.*

111

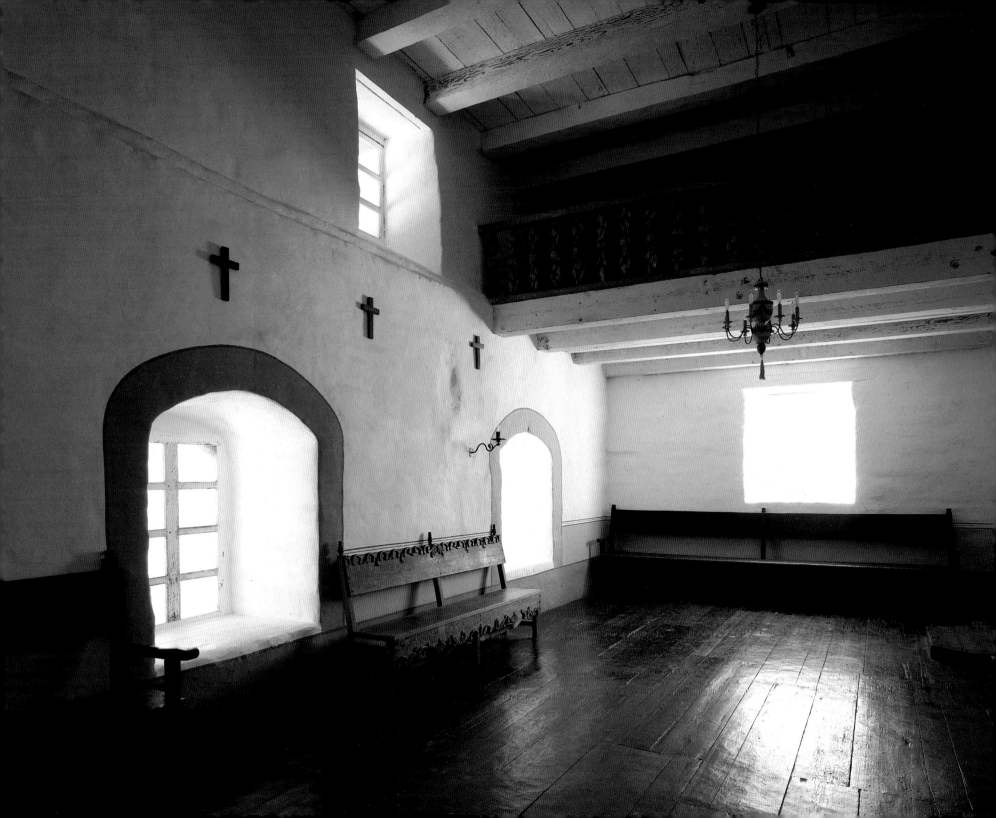

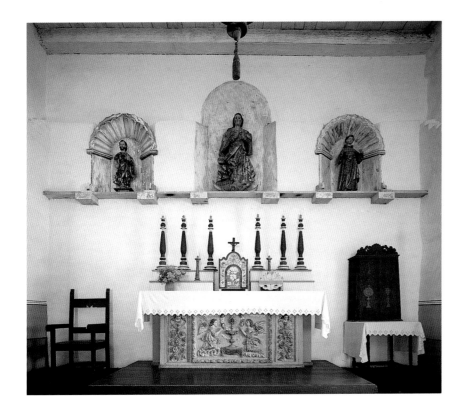

ABOVE *Mexican statues of Saint Joseph, the Virgin of the Immaculate Conception, and Saint Anthony of Padua stand in niches over the altar in the padres' quarters. Sacred vessels were stored in the wooden case to the right of the altar.*

RIGHT *Richly decorated confessionals like this one are still used in Spanish churches. The priest sits inside the low enclosure to hear the confession of sins by penitents, who kneel on either side and speak through grilles.*

FACING PAGE *The chapel in the padres' quarters includes a loft for singers and musicians. Fourteen wooden crosses on the wall mark the Stations of the Cross, in remembrance of stops along the road Jesus walked to Calvary in Jerusalem, where other Franciscans serve as care-takers for Catholic shrines.*

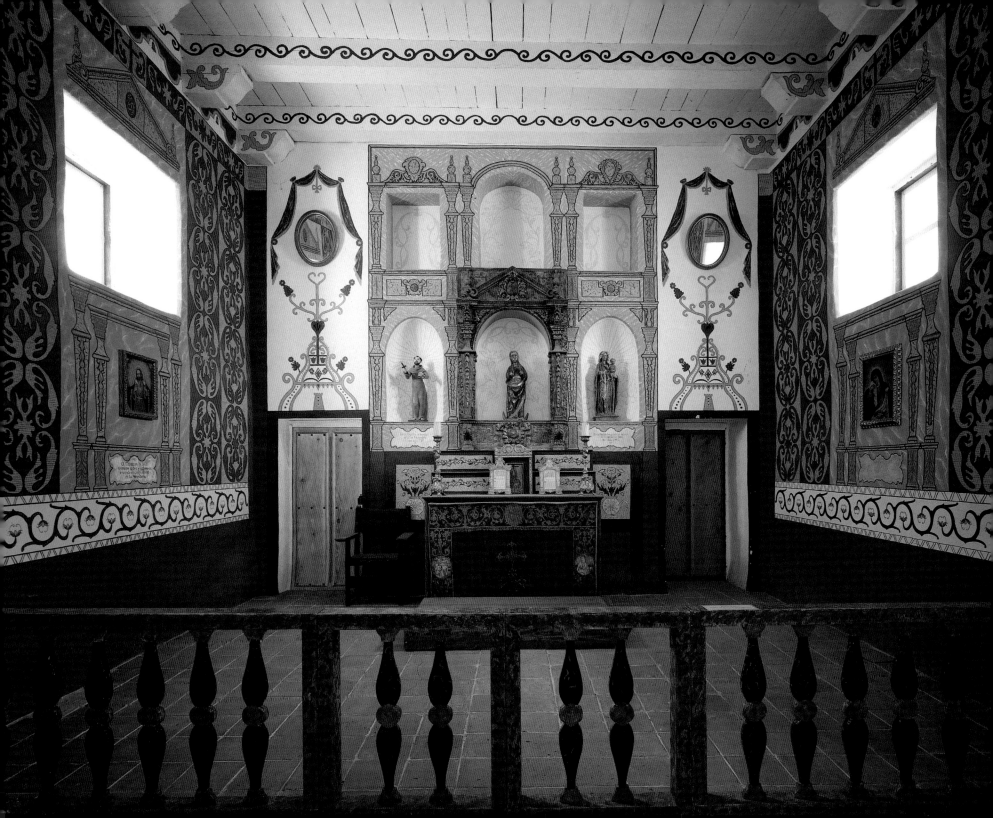

THE CHAPEL OF THE SPANISH ROYAL PRESIDIO
El Presidio de Santa Barbara State Historic Park
Santa Barbara, California

The Chapel of the Spanish Royal Presidio, which actually is a recent re-creation of an eighteenth-century building, was achieved through a detailed knowledge of historical style and an intuitive understanding of the psychology of the first builders. The design of the exterior follows an 1855 watercolor of the original building, founded in 1782.

Like other Spanish Army chapels in the New World, this one was luxuriously decorated. The chapel was rebuilt to look as it would have in the 1790s, and every effort has been made to limit the furnishings to items original to that decade. The painted decoration, too, reproduces typical motifs from the same years. Father Estevan Tapis, a Franciscan who also was an artist, was stationed here in the 1790s and may have done some work in the original building. His work is found in the Santa Barbara and San Juan Bautista missions. Thanks to the Santa Barbara Trust for Historic Preservation and the California Conservation Corps, as well as many volunteers, the Presidio Chapel gives us a good idea of what mission churches looked like when they were newly built and freshly painted; work on the re-creation of other presidio structures continues.

ABOVE *Excavation revealed some stone foundations and established the dimensions of the Presidio Chapel at Santa Barbara. The stark simplicity of the exterior is typical of many Southwest missions, but the richly decorated interior must have reminded the Spanish population of churches at home.*

FACING PAGE *Niches over the altar of the chapel hold statues of Saint Francis, the Virgin of the Immaculate Conception, and Our Lady of the Rosary, all work from the seventeenth and eighteenth centuries. Painting on the side walls imitates brocade. Inscriptions behind the altar state that the chapel was blessed for sacred services on the Feast of Our Lady of Guadalupe, December 12, 1797, and rededicated on the same day in 1985.*

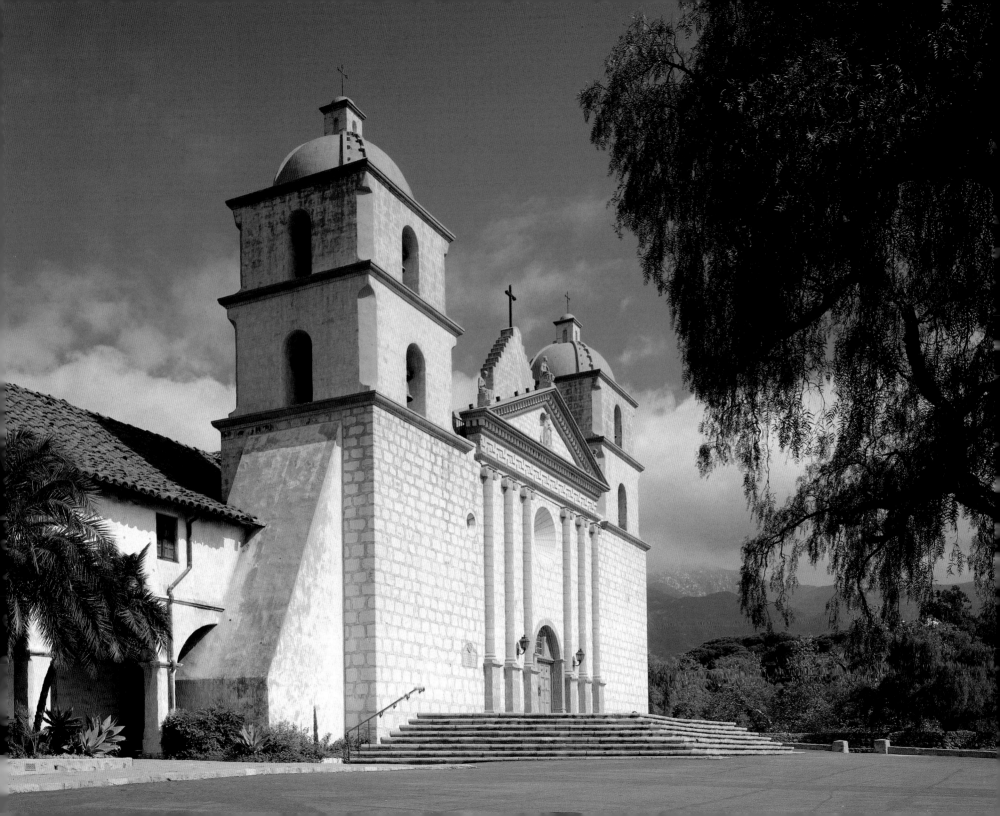

MISSION SANTA BARBARA
Santa Barbara, California

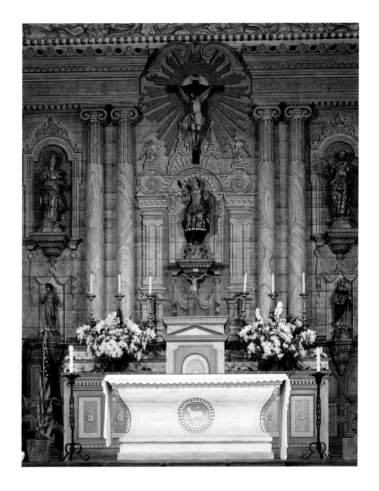

When Father Serra went to Santa Barbara to found the presidio there, he was under the impression that funds would be provided for a mission as well. More than two years passed before he was notified that the mission could be built. A month later, he was dead, and it fell to his successor, Father Fermin Lasuén, to found the mission on December 4, 1786, Saint Barbara's day.

A full complex of mission buildings followed: church and *convento*, workshops, granaries, houses for the native Americans, and all other necessary outbuildings. The most impressive construction, however, was the irrigation system that brought water from the hills. It is so well built that portions of it are still in use.

The present church is the last of a series of ever-larger constructions. It was built around an earlier structure that had been damaged in the earthquake of 1812. The classical detail on the façade was taken from a mission library copy of *The Six Books of Architecture* by the Roman architect Vitruvius, and built by the Chumash people of the area. Construction lasted from 1815 to 1820. The second tower was added to the façade in 1831, making this the only California mission with two identical towers.

ABOVE *An elegantly dressed Santa Barbara stands in the center over the altar at Mission Santa Barbara, flanked by the Virgin and Saint Joseph. Saint Francis and Saint Dominic appear in smaller scale below.*

FACING PAGE *The twin towers are a unique feature of this church, the tenth mission in the California chain. Chamfered corners reflect the light like facets on cut crystal.*

The Franciscans have never left Santa Barbara and, throughout the nineteenth century, friars from this mission traveled widely to serve numerous churches where there was no resident priest. Mission Santa Barbara is still a very active church and friary, beautifully situated among the red-tiled roofs of the town of Santa Barbara, and surrounded by carefully tended gardens.

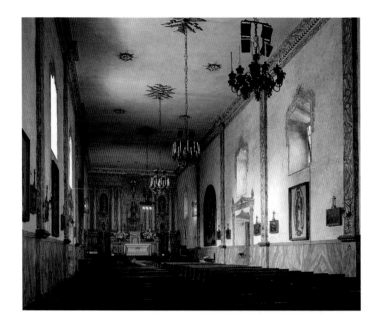

ABOVE *The elegant chandeliers still carry candles, but are electrified as well. The lightning-bolt escutcheons on the ceiling from which the lamps hang are copied directly from Vitruvius.*

LEFT *The cross on the faux-marble pilaster is one of twelve throughout the building, each accompanied with a candle affixed to the wall. They mark the building as a "consecrated" church, set aside for all time for liturgical functions only. The candles are lighted on the anniversary of the consecration. The interior of the church is covered with vigorous painting of veined marble and floral ornament.*

FACING PAGE *The influence of Roman architecture is unmistakable in the design of the façade. Santa Barbara is called the "Queen of the Missions," and the buildings really do have a regal presence. Sculpture on the façade represents Saint Barbara in the central niche, and the three theological virtues — Faith, Hope, and Charity — on the pediment above.*

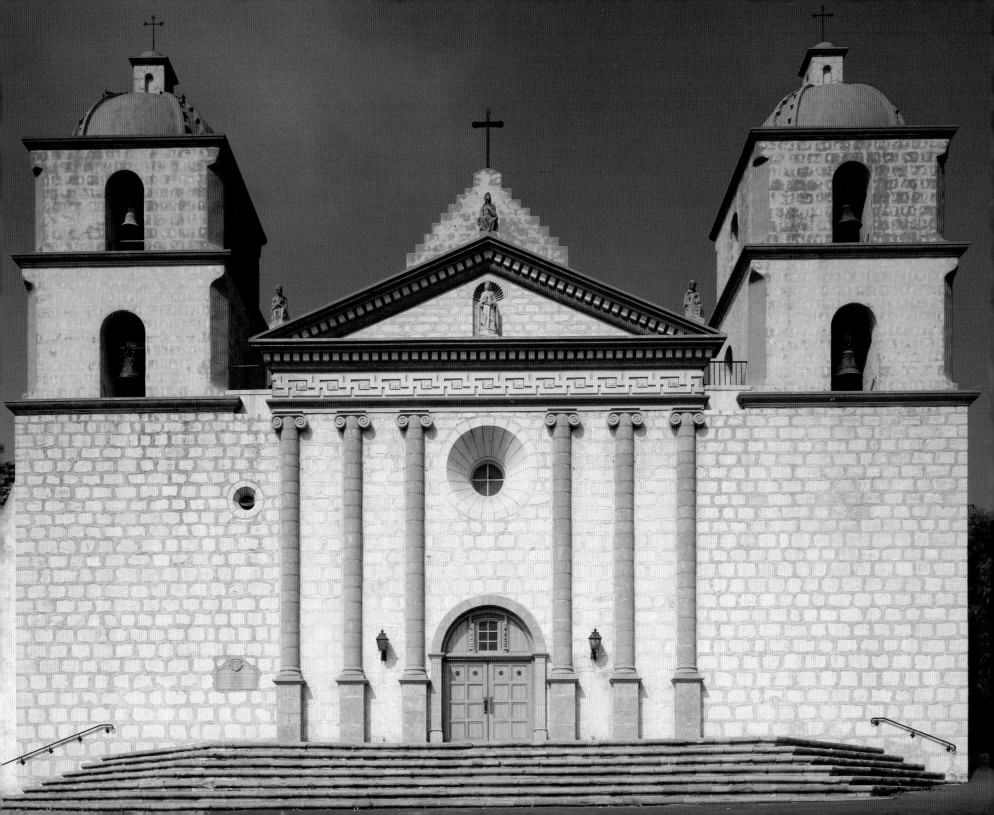

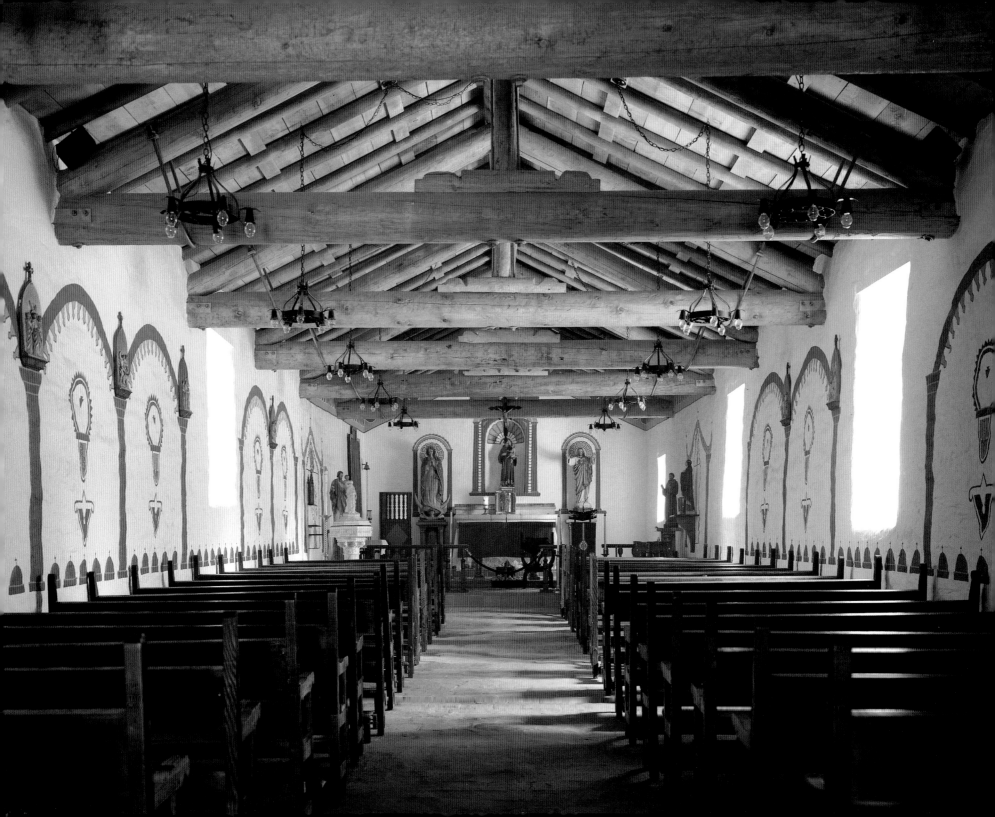

MISSION SAN ANTONIO DE PALA
Pala, California

Ⅰn a valley full of orange groves, approximately twenty-five miles from Oceanside, San Antonio de Pala has the distinction of being the only California mission to serve its native American congregation without interruption since its foundation. The name *Pala* is derived from the word for *water* in the local language.

The padres had proposed to build an inland chain of missions parallel to those along the coast. In 1795, Father Juan Mariner of the San Diego mission visited the Pala Valley in the course of his search for a new mission site. Impressed by the fertile land, by the abundance of water, and especially by the friendliness of the native population, he recommended that the proposed Mission San Luís Rey be founded there. Instead, it was established at its present location closer to the ocean, and Pala was developed as a dependent chapel.

On Saint Anthony's day, June 13, 1816, the chapel was officially founded by Father Antonio Peyri. Within two years, the native builders had completed construction of a large quadrangle measuring 236 by 181 feet. The roofs of the buildings were framed with cedar beams cut on Mount Palomar and dragged or carried to the mission. Father Peyri not only designed the buildings, but also constructed an aqueduct that brought an ample supply of water to the mission. All the reports by visitors to the mission in its early days remark on the prosperity and good order of the community.

ABOVE *The freestanding bell tower is the most distinctive feature of Mission San Antonio de Pala. Local traditions maintain that a cactus at the foot of the cross grew from a seed dropped in the adobe when Father Peyri set the cross in the damp bricks of the original tower.*

FACING PAGE *The framing of the roof and the painted designs on the walls are the strongest design elements of this church. The original painted decorations were whitewashed in 1903, but the parishioners objected, and a local native artist repainted the original designs.*

Following the secularization of 1834 the mission continued to function, thanks to traveling priests who not only looked after the community spiritually, but also did their best to maintain the buildings.

On Christmas Day 1899, the buildings suffered serious earthquake damage. Preservationists took an interest in the mission and, under their direction, the native population completed restoration of the chapel and two rooms of the quadrangle by 1903.

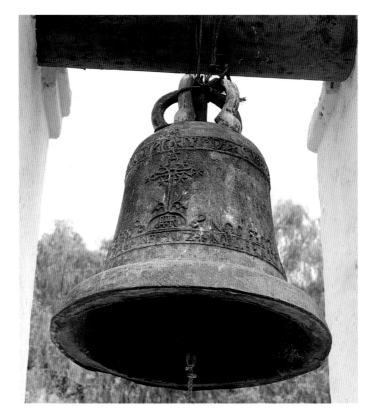

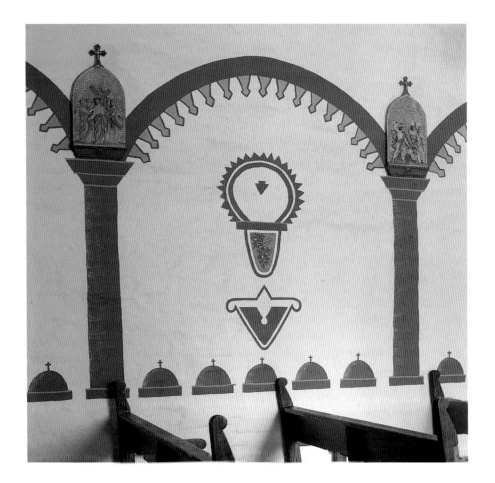

ABOVE *Inscriptions on the large bell include the year it was cast, 1816, the name of the bell founder, Cervantes, and the Latin text of a prayer that is sung in Catholic churches on Good Friday: "Holy God, Holy Mighty One, Holy Immortal One, have mercy on us."*

LEFT *Native motifs are mingled with grapes and wheat, symbols of the Holy Eucharist, in the wall paintings. The repeated design of a cross standing on a hill at the base of the decoration also appears as a relief ornament on both the mission bells.*

FACING PAGE *The stone altar replaces a wooden altar that had been ruined by termites. The painted decorations on the wall follow the original designs. The statues are modern replacements; the original carved images are kept in the mission museum.*

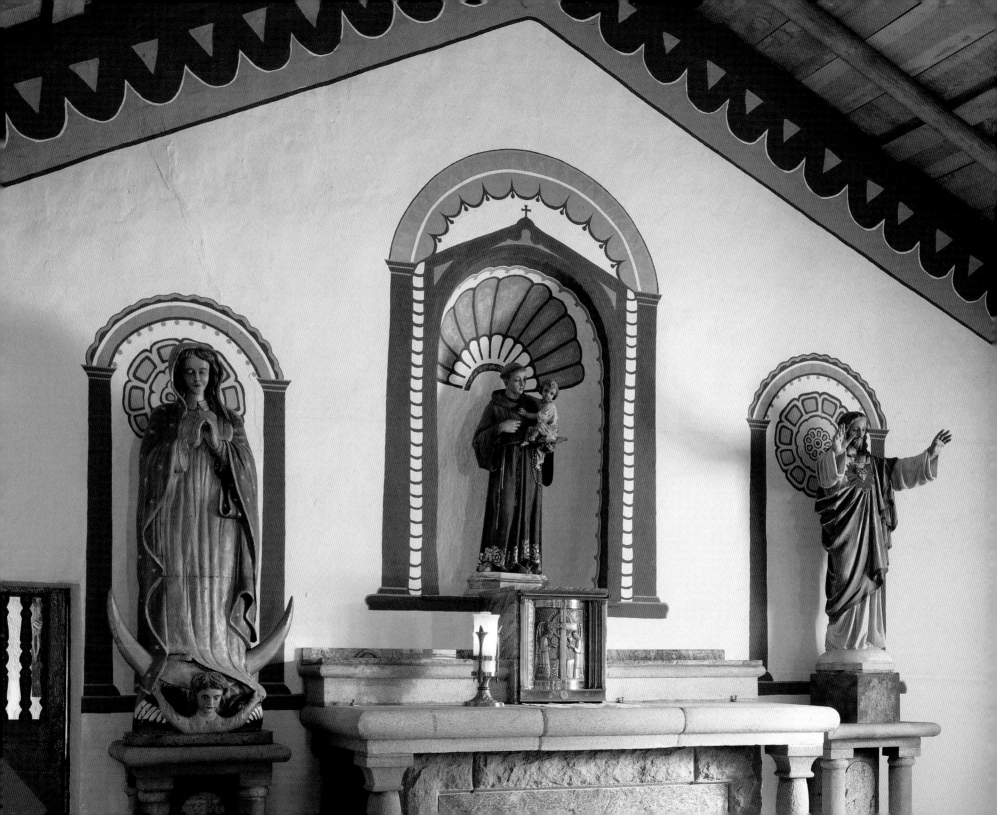

The most notable architectural feature of the mission is its freestanding bell tower, unique in California. In 1916, winter floods washed away the foundations and it fell. Fortunately, the two mission bells were unharmed, and within the year they had been rehung in a new tower, an exact copy of the original.

In 1954, a complete restoration of the quadrangle began, and the mission complex is now fully restored and in excellent condition. Many of the adobe bricks used in the restoration were made from material remaining from the original walls. The mission is an active church with seven dependent chapels in the surrounding area. Every year since its foundation the mission has celebrated a fiesta in June. Celebrations include native American music and games in addition to religious observances.

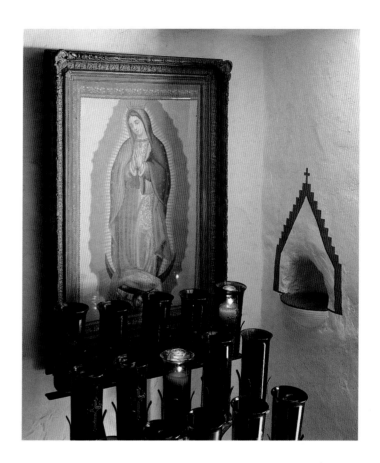

ABOVE *A picture of Our Lady of Guadalupe hangs next to the holy water font, which is simply a basin set into a niche surmounted by a stepped gable decoration.*

LEFT AND FACING PAGE *The blend of cultures represented by the California missions is visible here in the combination of simple European building technology, a baroque floral spray probably drawn from an engraving, and the lively rendering of native American designs painted on a mission wall.*

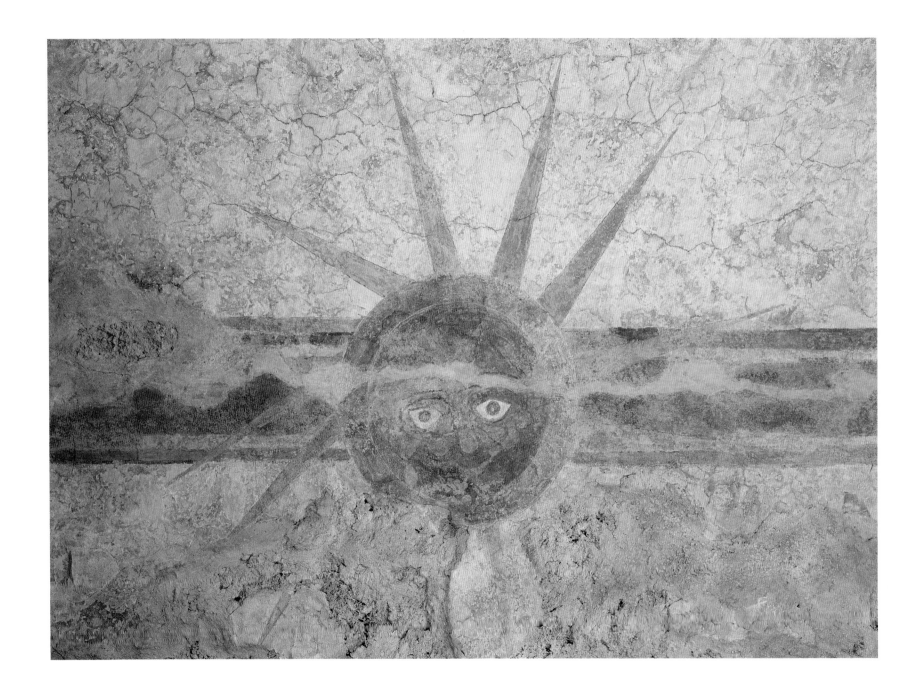

Visitor Information

ARIZONA

❖ MISSION SAN JOSÉ DE TUMACÁCORI, Tumacácori National Historical Park (page 95)

From Tucson, take I-19 south 43 miles to Tumacácori (exit 29). Open daily 8 AM to 5 PM except Thanksgiving and Christmas. Telephone: 602-398-2341.

❖ MISSION SAN XAVIER DEL BAC, Tucson (page 89)

From Tucson, take I-19 south 7 miles to San Xavier Road (exit 92). Turn right and follow the signs to the mission. Open daily 8 AM to 6 PM. Telephone: 602-294-2624.

CALIFORNIA

❖ CHAPEL OF THE SPANISH ROYAL PRESIDIO, El Presidio de Santa Barbara State Historic Park, Santa Barbara (page 115)

From Highway 101, take the Carrillo Street exit and go north to Anacapa Street; turn right and go to East Cañon Perdido Street; turn left and go to 129 East Cañon Perdido Street. Open daily 10:30 AM to 4:30 PM, except Thanksgiving, Christmas, and New Year's Day. Telephone: 805-966-9719.

❖ MISSION LA PURÍSIMA CONCEPCIÓN, La Purísima Mission State Historic Park, Lompoc (page 109)

From Highway 101, take the Highway 246 exit at Buellton and go west 14 miles to the park entrance on the right. Open daily 10 AM to 5 PM, except Thanksgiving, Christmas, and New Year's Day. Telephone: 805-733-3713.

❖ MISSION SAN ANTONIO DE PADUA, Jolon (page 101)

When traveling north on Highway 101, take the Fort Hunter Liggett exit (G-18) 1 mile north of Bradley; go 26 miles to Jolon; turn left at Mission Road and go 6 miles to the mission. When traveling south on Highway 101, take the Fort Hunter Liggett exit (G-14) at King City; turn right and go 23 miles to Jolon; turn right on Mission Road and go 6 miles to the mission. The mission is located on the Fort Hunter Liggett Military Reserve. You will need a driver's license, car registration, and proof of car insurance to enter the military reserve. Open Monday through Saturday 10 AM to 4:30 PM, and Sunday 11 AM to 5 PM. Closed daily from noon to 1 PM. Telephone: 408-385-4478.

❖ MISSION SAN ANTONIO DE PALA, Pala (page 121)

From I-5, take Highway 76 at Oceanside and go 25 miles east to Pala. The church is located in the center of town. Open daily 6:30 AM to 6:30 PM; the store and museum are open Tuesday through Sunday 11 AM to 3:30 PM, except Thanksgiving, Christmas, New Year's Day, and Good Friday. Telephone: 619-742-3317.

❖ MISSION SAN MIGUEL ARCÁNGEL, San Miguel (page 105)

When traveling north on Highway 101, take the San Miguel exit and turn right; the entrance to the mission is on the left. When traveling south on Highway 101, take the San Miguel exit; stay on the service road and go through the commercial area. The mission is at the south end of town, on the right. Open daily 9:30 AM to 4:30 PM, except Thanksgiving, Christmas, New Year's Day, and Easter. Telephone: 805-467-3256.

❖ MISSION SANTA BARBARA, Santa Barbara (page 117)

From Highway 101, take the Mission Street exit and go north to Laguna Street; turn left and go to the end of Laguna Street. Open daily 9 AM to 5 PM, except Christmas and Easter. Telephone: 805-682-4713.

COLORADO

❖ CHURCH OF SAN ACACIO, San Acacio (page 75)

From San Luís, Colorado, go 4.5 miles south on Highway 159 to Old San Acacio Road; turn right and go 1 mile to the church on the right. From Taos, New Mexico, take Highway 522 north 39 miles to the Colorado border, where the highway number changes to 159. Continue on Highway 159 approximately 15 miles to Old San Acacio Road; turn left and go

1 mile to the church on the right. If the church is locked, try knocking on the door of the house across the road and ask to see the church. For more information call the Sangre de Cristo Parish in San Luís (719-672-3685).

NEW MEXICO

❖ CHAPEL OF SAN MIGUEL, Santa Fe (page 45)

From I-25, take the Old Pecos Trail (exit 284) and go north for 3.5 miles toward downtown Santa Fe. The name of the road will change from the Old Pecos Trail to Old Santa Fe Trail. The chapel is on the right at 401 Old Santa Fe Trail. Open daily except Christmas and New Year's Day. Winter hours 10 AM to 4 PM; summer hours 9 AM to 4:30 PM. Telephone: 505-983-3974.

❖ JEMEZ STATE MONUMENT, near Jemez Springs (page 83)

From I-25, take the Highway 44 exit just north of Bernalillo and go north 24 miles to Highway 4; turn right and go 18 miles to the entrance of the monument on the right. Open daily, except Easter, Thanksgiving, Christmas, and New Year's Day. Winter hours 8:30 AM to 4:30 PM; summer hours 9:30 AM to 5:30 PM. Telephone: 505-829-3530.

❖ NUESTRA SEÑORA DEL SAGRADO ROSARIO, Truchas (page 63)

From Santa Fe, take Highway 285 north 24 miles to Española. Turn right on Highway 76 and go 18 miles east to Truchas. The church is in the center of town on the right, close to the edge of the valley. Call the Holy Family Church for visiting hours: 505-351-4360.

❖ PECOS NATIONAL HISTORICAL PARK, Pecos (page 85)

From Santa Fe, take I-25 north 14 miles to the Pecos exit. Go left and follow the signs to the park (about 7 miles). Open daily 8 AM. to 5 PM, except Christmas. Telephone: 505-757-6414.

❖ SALINAS PUEBLO MISSIONS NATIONAL MONUMENT, Mountainair (page 81)

From Albuquerque, take I-25 south 36 miles to the Belen exit. Turn left and take Highway 47 east 22 miles to Highway 60. Turn left and go 22 miles to the visitor center in Mountainair. (The road to the Abó Ruins is to the left on the way to Mountainair.) The visitor center is 1 block west of the junction of Highways 60 and 55. Open daily from 8 AM to 5 PM.

The individual sites are open daily 9 AM to 5 PM, except Christmas and New Year's Day. Telephone: 505-847-2585.

The Abó Ruins are on Highway 513, 9 miles west of Mountainair off Highway 60. The Gran Quivira Ruins are 26 miles south of Mountainair on Highway 55. The Quarai Ruins are 8 miles north of Mountainair on Highway 55.

❖ SAN ANTONIO DE PADUA, Córdova (page 59)

From Santa Fe, take Highway 285 north 24 miles to Española. Turn right on Highway 76 and go 15 miles east; turn right at the sign for Córdova. Go down into the valley; the church is in the center of town. Call the Holy Family Church to arrange a visit: 505-351-4360.

❖ SAN FRANCISCO DE ASÍS, Rancho de Taos (page 73)

From Taos, go 4 miles south on Highway 68 to Rancho de Taos. The church is on the left. Open daily from 9 AM to 4 PM. Telephone: 505-758-2754.

❖ SAN JOSÉ DE GRACIA, Las Trampas (page 67)

From Santa Fe, take Highway 285 north 24 miles to Española. Turn right on Highway 76 and go 26 miles east to Las Trampas. The church is on the right and faces the old plaza of Las Trampas. If the door is locked, try asking the people at the gift shop La Tiendita, on the right as you enter the plaza, to let you in the church. For more information, call the Holy Family Church: 505-351-4360.

❖ SAN JOSÉ DE LAGUNA, Laguna Pueblo, Laguna (page 39)

From Albuquerque, take I-40 west 45 miles to the Laguna exit. The church is on top of a hill north of I-40 and is visible from the interstate. Open Monday through Friday 9 AM to 3 PM. The church is not open to the public during religious ceremonies. Telephone: 505-552-9330.

❖ SANTA CRUZ DE LA CAÑADA, Santa Cruz (page 49)

From Santa Fe, take Highway 285 north 24 miles to Española. Turn right on Highway 76 and go 2.5 miles east. Turn left into the village of Santa Cruz; the church is on the left. Call the parish office for visiting hours: 505-753-3345.

❖ SANTUARIO DE CHIMAYÓ, Chimayó (page 53)

From Santa Fe, take Highway 285 north 24 miles to Española. Turn right on Highway 76 and go 8 miles east to Highway 520; turn right and go 3 miles south to the sign for El Santuario; turn left and go a few hundred yards to the church. Open daily. Summer hours (June to September) 9 AM to 5 PM; winter hours 9 AM to 4 PM. For more information, call the Holy Family Church: 505-351-4360.

TEXAS

❖ CHAPEL OF NUESTRA SEÑORA DE LORETO, Presidio la Bahía, Goliad (page 31)

From San Antonio, take I-37 south to Highway 181 and go south 60 miles to Kenedy; turn left on Highway 72 and go 3 miles to Highway 239; turn right and go 27 miles to Highway 59; turn left and go 3 miles to Goliad. Turn right on Highway 183 and go south 1.5 miles to the entrance of Presidio la Bahía on the left. Open daily 9 AM to 4:45 PM, except Easter, Thanksgiving, Christmas, and New Year's Day. Telephone: 512-645-3752.

❖ MISSION NUESTRA SEÑORA DEL ESPÍRITU SANTO DE ZUÑIGA, Goliad State Historical Park, Goliad (page 27)

From San Antonio, take I-37 south to Highway 181 and go south 60 miles to Kenedy; turn left on Highway 72 and go 3 miles to Highway 239; turn right and go 27 miles to Highway 59; turn left and go 3 miles to Goliad. Turn right on Highway 183 and go south 1 mile to the entrance of the park on the right. Open daily 8 AM to 5 PM, except Christmas. Telephone: 512-645-3405.

❖ MISSION NUESTRA SEÑORA DE LA PURÍSIMA CONCEPCIÓN, San Antonio Missions National Historical Park, San Antonio (page 13)

From downtown San Antonio, take I-37 south to I-10, go west 1 mile and exit at Probandt Street. Turn left on Probandt and go 1 block to Mitchell Street; turn left and go to Mission Road; turn right and the mission is on the left. Open daily 8 AM to 5 PM, except Christmas and New Year's Day. Telephone: 210-229-5701.

❖ MISSION SAN FRANCISCO DE LA ESPADA, San Antonio Missions National Historical Park, San Antonio (page 23)

From downtown San Antonio, take I-37 south to I-10; go west 1 mile and exit at Probandt Street. Turn left on Probandt and go 1 block to Mitchell Street; turn left and go to Roosevelt Avenue; turn right and go 4 miles to Ashley Road. Turn left and go 1 mile to Espada Road; turn right and go 1.5 miles to the mission on the left. Open daily 8 AM to 5 PM, except Christmas and New Year's Day. Telephone: 210-229-5701.

❖ MISSION SAN JOSÉ Y SAN MIGUEL DE AGUAYO, San Antonio Missions National Historical Park, San Antonio (page 17)

From downtown San Antonio, take I-37 south to I-10; go west 1 mile and exit at Probandt Street. Turn left on Probandt and go 1 block to Mitchell Street; turn left and go to Roosevelt Avenue; turn right and go 2 miles to the mission on the left. Open daily 8 AM to 5 PM, except Christmas and New Year's Day. Telephone: 210-229-5701.

❖ NUESTRA SEÑORA DE LA PURÍSIMA CONCEPCIÓN, Socorro (page 35)

From downtown El Paso, take I-10 east 12 miles and exit at Americas Avenue. Turn right and go 2.5 miles to Socorro Road (Highway 258); turn left and go 1.5 miles to the mission on the left. Open daily 8 AM to 6 PM. Telephone: 915-859-7718.

❖ SAN ELIZARIO PRESIDIO CHAPEL, San Elizario (page 33)

From downtown El Paso, take I-10 east 12 miles and exit at Americas Avenue. Turn right and go 2.5 miles to Socorro Road (Highway 258); turn left and go 7 miles to San Elizario. The chapel is on the right side of Highway 258 just past San Elizario Road. Open daily 8 AM to 6 PM. Telephone: 915-852-2333.

FURTHER READING

DOMINGUEZ, FRAY FRANCISCO ATANASIO. *The Missions of New Mexico, 1776.* Translated and annotated by Eleanor B. Adams and Fray Angelico Chavez. Albuquerque: University of New Mexico Press, 1956. A fascinating translation of an important primary source on the history of the New Mexico missions, this book represents the report of an inspection made for church authorities in 1776, with complete descriptions of the buildings.

GUERRA, MARY ANN NOONAN. *The Missions of San Antonio.* San Antonio: The Alamo Press, 1982. This brief study is a guide for serious visitors and includes historic illustrations, photographs of architectural details, reproductions of old paintings, and a detailed chronology of these monuments.

JOHNSON, PAUL C., AND EDITORIAL STAFF OF SUNSET BOOKS. *The California Missions.* Menlo Park, Calif.: Lane Book Company, 1964. A comprehensive survey of the subject with numerous illustrations from a variety of sources. Tables at the back include chronological and religious information, and a visitor's guide lists special annual celebrations at the missions. A selection of mission recipes is included.

KESSELL, JOHN L. *Friars, Soldiers, and Reformers: Hispanic Arizona and the Sonora Mission Frontier, 1767–1856.* Tucson: University of Arizona Press, 1976. A very readable history of the Spanish presence in Arizona, with copious quotations from primary sources.

KESSELL, JOHN L. *The Missions of New Mexico since 1776.* Albuquerque: University of New Mexico Press, 1980. A survey of the missions of New Mexico, richly illustrated with historic photographs and old drawings. Includes many quotations from nineteenth-century travelers and visitors.

KUBLER, GEORGE. *The Religious Architecture of New Mexico in the Colonial Period and Since the American Occupation.* Albuquerque: University of New Mexico Press, 1990. The new edition of this important study, first published in 1940, contains updated information. As the foreword states, there is still "no better handbook for the eager pupil" than Kubler's excellent text.

MAYS, BUDDY. *Indian Villages of the Southwest.* San Francisco: Chronicle Books, 1985. A guide to the Pueblo Indian villages of New Mexico and Arizona, including a history of the people.

MORGADO, MARTIN J. *Junípero Serra: A Pictorial Biography.* Monterey, Calif.: Siempre Adelante Publishing, 1991. A comprehensive biography rich in quotations from original documents, with extensive illustrations.

NEUERBURG, NORMAN. *The Decoration of the California Missions.* 2d ed. Santa Barbara, Calif.: Bellerophon Books, 1989. An engaging collection of sketches, photos, reproductions of painters' models, and native American design elements from the missions, with comments by the author, an expert who has restored much of the painted decoration in these buildings.

NEWCOMB, REXFORD. *Spanish Colonial Architecture in the United States.* New York: Dover Publications, 1990. A reprint of a standard work, first published in 1937, this authoritative study includes a short text, historic and modern photographs, and scaled architectural drawings of plans, elevations, and details.

WILDER, MITCHELL A., with Edgar Breitenbach. *Santos: The Religious Folk Art of New Mexico.* Colorado Springs: The Taylor Museum of the Colorado Springs Fine Arts Center, 1943. Sixty-four black and white plates accompanied with an informative and accurate text about the iconography of these paintings and carvings.

WRIGHT, RALPH B., ed. *California's Missions.* Arroyo Grande, Calif.: Hubert A. Lowman, 1980. Now in its twelfth printing, this book has served as a brief guide for visitors since 1950. Pencil drawings by Herbert C. Hahn often present unusual views of the buildings, artifacts, and historic scenes associated with the missions.

WROTH, WILLIAM. *Christian Images in Hispanic New Mexico: The Taylor Museum Collection of Santos.* Colorado Springs: The Taylor Museum of the Colorado Springs Fine Arts Center, 1982. Nearly two hundred plates, many in color, accompanied with text that is strong on stylistic and historical information.

WROTH, WILLIAM. *Images of Penance, Images of Mercy: Southwestern Santos in the Late Nineteenth Century.* Norman, Okla.: University of Oklahoma Press, 1991. This catalog of an exhibition of paintings, carvings, and religious artifacts is an excellent introduction to the subject.

INDEX

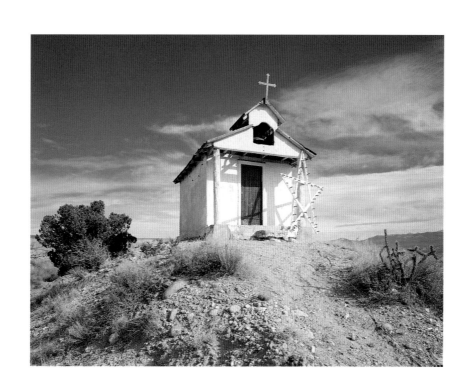

A Sense of Mission

The text type is Centaur roman, designed by Bruce Rogers,
with Arrighi italic, designed by Frederic Warde.
The display type, Charlemagne,
was designed by Carol Twombly.